Outdoor Flash Phot

Maximizing the power of your camera's flash is difficult enough in a studio set-up, but outdoors literally presents a whole new world of challenges. John Gerlach and Barbara Eddy have taken the most asked about subject from their renowned photography workshops and turned it into this guidebook that is sure to inspire your next outdoor shoot, while also saving you time and frustration.

Outdoor Flash Photography covers a range of practices from portrait to landscape, including unique strategies that the authors have pioneered through 40 years in the field. Mastering the use of multiple flashes to freeze action is shown through one of the most challenging subjects in nature, hummingbirds in flight. This book will benefit photographers of all experience levels who are eager to evolve their outdoor photography and get the most out of their equipment.

John Gerlach and **Barbara Eddy** are founders of Gerlach Nature Photography. They are professional nature photographers. Their pictures have been published in *National Wildlife, Sierra, Natural History, Petersen's Photographic, Ranger Rick, Birder's World, Michigan Natural Resources, Audubon, Outdoor Photographer* and *Popular Photography*, as well as in books published by National Geographic Society, Sierra Club and Kodak. They have written Focal's *Wildlife Photography, Digital Landscape Photography, Close Up Photography in Nature* and *Digital Nature Photography*.

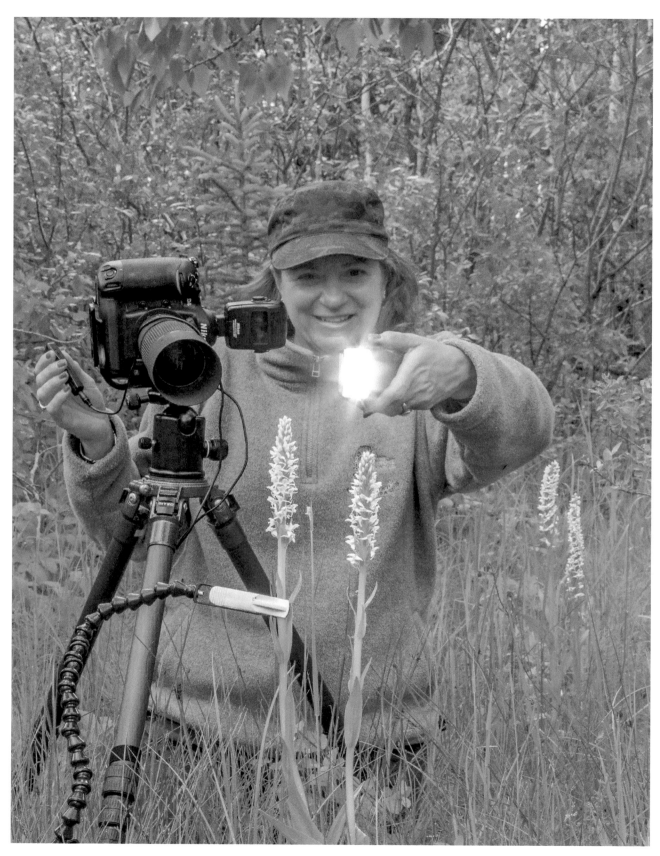

Barbara handholds a Nikon SB-800 Speedlight to add fill light to a bog orchid. The Nikon SU-800 optical controller mounted in the camera's hot shoe enables wireless flash control. Canon EOS 5D Mark III, 24-105mm lens at 58mm, ISO 100, f/20, 1/8, Cloudy WB, FEC – 1.3 stops.

Outdoor Flash Photography

John Gerlach and Barbara Eddy

Routledge
Taylor & Francis Group

NEW YORK AND LONDON

First published 2017
by Routledge
711 Third Avenue, New York, NY 10017

and by Routledge
2 Park Square, Milton Park, Abingdon, Oxon OX14 4RN

Routledge is an imprint of the Taylor & Francis Group, an informa business

© 2017 Taylor & Francis

The right of John Gerlach and Barbara Eddy to be identified as the authors of this work has been asserted by them in accordance with sections 77 and 78 of the Copyright, Designs and Patents Act 1988.

Library of Congress Cataloging in Publication Data
A catalog record for this book has been requested

ISBN: 978-1-138-21222-0 (hbk)
ISBN: 978-1-138-85646-2 (pbk)
ISBN: 978-1-315-71962-7 (ebk)

Typeset in Slimbach and Helvetica
by Keystroke, Neville Lodge, Tettenhall, Wolverhampton

Table of Contents

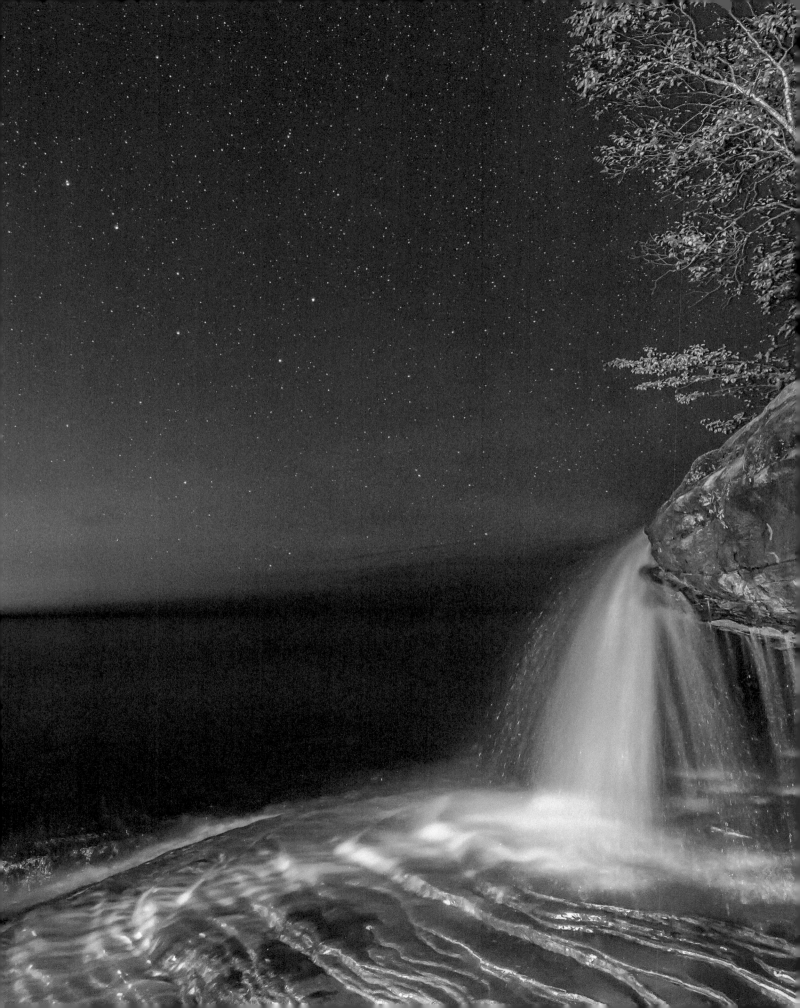

Acknowledgments

John Shaw and Larry West, widely-acclaimed nature photographers and educators deserve endless thanks for giving me such an excellent start in my nature photography career. When I attended their week-end nature photography workshop at Central Michigan University's biological field station, and later that summer a week-long field work-shop near Houghton Lake, Michigan, little did I realize how much the experience would entirely change my life. When I graduated from CMU in 1977, my desire to be a wildlife biologist evolved into becom-ing a professional nature photographer. As it turned out, the nature photography business and lifestyle suited me perfectly.

As a nature photographer, my life has been endlessly filled with excit-ing wildlife encounters, frequent travel to remote wild corners of the earth, time spent with wonderful people in and from many countries, and constant learning about nature, photography, teaching and writing.

Barb Eddy has been my constant companion for over 26 years and has helped tremendously in discovering numerous and many new ways to use photo gear in the field. She deserves enthusiastic applause for not only putting up with, but actively encouraging, my maniacal pursuit of nature photography. Her own ability to quickly learn and apply new photo features is almost legendary, and her skills with the camera and photo editing software are absolutely awesome!

Barbara is an accomplished computer user who makes Photoshop and Lightroom jump to her every command. She carefully selected and processed all of the images used in this book from a library of a zillion (at least more than we can count) images. She starts with large RAW files, works her artistic Photoshop and Lightroom magic, and finally changes them to JPEG format for publication.

The thousands of eager photographers, beginner and expert alike, who have attended our photo workshops deserve tremendous praise, espe-cially for helping us learn new photo strategies. Participants often ask questions that lead us down hitherto unexplored pathways to new discoveries. Student questions help us identify concepts that are dif-ficult for the students to understand. Feedback is always important to open-minded instructors, and we welcome your comments.

Two-foot high Elliot Falls pours over a rocky ledge on the east side of Miners Beach in Pictured Rocks National Lakeshore. A low viewpoint permits framing the falls against the starry north sky. This is a Nikon D4 double exposure. Exposure #1 was focused on the waterfalls using ISO 1600, f/11, 30 seconds, Manual exposure, Sun WB, 14mm. A single Nikon SB-800 was fired twice to light the foreground. Exposure #2 is focused on the stars, no flash, and the shutter speed is 20 seconds, f/2.8, and ISO 1600 to capture the stars.

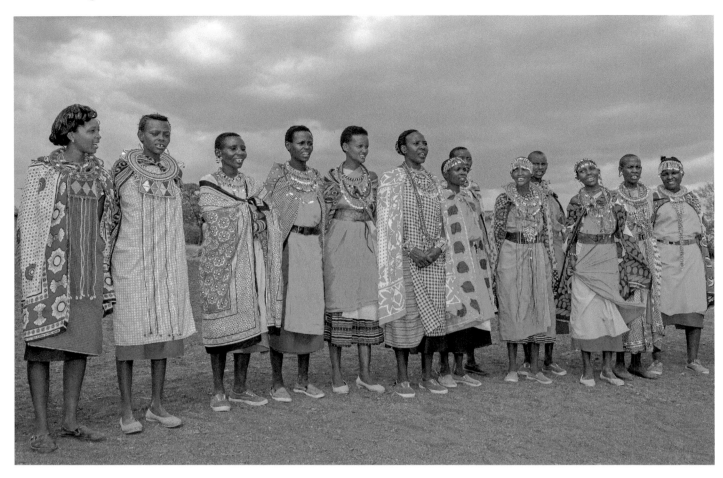

On-camera flash is used here to bring out the detail in the dark skin of these delightful Masai people. Nikon D4, 34mm, ISO 400, f/6.3, 1/1600 with HSS, Shutter Priority, Cloudy WB, +3 FEC.

Introduction

Electronic flash is an extremely useful tool that all photographers should use frequently to improve the light in their images. Unfortunately, flash is underutilized by most photographers and not used at all by many others. Most maintain that they see no need to use flash or declare that flash produces ugly light. Stating there is no need for flash is like saying there is no need for good light. We agree flash does produce ugly light when used poorly, and sadly this is too often the case. Barb and I have taught flash techniques in our field workshops for more than a decade. We understand the reason is that flash is scary to so many photographers. We have three major reasons for thinking most photographers avoid using flash outdoors:

1 TERMINOLOGY

Flash technology regrettably uses many terms unfamiliar to photographers, and it can make flash give the impression of being extremely complicated. When new users see and read terms like sync speed, second-curtain sync, high-speed sync, lighting ratios, preflash, slow-speed sync, Inverse Square Law, flash exposure compensation and other equally unfamiliar terms, they are defeated and abandon their expensive flash because it appears so excessively complicated.

2 GETTING STARTED

Successful flash usage in outdoor shooting generally requires that the flash not be built-in, or mounted on top of the camera. Instead, the flash should be remote from the camera. An interconnecting cord or a wireless remote controller is needed to connect camera and flash. Remote controllers can be separate devices or can be built into the camera. Controllers require that the external flash be set to *slave* mode (Canon's term) or *remote* mode (Nikon's term). Instructions are often difficult to grasp regarding what to set and how much to set it, which discourages many new users from ever starting.

Default camera settings buried deep in the menu discourage even the more adventuresome beginner. An example would be when using an automatic exposure mode such as Aperture Priority, your camera might default to the sync speed for your camera which is the maximum shutter speed for ordinary flash use. The sync speed might be 1/200 second, even though you are using a tripod and photographing a landscape. You would rather use a 1/4-second shutter speed to allow some of the ambient light to expose the scene, but the camera detects a flash in use and automatically changes the shutter speed to the faster sync speed.

Camera makers assume most people are shooting handheld, so they try to help users avoid soft images caused by the ambient light portion of the exposure. But careful photographers like you solve the soft image problem by diligent use of good tripod techniques. Next, you must find where the default flash shutter speed setting is located and change it to something slower. Most likely that setting is in the camera, but, frustrating your best efforts, it might be in the flash or the flash controller. It's good to keep in mind that when your camera refuses to do your bidding, look for a setting that must be changed. Use the manuals that come with your flash and camera.

Read and reread the flash options meticulously so you know your choices. Mystery options lurking in the deep dark depths of your camera menus undoubtedly impede your path to flash success. Again, study your manuals for both the flash and the camera carefully.

3 PERCEIVING THE NEED FOR FLASH

Most photographers, even after becoming comfortable with the terminology and initial settings of their flash gear, still don't use flash nearly as much as would be beneficial. Why? Because they just don't perceive the improved lighting and better quality images that flash can bring. Often

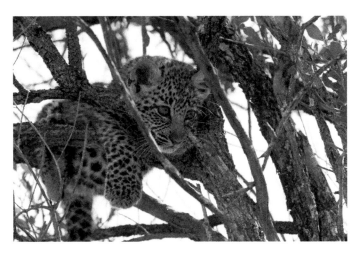

The Masai Mara leopard resting in the shade was captivating, while the ambient light was dreadful. Nikon D300, 400mm, ISO 400, f/6.3, 1/400, Aperture Priority, Cloudy WB, no flash.

Flash balanced the light by opening up the dark shadows. Barbara used a Walt Anderson Better Beamer on her flash head to concentrate the light on the leopard. Nikon D300, 330mm, ISO 400, f/6.3, 1/250 (max sync speed), Aperture Priority, Cloudy, +1 FEC.

the changes are subtle until compared directly in order to see the difference between with and without flash.

I understand that entirely. Despite that, in a 40-year career working as a professional photographer where I always used flash, I still increasingly find additional and more superior ways in which to use flash. Indeed, with all of the new digital camera technology and the much improved and higher ISOs available on newer cameras, today's opportunities for creative flash use are steadily expanding.

Perceiving opportunities to creatively apply flash to outdoor photography is among the most valuable of lessons to be learned.

We will be illustrating many image pairs, flash and no-flash, to emphasize how much your images can be improved by using flash. Barbara and I hope this will inspire you to become an accomplished flash user.

Recent years have brought a gratifying resurgence in the popularity of photography, and flash is playing an important part in that recovery. Advances in HDR methods, low-noise high ISO abilities, focus stacking, autofocus accuracy and speed, metering systems, histograms and more all help current photographers. Flash users can enjoy optical and radio-based wireless flash, uncomplicated multiple flashes, automatic flash exposure systems, and the ease of mixing ambient light with flash light. These advances make today's flash photography a latter-day piece of cake! Flash use is crucial to the latest renaissance. Astute shooters will take advantage of this technology to become increasingly comfortable with flash and then use it frequently to improve their images. The learning curve is gentle, while opportunities for superior images are unbounded! Barb and I encourage you to embrace flash as extensively as we do. We know that when you become familiar and therefore comfortable with flash, and have realized the many powerful possibilities, you will be amazed that you ever got along without it.

THE FOCUS OF THIS BOOK

I have long held a keen interest in using flash to improve photographs, and I've read most of the available flash books on the art and the craft. Authors tend to approach flash books in one of two ways. Numerous books are devoted to a specific camera brand. For example, there are books that only explain the Canon flash system. Countless others are devoted to only the Nikon Creative Lighting System. These books cover all of the equipment made by

a specific system and explain the many options in exacting detail. A book solely on the Nikon or Canon flash system will help you learn what buttons to push and dials to turn to make the Nikon or Canon flash system work. I study these books because they contain plenty of useful information and they make much easier reading than a typical boring and cryptic flash manual.

The second way authors usually explain flash is to describe human portrait photography using multiple flash

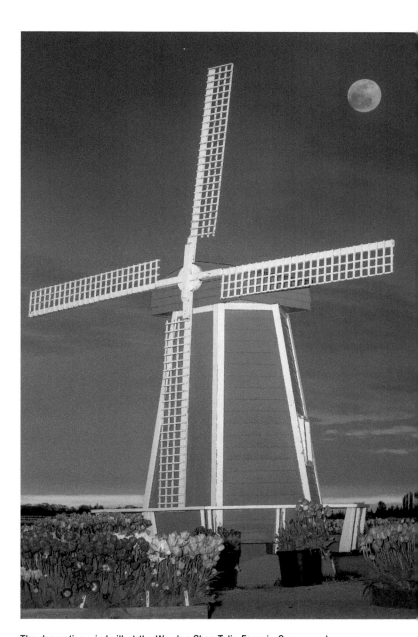

The decorative windmill at the Wooden Shoe Tulip Farm in Oregon makes an attractive foreground against the evening sky. Flash lit, the windmill and the moon was double exposed into the scene. Nikon D4, 200mm, ISO 1000, f/10, 1/1000, Sun WB, +1 FEC.

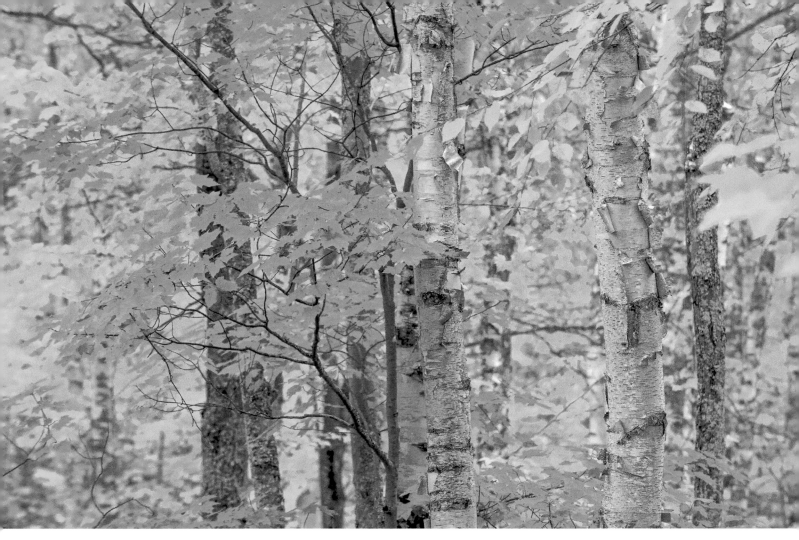

The White Birch Forest east of Munising, MI reaches peak color around October 15. The combination of white birch trees with their bright yellow leaves amid red maple leaves is stunningly colorful. Flash was used to light the birch trunks in the foreground. Nikon D4, 150mm, ISO 100, f/8, 1/30, Cloudy WB, Manual exposure, SB-800 TTL flash with +1 FEC.

setups primarily in the studio, although some authors discuss outdoor portraiture in helpful detail. These books are useful if you wish to photograph people and some of these techniques are also effectively applied to animal photography.

Whether books are devoted to a single flash system or portrait photography, they all have merit for many photographers. I am pleased to know that skillful authors/photographers spend the time and effort to produce books because the entire photographic community benefits. I wrote this book with the sole point of addressing a critical need that I am convinced has never yet been met.

One goal of this book is to present an abundance of instructional and inspirational images to illustrate and explain how to use flash to significantly improve your outdoor images of people, animals, plants and landscapes. We originated many of the flash strategies we use to

effectively light our outdoor images, and we'll explain this in detail. In doing so, we will learn more too! Barbara and I certainly don't know everything about flash—no one ever does—but we use flash quickly and correctly to improve our light.

Viewers of many of our flash images, including some professional photographers, would never even suspect that flash had contributed to the light. Flash can be subtle. The secret to making flash look natural is to mix flash and ambient light together. That may sound complicated, but it isn't. Current digital cameras offer immediate review of the image so that light from the flash or the ambient light can be individually adjusted while the subject is still present. We sincerely hope you'll enjoy your journey into the wonderful world of outdoor flash photography. Beautiful images made by combining ambient light and flash await you.

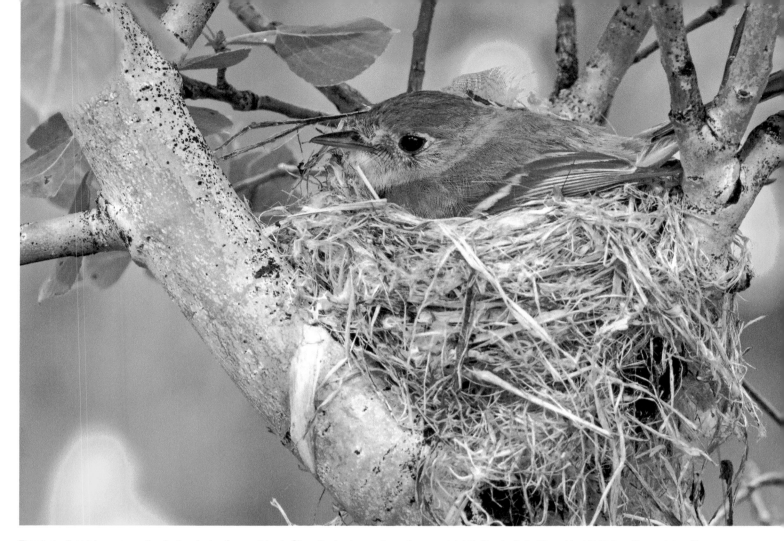

The dusky flycatcher was nesting in the shade of a small bush. Since the background was far more brightly illuminated with ambient light than the nest, two Canon 580 EX Speedlites were used to light the shaded nest. A Canon ST-E2 optical controller triggered the flashes. This is an example of balanced flash where ambient light illuminates the background exclusively and flash lights the flycatcher almost exclusively. Canon 7D, 300mm f/4 lens, ISO 250, f/11, 1/60, Cloudy WB, FEC + .7 stop.

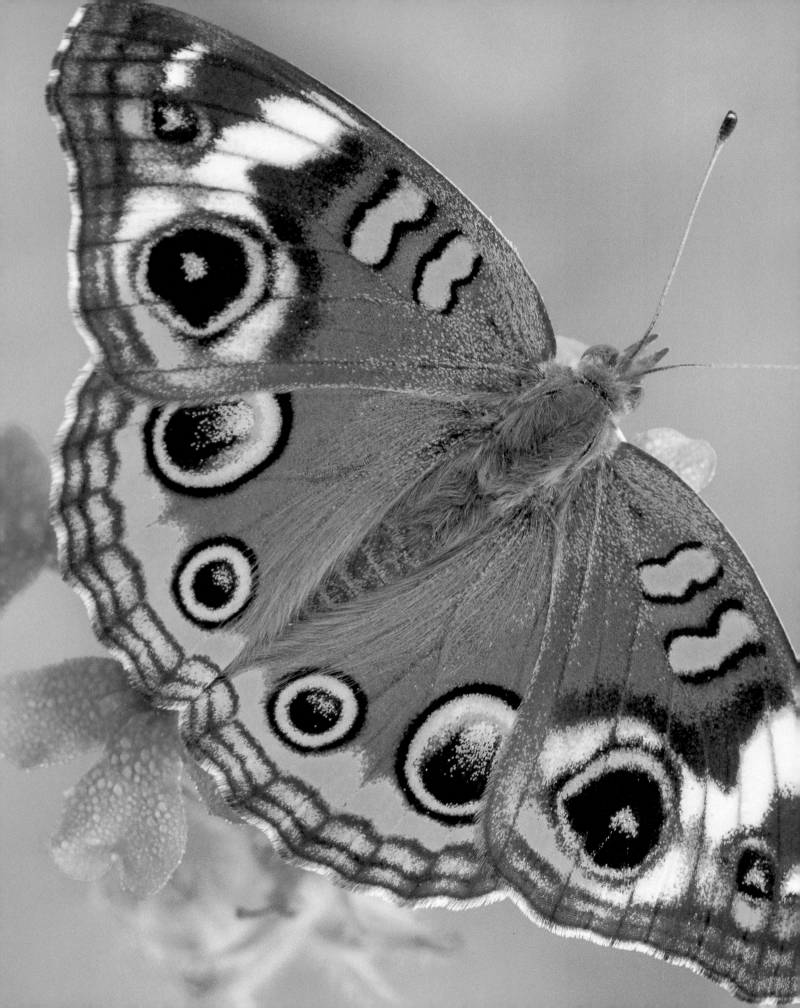

Getting started with flash

To begin our journey into flash photography we will explain what flash is and how it can help you shoot well-illuminated and dramatic images. Let's first clarify at least one notorious nomenclature nuisance—the word *flash* itself. We photographers use the word flash in at least three ways:

- As a noun—an electrical device that, on demand, emits a burst of light.
- As another noun—the burst of light that is emitted by the device.
- As a verb—the act of illuminating a subject ... "To flash, or not to flash, that is the question...."

This triple use of the word *flash* can be confusing. Moreover, some companies use their "own" name for their flash units. Canon calls their proprietary line *Speedlites* and Nikon calls them *Speedlights* (Nikon is less trendy!). Rather than adopting the maker name, it may be simpler to use flash to refer to the device emitting the light, the light being emitted, and the act of causing the emission. The context of the usage should make the meaning clear.

Why do Speedlights and Speedlites exist? What's so speedy about either or both, or one by another name? These small flashes produce much shorter and much brighter bursts of light than the flash bulbs of decades ago. Unlike those flash bulbs, modern flashes are capable of generating their large amounts of light in tiny fractions of a second, all while creating very little heat.

COMMANDER OR MASTER

Using one or more flash units, not mounted on the camera or attached to the camera by a cord, is an excellent way to light most outdoor subjects. When no wires connect the camera to the flash, it is called wireless flash. Multiple wireless flash setups are accordingly quicker to set up and modify. Moreover, getting rid of the wires eliminates the tripping and entangling hazard that otherwise might exist. The camera controls the remote flashes by use of a commander or master device.

Firing the flash at right angles to the buckeye butterfly helps to bring out wing details by creating soft shadows. Nikon D3, 200mm Nikon micro lens, ISO 200, f/20, 1/13, Cloudy WB, Manual exposure, and auto flash using FEC +1/3.

CANON AND NIKON

Once again the two major camera companies—Canon and Nikon—use different terms to describe identical things. A wireless remote flash requires a device to send an optical or radio signal to fire the flashes. Nikon calls both its internal and external devices that send such signals *commanders*. Canon calls them *masters*. The flash units receiving the signals are called *remotes* by Nikon and, to my discomfort, they are called *slaves* by Canon. I am a Canon user, but that discomfort spurs me to prefer Nikon's terminology.

Disregarding my concerns, the industry accepts commander/remote and master/slave as interchangeable word combinations. I use commander and remote in this book, but I will use master and slave when specifically addressing Canon, just to be consistent with Canon's manuals. When I am elected to Grand Exalted Terminology Wizard, I'll require all camera companies to use standard nomenclature!

A CONTROLLABLE LIGHT SOURCE

Flash units produce brilliant bursts of light whenever commanded. They are extremely reliable and safe to use. Think of the flash as a "sun in the box" because it looks like a plastic box, and its light is able to make spectacular images.

The light emitted by a flash is similar to midday sun in color temperature, about 5500 K or 5500 Kelvin. Flash is a tiny sun whose light can be easily colored with gel filters in various hues.

Fear of the unknown causes anxiety in nearly all of us. Barb and I often notice that anxiety in our clients when we encourage them to use flash for the first time. Should we even as much suggest they use their flash to add backlight to a flower blossom, we observe just the thought overwhelms them. With gentle encouragement, they reluctantly get out their dedicated flash and a dedicated cord that allows off-camera flash positioning. That is when we notice that they have a pop-up flash that can be programmed to act as a flash commander. We now urge them to use the built-in wireless flash system that until now they did not understand they already had. Again, they protest! However, with a little persistence and guidance, they quickly have their pop-up flash correctly set in the commander mode and their handheld flash properly in *remote* mode. Students are amazed at how simple it was

to set everything into the wireless flash mode. Within an hour, they are using the wireless flash system effortlessly and they begin the steady downhill progression to skilled flash use.

Flash is so widely underused by outdoor photographers simply because most do not perceive that it can, and will, create attractively illuminated images. Here are several examples. I was photographing Grand Prismatic Spring in Yellowstone National Park on a cloudy day. Although 20 photographers were actively shooting in the basin, I was the only one using flash. One puzzled photographer questioned the reason I used flash. I showed him the image I was shooting on my camera's LCD. He was indeed enthralled. However, he could not duplicate it because he had no separate flash and his pop-up flash had inadequate power.

Most outdoor photographers love to photograph waterfalls. Have you ever seen anyone use a flash on a waterfall? Have you noticed that many outdoor photographers seem to be afraid of the dark because they pack up their gear and flee as soon as the sun fades away? Instead, I put my flash to work. Moreover, I use flash in about 35% of the landscape images I shoot. Consider a butterfly quietly clinging to a flower on a chilly morning. Most photographers would shoot it with ambient light, a quality macro lens, and a tripod to help good composition and to make a sharp image. I do that too, but additionally I nearly always mix flash with the ambient light, especially with close-up subjects.

I hope you are wondering about the reasons for so often using flash in those, and similar situations. The cloudy day at Grand Prismatic spring had flat, dull light. Yes, I used a polarizing filter to remove the glare from the colorful foreground of the hot spring's runoff channel, but the white sky remained unappealing and distracting. If the sky were a dark gray, and a shaft of warm sunlight penetrated the overcast sky to brightly light the runoff channel, the light would be vastly improved. Since I was using a wide-angle lens and the foreground was only a couple of yards away, well within reach of the flash, I could make that light happen! I underexposed the ambient light by about two stops to turn the cloudy background dark gray, and used my flash to imitate the shaft of sunshine to brilliantly light the foreground. Instead of a dark, dull foreground and a bright sky background, the flash changed the light ratios to produce a bright foreground with a dark background!

The patterns in the runoff channel at Grand Prismatic Spring offer an appealing foreground. On a cold and cloudy day, though, the foreground doesn't grab your attention quickly. Canon 5D Mark III, 28mm, ISO 500, f/11, 1/60, Cloudy WB, Manual.

Hoping for a shaft of sunlight to light the foreground without success, John shot a two-shot multiple exposure that let him light the foreground with a 1/2 CTO filtered Canon 600EX-RT Speedlite. He zoomed the flash head to about 50mm to light the nearest foreground, then zoomed to 200mm for the second shot of the double exposure to light the more distant foreground. He also underexposed the ambient portion of the image to make the gray skies menacing. Canon 600EX-RT Speedlite fired at 50mm and 200mm zoom on manual to make certain the Speedlite emits all of the light. The Master was a Canon ST-E3-RT.

Consider photographing a waterfall by mixing ambient light with flash using a long exposure. The long shutter speed causes the water to blur, while the flash freezes some of the water drops in mid-air, making the waterfall look "wetter" in the final image. Think of a dark night sky filled with twinkling stars. Expose so the stars are correctly rendered by ambient light, and use your flash to expose and reveal the foreground. As for that sleepy butterfly, ambient light does an excellent job. But a slightly underexposed butterfly with a little flash skimming across the wings to reveal the wing texture works far better. Alternatively, I use the flash as a backlight to highlight the edges of the butterfly. In both cases, the flash makes the butterfly appear to have more depth and to look more three-dimensional.

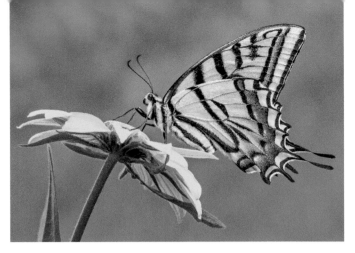

The two-tailed swallowtail is one of the largest butterflies in America. A Nikon SB-800 Speedlight front-lit this fine specimen. Nikon D4, 200mm micro lens, ISO 200, f/22, 1/6, Cloudy WB, Manual ambient exposure, TTL flash.

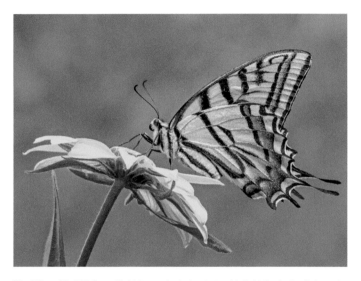

The Nikon SB-800 Speedlight is used wirelessly to sidelight the butterfly in order to reveal more texture.

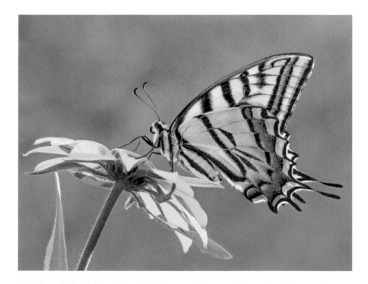

The Speedlight lights the butterfly from behind providing a pleasing backlight.

Photographers find outdoor flash so extremely useful because it conquers numerous lighting problems. Flash mainly helps to create flattering light when the ambient light is a bit on the bland side. Here's a list of eight worthy applications for outdoor flash:

- To add light to help reduce dark shadows—the conventional fill flash.
- To be the main or primary light on the subject, using ambient light for fill.
- To exclusively light a subject—using no ambient light.
- To correctly expose an otherwise dark area of the image using balanced flash.
- To improve the color of the subject or background.
- To sharpen the image.
- To backlight or sidelight the subject.
- To freeze fast subject motion, such as hummingbirds' wings.

USE FLASH EFFECTIVELY

The key to successful flash use outdoors, generally, is to combine flash with ambient light. The combination avoids the harsh and high contrast light of a single off-camera flash, or the flat light of an on-camera flash. We all see noticeably too many poorly lit flash images, so it is little wonder that many photographers avoid flash. Many photographers struggle with ambient light exposures, while others are quite mystified by flash exposure. Mixing the two light sources together sounds doubly challenging—almost impossible perhaps—but it truly is not, if only two easy steps are followed:

1. Using no flash, expose the subject for the ambient light. Correct and repeat as necessary for the desired result.
2. Add the flash, and again correct and repeat as necessary for *the* desired result!

Novice flash users have a tendency to shoot the ambient light and the flash together on the first exposure. Proper correction is difficult when both ambient and flash are shot together on the first exposure. If, after a first shot using both sources, one finds blinking highlight alerts (the dreaded blinkies), which light source should be reduced? Flash mavens though, follow the "two-step rule" and first shoot the ambient light to achieve the desired result and to make certain it is not causing overexposure.

USE THE MANUAL EXPOSURE MODE FOR THE AMBIENT LIGHT

Your camera may offer several exposure modes for the ambient light. These include Aperture Priority, Shutter Priority, Program and Manual. We recognize that Aperture Priority is widely popular among novice and skilled photographers alike. The aperture controls depth of field. In a landscape image, f/16 will typically produce plenty of depth of field—the zone of satisfactory sharpness— which helps to sharply record everything in the scene. Therefore, many photographers choose Aperture Priority set to f/16 or f/22, especially when using a tripod in order to make shutter speed less critical.

Aperture Priority is referred to as an automatic exposure mode though I think of it as a semi-automatic mode. The photographer manually sets the desired aperture. Perhaps f/16 is best for extra depth of field to make a landscape image. F/4 would be better to allow a faster shutter speed for galloping cheetahs or to blur a background. At any given ISO, the camera automatically selects the shutter speed necessary for a standard exposure. If the standard exposure is not optimal because of a non-average subject tonality or other factors, the shooter makes the image lighter or darker with the camera's exposure compensation control (EC). As the name of the mode implies, Aperture Priority fixes the aperture (f/stop) as set, and the shutter speed changes as needed.

Despite the popularity of Aperture Priority, we rarely use it and never when employing flash. There are internal camera settings that can and will spoil your best-laid plans

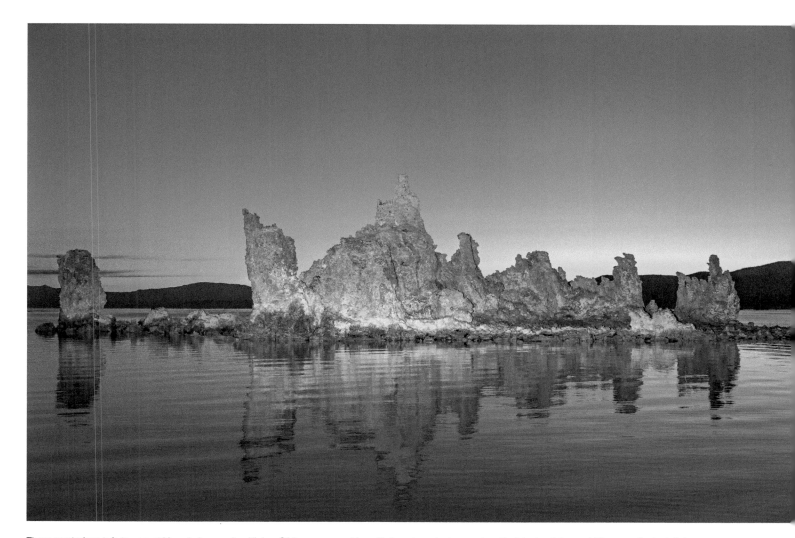

These mysterious tufa towers at Mono Lake near Lee Vining, CA have emerged from their underwater home when the lake level dropped. These particular tufa towers are about seventy yards offshore. A double exposure allowed John to fire two Canon 600EX-RT Speedlites on manual power twice to enable lighting this distant subject. The light on both Speedlites was filtered with 1/2 CTO Honl filters. Canon 5D Mark III, 58mm, ISO 1000, f/4, 1/30, Manual ambient light and flash exposure.

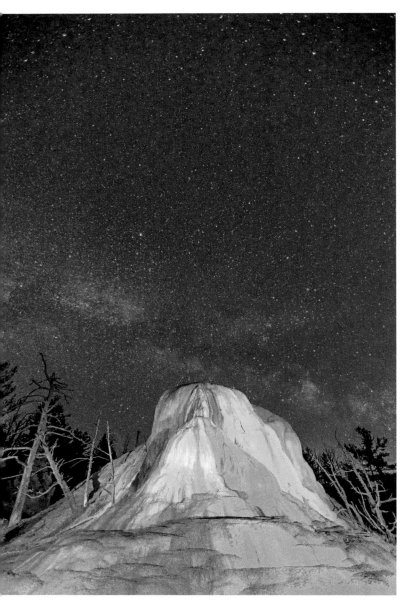

Orange Spring Mound in Yellowstone National Park is a favorite subject, especially at night. John used an incredibly useful, but largely unknown in-camera technique to expose and focus on both the mound and the stars with the multiple exposure option. Using four Canon 600EX-RT Speedlites, John first set the flash exposure to optimally expose the mound with ISO 3200, f/16, and 1/50. He then manually focused on the stars using a magnified live view image while exposing with ISO 3200, f/2.8, 20 seconds.

when flash is used with Aperture Priority. Take the Canon 5D Mark III, for example, and assume you are photographing a night scene handheld and want to adequately light a person in the image. When using Aperture Priority (Av mode), the camera defaults to an "Auto" mode which automatically selects a shutter speed to properly expose the overall scene. The range of shutter speeds available to do this is between the maximum sync speed of 1/200 second and the slowest available which is 30 seconds.

But you probably don't want to use slow shutter speeds handholding. Don't worry, your camera will rise to the rescue. You will be offered two options to help prevent subject blur by holding the fastest effective shutter speed. One option is to set the camera to the *1/200 (fixed)* mode (the maximum shutter speed for flash use with this particular model), which is much better for handholding, although the background might be exposed quite darkly. The second option is for you to set the camera to the *1/200—1/60 mode*, in which the camera tries to reduce blur by using the faster shutter speed, perhaps a little more effectively than the first option. This option allows the shutter speed to slow to 1/60 second, but no further, which allows more ambient light to add to the image without the shutter speed slowing too much for a sharper image. Your job as a flash "newbie" is to be aware that these options are available and learn to use them. When needed, they will pop into your mind instantly!

Some cameras influence the flash output when using any automatic exposure mode. They might assume you surely want fill flash, not the main flash you are actually seeking, and reduce the flash output without your permission. Camera makers persistently attempt to produce cameras that make it easier for you to shoot stunning images, but sometimes their assumptions and automatic features are literally counterproductive. How is it possible to escape assembly line automation?

Perhaps you already surmised that Barb and I are not fond of the extremely popular Aperture Priority exposure mode. Our argument is that contrary to many others, it actually saves no photographer effort and there is even a justification for the opposite. Consider this:

1 Aperture Priority procedure
 - Set the desired aperture.
 - Set the exposure compensation dial as needed.
2 Manual exposure procedure
 - Set the desired aperture.
 - Set the shutter speed as indicated, or as needed for compensation.

In each case, about the same amount of time is needed to set the optimum exposure.

For nearly all of our outdoor flash work, Barb and I first manually set the exposure for the desired ambient light result. Then, when adding flash, we usually use the TTL (through the lens) flash mode to obtain the desired effect on the image. When shooting landscapes, we generally

use Manual exposure for the ambient light and Manual exposure for the flash too.

Reliance on Manual exposure modes allows us to be in complete control of the exposure while bypassing the camera's well-meant, but often ill-advised, assumptions and automation. We honestly believe that if you are not regularly using Manual exposure modes, you will one day "see the light," as we see it, adopt it, and use it often. You will never regret it nor will you ever look back.

FLASH METERING AND AMBIENT LIGHT METERING ARE DIFFERENT SYSTEMS

Flash metering and ambient light metering are accomplished by various and mostly independent camera systems. They can be used together with both set to manual, both to automatic, or one on manual and one on automatic. Autofocusing is another divergent system. *All three of these systems can be used manually or automatically in any combination.*

Irrespective of metering mode, the camera's ambient light metering transpires when the shutter button is depressed half-way or the button is pushed when back-button focusing is used. Flash metering is triggered by a full press of the shutter button, when a low-intensity preflash is emitted when using auto flash, reflected by the subject, and measured by the flash unit or the camera, all before the shutter opens.

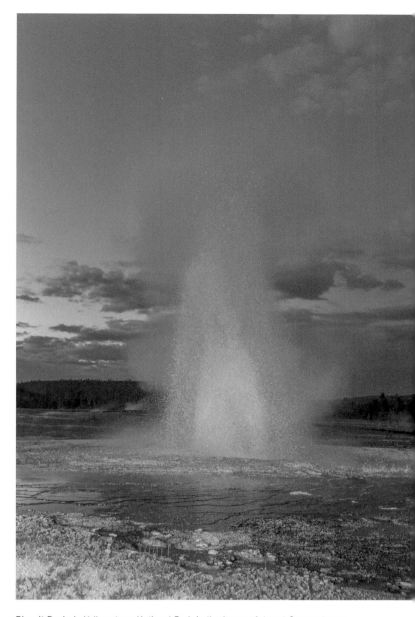

Biscuit Basin in Yellowstone National Park is the home of Jewel Geyser. It conveniently erupts several times an hour. Two Canon 600EX-RT Speedlites light the geyser during its brief eruption. The flash FEC was +2 while the exposure compensation for the ambient was −1 to keep the evening sky from being too bright. Often, when using auto flash and auto ambient exposure, both the FEC (flash exposure compensation) and the EC (ambient exposure compensation) must be adjusted on the camera to achieve the desired result. Canon 5D Mark III, 35mm, ISO 1000, f/4.5, 1.6 second. Daylight WB.

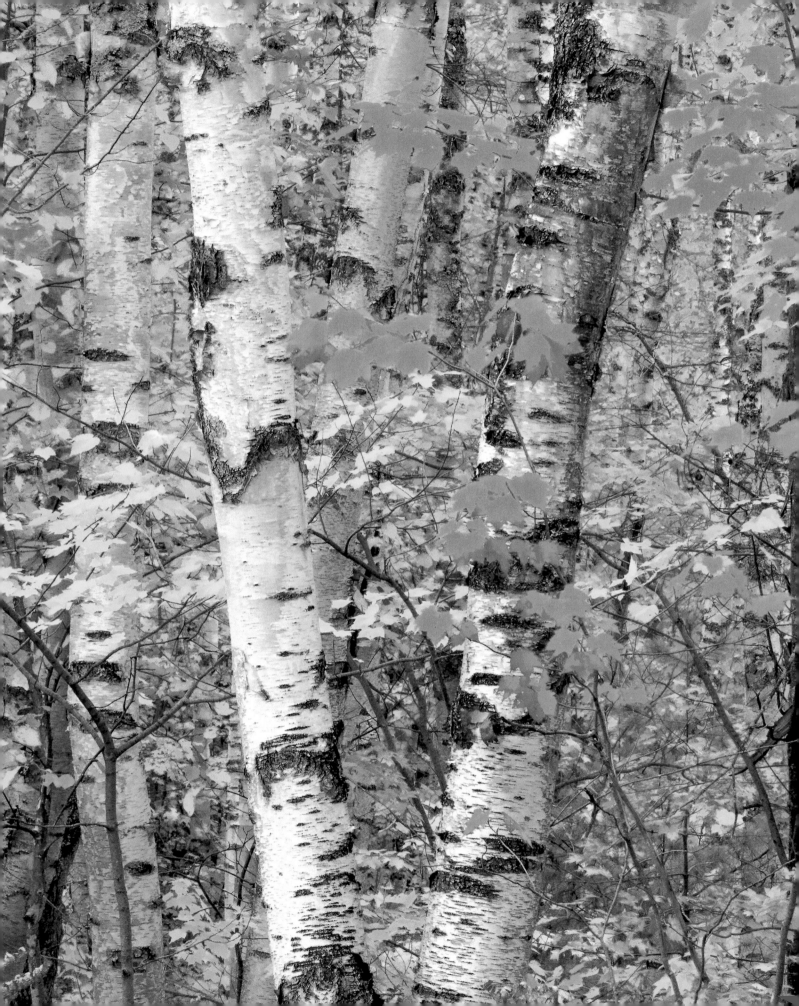

Flash features and controls

The electronic flash unit is a simple device. It houses electronic circuits, a capacitor to store energy, and a flash tube. Power from batteries, or sometimes AC household power, is modified by the internal electronic circuits and stored in the capacitor. When you trigger the flash, the capacitor's energy is transferred to a gas-filled flash tube. The gas almost instantly ionizes, producing a brilliant burst of light for a short time. The length of time of the flash burst is established by the amount of light required by the user. It is appropriate to note that when the user directs the flash to produce a needed amount of light less than full power, the flash does *not* vary in brilliance. It controls exposure by varying *only* the duration of its light burst.

Designs vary, but a typical flash burst at full power output lasts between a longer 1/700 of a second and a shorter 1/1000 of a second. If you do not like fractions, just think of a time lasting between a longer 1.4 milliseconds and a shorter 1.0 millisecond. Moreover, a millisecond is the thousandth part of a second.

ON/OFF SWITCH

If the flash fails to fire, check to make certain it is turned on! Next, check that the ready light is on, showing satisfactory batteries and an adequately charged capacitor. If the flash is part of a wireless setup, ensure camera and flash are set to the same group, and channel so that the remote and the commander are accurately communicating.

THE DIFFUSER PANEL

Many flashes have a pull-out diffuser panel that spreads the light emitted by the flash unit. By diffusing the light, it reduces the contrast a little. Flash is often used indoors with a wide-angle lens to spread the light over a larger area. Novice flash users quite often use the diffuser panel when it is not necessary and may even be detrimental. Outdoor flash users seldom need the diffuser panel. It reduces the ability of the flash to adequately light distant objects and its light-softening effects

Underexpose the ambient light by two-thirds of a stop and use main flash to brighten the white birch tree in the foreground. The trees separate better from the background, the fall colors intensify, and the tree bark is a brighter white. Nikon D2X, 70–200mm at 78mm, ISO 200, f/16, 1/2.5, Cloudy WB, Nikon S B-800 at +1.3 FEC.

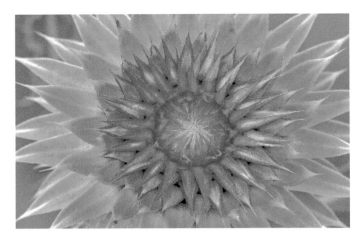

Since flash is the only light source being used to illuminate this thistle blossom in Texas, Barbara used an add-on diffuser to soften the harshness of the light. Nikon D3, 200mm, ISO 200, f/29, 1.6 seconds, Cloudy WB, Aperture Priority, Nikon SB-800 Speedlight with Honl Flash diffuser.

are mostly unnecessary when mixing flash with ambient light. However, the diffuser panel can be helpful to soften the shadows produced by the harsh light of the flash when you use flash as a dominant main light in close-up photography.

AF-ASSIST LIGHT

In low light or when the subject has little contrast, many flash units can emit a patterned light source that helps the camera achieve accurate autofocus. It is helpful for portrait photography under dim ambient light, but the red light can be annoying to some subjects. For years, I thought the autofocus assist light (sometimes called the autofocus illuminator light) did not work with my Canon camera. When I bought a newer Canon camera and another Canon flash, it didn't work either. Then one day it unexpectedly started to work. Though I never saw it stated in the Canon manuals, I found that the autofocus assist light only works when it is activated (I had done that) and One-shot or AI Focus is being used. I always use either manual focus or a third autofocus choice called AI Servo, and the AF illuminator doesn't work in that mode. It is one more warning of a manual which does not include exactly what you need to know. I was ignorant about this for years, so I'm overjoyed to finally be able to use my AF illuminator in low light with the One-shot or AI Focus autofocus mode.

THE FLASH ZOOM CONTROL

To better light objects at different distances, the full-featured modern flash is able to zoom the flash head

concentrate or expand the beam (field of view) of the emitted light. In all of the flash models I use, the default setting is Auto Zoom where the flash automatically zooms the flash head to match the field of view of the focal length of the lens in use. Some flashes even take into consideration what the light coverage needs to be if you have a small-sensor camera. The Nikon SB-700, for example, can zoom

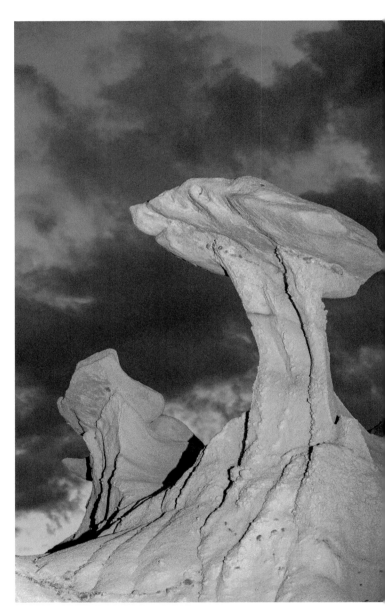

This Bisti badlands hoodoo in New Mexico is conveniently perched on a small hill. Since the hoodoo was impossible to photograph with a short lens, using the zoom control on the flash to manually set 200mm made it much easier to light from a greater distance. Manually zooming the flash head to a setting much longer than the focal length being used is an enormously important part of successful landscape images using flash. Canon 5D Mark III, 105mm, ISO 500, f/13, 1/6, Manual ambient and flash exposure with Canon 600EX-RT and ST-E3-RT Master controller.

out to a maximum of 120mm or widen to 24mm. If you are using a lens that is wider than 24mm, the flash beam cannot cover the entire field of view, though using the diffuser panel will help spread the light. With the SB-700, or for that matter with any flash, if the lens is longer than the flash unit's zoom capability, the flash cannot additionally concentrate the flash beam to reach farther, but it will adequately cover the field of view of the longer lens.

The zoom control should usually match the lens focal length when photographing people indoors with flash so the walls receive illumination, but outdoors this is seldom important since the flash can't light the huge background anyway. Outdoors, the flash is used to cover only a portion of the image, so its beam is constrained to more efficiently light that desired area or subject. Most flashes allow manual setting of the zoom position to make the flash's coverage independent of the lens focal length. If you are buying a new flash, make sure it allows manual control over the zoom position! Using the zoom control on the flash is incredibly useful for selectively lighting a portion of the image or for controlling Manual flash exposure. I use the zoom control for nearly every image I make with flash!

THE MOUNTING FOOT

Countless flashes have plastic mounting feet which are easily damaged. Flashes should be mounted carefully, fully, and if so equipped, locked in place. Some flashes come with an accessory plastic mounting base used to mount an off-camera flash on a tripod, a light stand, a table and more. Aftermarket adapters are available for various purposes such as mounting the flash on a tripod or ball head.

THE HOT SHOE CONTACTS

The small contacts on the bottom of the flash foot match up with similar contacts on the top of the camera to allow electrical signals to flow back and forth between flash and camera. The match-up makes the physical positioning of the flash important, which is one reason to mount the flash carefully. Different manufacturers arrange their contacts differently, so trying to use a flash on a camera not designed for its pin configuration will not work and may damage the camera, flash, or both.

FLASH HEAD ANGLES

A good flash unit is able to be tilted up and down and swiveled left and right. A photographer might tilt the flash head up to bounce the light off a ceiling, or down to light an object close to the front of the lens. The ability to swivel the flash left or right simplifies aiming the flash at the subject. The swivel is especially important for optical wireless flash setups. Flash units so equipped have a sensor that must receive the optical signal being emitted by the commander unit, requiring that the remote flash sensor and the commander be in the line-of-sight. This occasionally requires a flash head to be swiveled horizontally, perhaps as much as 180 degrees.

POWER TO THE FLASH!

Electrical power to operate flashes is typically derived from batteries or from AC household power. Batteries may be the disposable type or the rechargeable type. Batteries will be discussed extensively later. AC power is very convenient when available at the shooting location since it eliminates concerns regarding undercharged batteries. A relevant example is our annual hummingbird photography workshops in which we have 24 flashes being used simultaneously. Twenty-four extension cords hooked to AC power are far easier to manage than tracking the condition of one hundred or more batteries in various states of charge. However, in 2016 I used some battery-powered Speedlites for a couple of stations, and when the Speedlites are set to 1/32 power, more than 2500 images can be exposed before the batteries need replacement. That is not bad!

THE CAPACITOR

An important component of a flash unit is called a *capacitor*. Often cylindrical, it may be similar to the shape and size of your thumb. The function of a capacitor is to store energy from batteries or AC power source until that energy is needed to fire the flash. The capacitor must be charged with an electrical voltage higher than that supplied by the batteries or the AC house power, so electronic circuits within the flash unit raise the supply voltage to the higher voltage needed to charge the capacitor. When the flash is triggered, the electrical energy stored in the capacitor is released into a gas-filled glass *flash tube* to provide the desired brilliant burst of light. Note that as flash power varies by either automatic or manual means to control exposure, *the brightness does not change*. What does change? Only the flash length of time known as the *duration of the flash burst*.

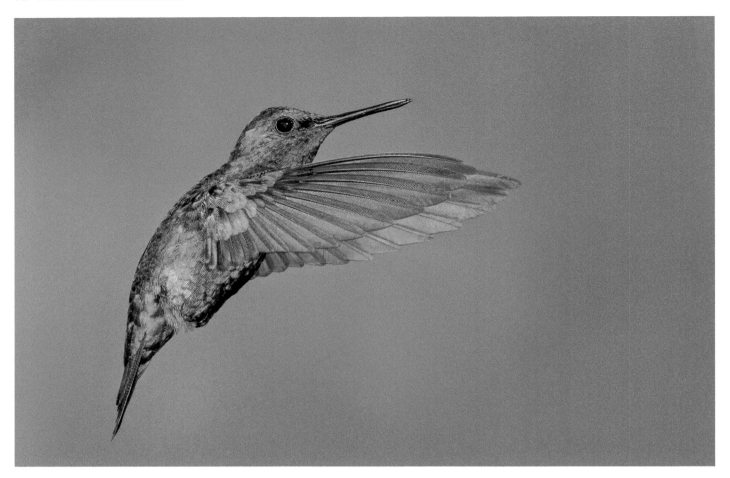

It is helpful to use AC power when feasible to keep the flashes always ready to fire. AC avoids the problem of charging and changing batteries. Often, hummingbirds are found where there is AC power. Here, four Sunpak 544 flashes light this western emerald hummingbird. Canon 1D-Mark III, 300mm, ISO 100, f/16, 1/200, Flash WB, Manual exposure, four Canon 580 Speedlites set to 1/16 power.

When you need the full power of the flash, the system allows essentially the full charge of the capacitor to be delivered to the flash tube. After a full power flash, the capacitor's energy is depleted, the flash tube turns off, and the capacitor begins charging again, preparing for the next burst. If something less than full flash power is needed (*reminder: the flash brightness is not controlled*), internal electronic circuits interrupt the flow of energy between the capacitor and the flash tube at the proper time, the light emission is terminated, and the capacitor's energy is only partially depleted.

The capacitor is recharged after each flash burst. The more light delivered by a burst, the greater the energy lost from the capacitor that must be replaced, and the greater the time required to replace it. The time between a flash burst and the capacitor being recharged and ready to go again is named the *recycle* time. Unequivocally, let me state: powerful flash bursts equal longer recycle times. Moreover, shorter flash bursts equal faster recycle times. Incidentally,

the condition of the batteries also affects recycle times. These recycle times are not long (it takes my Canon 600EX-RT flash a couple of seconds to fully recharge a full power flash burst), but it means you cannot shoot images faster than one image every couple of seconds.

THE FLASH READY LIGHT

Every flash I have ever seen has a *ready light* to inform the user when the capacitor has recharged adequately and ready to take the next shot. Some flashes relay that to the camera. The ready light in the camera is usually a small red indicator in the viewfinder telling the user another shot is possible. The recycle time for the flash is a function of the size of the flash unit, that is, the flash's ability to provide high-power flash bursts, the power of the previous flash burst, the type of batteries, the state of the batteries, and other factors. Recycle times can vary from a fraction of a second to several seconds.

The Bisti badlands south of Farmington, NM is a top spot for spectacular hoodoos. This hoodoo was exposed with a single Canon 600EX-RT Speedlite filtered with a 1/2 CTO gel filter. Due to the size of the hoodoo and stopping down to f/13 for depth of field, the entire charge in the flash was needed. This is a simple balanced flash shot. Set the ambient exposure to make the background sky appear as desired. Then use flash to light the hoodoo. Canon 5D Mark III, 22mm, ISO 800, f/13, 1/200, Cloudy WB.

MORE ON FLASH DURATION

A good understanding of flash duration is so critical to your flash photography that it is necessary to expand what we've already stated. We previously noted that the duration of a typical full-power flash burst is between 1/700 second and 1/1000 second and it is the duration of the burst that controls the exposure.

In Manual mode, the user controls the exposure by setting the flash's power level, either with a dial on older flashes or a menu on newer ones. Common power levels available are 1, 1/2, 1/4, 1/8, 1/16, 1/32, 1/64, and 1/128 fractions of full power. Note the one-stop exposure sequence, where each setting either doubles or halves the flash power. For example, the flash emits two stops less light when changed from 1/2 to 1/8 power. If changed from 1/16 power to full power, four stops more light is emitted. When auto flash is in use, the flash is not limited to the above steps, but, within the limits, can use in-between timings as well.

Flash power (exposure) is set by flash duration, but what meaning does that duration have? When would you need to use this? Arresting extremely fast action is needed to photograph speeding bullets, splashing water droplets, or galloping racehorses. I enjoy photographing birds. Therefore, I annually teach a hummingbird photo workshop in British Columbia. A hummingbird's wings beat extremely fast—around 60 to 80 beats per second—and the sound the wings produce is well within the range of human hearing, hence the "hum" in their name. To arrest that wing motion in a photograph, the exposure must be so short that mechanical shutters are too slow to do the job and we must rely on very short flash bursts for the exposure. Below is the relationship between the power settings and the approximate flash durations of a typical high-power flash, the Nikon SB-910. The duration numbers are approximate because they can vary between units and can vary with battery conditions, measurement techniques, and instrumentation.

The small artificial pond in my yard attracted the white-crowned sparrow. Since the sparrow's location on this partially submerged rock is known, John set the four Canon 600EX-RT Speedlites to manual at 1/4 power and close to the spot where the bird will land. Why? More images can be shot immediately if the flashes don't discharge all of their energy in one burst! Canon 5D Mark III, 300mm, ISO 160, f/16, 1/200, Flash WB.

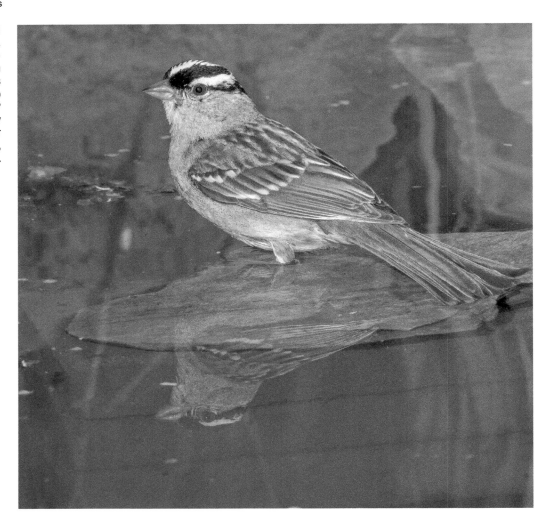

Further, it's easy to see from the chart that as you lower the power to get shorter and shorter flash durations to stop the wings of speedy hummingbirds, flash power can become problematical, and multiple flashes may be necessary to obtain adequate exposure. I typically use the 1/16 power level because the flash duration of 1/10000 second nicely freezes most wing motion while still providing enough light to optimally expose the hummingbird.

Flash power fraction	Flash duration (seconds)
1 (full power)	1/880
1/2	1/1100
1/4	1/2500
1/8	1/5000
1/16	1/10000
1/32	1/20000
1/64	1/36000
1/128	1/39000

MORE ABOUT BATTERIES

Batteries, whether disposable or rechargeable, eliminate the need for AC power, and negate the need and nuisance of using power cords, which I perceive as a writhing nest of vinyl and copper serpents lying in ambush and waiting to trip an unwary passerby, or knock over an expensive camera and tripod or light stand (I guess you can tell I am not extremely fond of having wires running everywhere when I am photographing). Batteries, therefore, are certainly on the agenda when the nearest AC power is much too far from the wildlife blind. So, Barb and I are big fans of high-quality batteries. We use rechargeable batteries, having found that their initial expense, although greater than that of disposables, amortizes better over time. Moreover, the rechargeables generally offer higher capacities (more flashes!) than disposables. Another gift of rechargeables is their generally better behavior as they come to their end-of-charge state. They come to that state abruptly, rather than via the slow decay of disposable

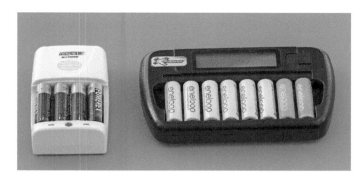

Dependable rechargeable batteries and chargers are important to flash users, especially when photographing far away from household power. Eneloop and Powerex batteries work well and can be recharged several hundred times. You can't go wrong with these two Powerex chargers: Model MH-C204W on the left and X2RECH-8 on the right.

batteries. That slow decay causes recycle times to rise annoyingly and we've lost more than one good wildlife shot waiting for a flash to recycle.

No one ever accused either Barbara or myself of being a battery expert, but we have benefitted from excellent success with Powerex AA 2700 rechargeable batteries. They use nickel-metal hydride (NiMN) chemistry, provide 1.2V (1.2 volts) and have an energy capacity of 2700mAh (milliampere-hours). These batteries do not have undesirable memory characteristics and can be recharged hundreds of times—a tremendous cost saving in the long run over disposable batteries.

BATTERY AND CHARGER RECOMMENDATIONS

After an exhaustive Internet search looking for the most highly recommended batteries, my findings for rechargeable batteries were for *Powerex Imedions* and for *Sanyo Eneloops*. The most popular disposables were the *Energizer Ultimate Lithium* and the *Duracell Coppertop*. The lithium battery has far better characteristics than an alkaline *Coppertop*, but is more expensive. Coppertops have the advantage of being universally available. I have personally used all of those batteries and absolutely agree with the survey. We currently use *Powerex AA* and *Eneloops*, both excellent rechargeables. Just recently, Canon advised that lithium batteries should not be used in their Speedlites because they sometimes become overly hot during usage. No matter what flash system you use, it would be prudent to avoid lithium batteries.

It follows, when using rechargeable batteries, that you've got to charge them. Always fully charge new rechargeable batteries before using them. All battery chargers are not

created equal. I once again searched the Internet to learn that the experts rated the LaCrosse Alpha BC-1000 and the PowerEx MH-C801D among the best battery chargers. We use the PowerEx model with excellent success. This charger individually charges each battery and turns off when the battery is fully charged.

EXTERNAL BATTERY PACKS

If one is shooting a great deal during the day and doesn't want to be bothered fiddling with battery changes in mid-action, a solution is at hand. Several companies offer high-capacity external battery packs. Nikon's unit is the SD-9 and Canon's equivalent is the Compact Battery Pack CP-E4. External battery packs are often used by wedding photographers, although we've not yet encountered a need for them in our own wildlife shooting. Only in the interests of full disclosure, one of our penny-pinching workshop clients uses two aftermarket external packs for his flashes for a small fraction of the camera manufacturer's price and is quite satisfied with them.

FLASH CHOICES

Camera makers and third-party companies make an assortment of flash units. Your camera maker's flash units will undoubtedly be more expensive than those made by third-party companies such as Sunpak. It is tempting to save money by purchasing third-party equipment, but we

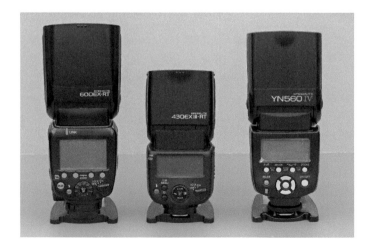

Every camera maker offers flashes for their cameras. From left to right are the Canon 600EX-RT, Canon 430EX III-RT, and the Yongnuo YN560IV. I am a huge fan of Canon gear and Barbara loves Nikon, but I tried out a set of Yongnuo Speedlites in my hummingbird photo workshops a couple of weeks before sending this book to the publisher and I was impressed! If money is tight, consider that for the cost of one Canon 600EX-RT Speedlite, you can buy six Yongnuo Speedlites and the radio flash controller to go with it!

always advise otherwise. In our electronically sophisticated and complex systems oriented world, it is assured that your camera maker's flash devices will work flawlessly with your equipment and no doubt be more reliable. In the long run, it is advisable to buy your camera maker's equipment, or as my grandma used to say, don't be penny-wise and pound-foolish. Besides, if you find yourself in a warranty dispute and the manufacturer of a damaged camera claims an off-brand flash caused the damage, you lose more than you gain. Purchasing camera maker apparatus narrows your choices and makes the final decision easier. Let's look at the choices for the two most popular camera systems.

Needless to say, flash technology continually changes. Some choices will likely be discontinued by the time you read this and new flash equipment may become available. If you shoot with some other system—Sony, Pentax, Olympus, etc.—you have many flash choices as well. Consider your options carefully. Keep in mind that automatic flash features and greater light output are always beneficial. This is especially true in outdoor photography where flash-to-subject distances tend to be extended.

Examine useful flash accessories from your camera maker. These accessories include external battery packs, color filter sets, flash stands, wide-angle diffusers, hot shoe to PC adapters, and straight or coiled sync cords in various lengths. Accessories that we find useful will be addressed as we proceed and they become germane to the discussion.

CANON

Canon's most powerful flash, and the one I use the most, is the 600EX-RT. It works in the camera's hot shoe or wirelessly with the ST-E3-RT (Speedlite Transmitter–Model E3–Radio Transmission) flash controller.

Most wireless systems, commander and remote, use an optical communications link, but this flash is one of the first to have a built-in radio-control system that works over much larger distances, and doesn't require line-of-sight to reliably fire when called upon. Hopefully, other camera makers will follow Canon's lead and produce radio-controlled flash gear. The slightly less powerful 430EX II flash also works in the camera's hot shoe or wirelessly. As I write this, a new Canon 430EX-RT Speedlite has become available, using either optical or the much preferred radio signal for wireless control.

The pop-up flash on some Canon cameras can be set to a master mode and the flash units set to their slave mode to implement a wireless system that not only triggers the flash, but can also control the slave's flash exposure compensation (FEC). Moreover, if your Canon camera has no pop-up flash such as the 5D Mark III, you can merely mount a Canon ST-E2 flash controller in the hot shoe and enjoy optical wireless flash that way. I've used that exact scheme for many years to control my now discontinued Canon 580 II Speedlites.

Canon's two smaller flashes, the 90EX and the 320EX, are useful for many purposes, but they are not adequately powerful for general outdoor photography. They can be mounted in the hot shoe to provide considerably more power than the pop-up flash. The 90EX can also function as an optical master controlling one or more slaves, and it is less expensive than the ST-E2.

For close-up and macro work, Canon offers two products: the Macro Ring Lite MR-14EX and the Macro Twin Lite MT-24EX. The nearly shadow-free light produced by the Macro Ring Lite offers advantages especially in scientific photography—dentists often use them to photograph teeth—but for my kind of shooting I prefer the Macro Twin Lite setup. It allows me to easily control both strength and direction of lighting, to produce the shadows and textures that enhance so many subjects.

Here's the entire Canon Speedlite lineup as of this writing:

Model #	Approximate 2016 price	Comment
600EX-RT	$500	The most powerful and versatile of Canon's flashes. It is quite an impressive flash to deploy, and the release button on the flash is convenient for holding the flash some distance from the camera. Pressing the REL button on the flash fires the camera, a tremendous advantage when using flash in landscape photography.
430EX III-RT	$300	Excellent radio and optical flash that is about 2/3 stop weaker than the 600EX-RT. Its small size is ideal for close-up work, especially when supported on a bracket, eliminating interference by a lens hood.
320EX	$234	It doesn't provide enough light to be really useful in outdoor photography.
270EX II	$140	It doesn't provide enough light to be really useful in outdoor photography.

90EX	$60	An inexpensive way to put a master controller on top of the camera.
ST-E3-RT	$264	Master radio controller that works only with the 600EX-RT and the 430EX III-RT.
ST-E2	$224	Master optical controller for all Canon flashes, including the 600EX-RT when the flash is set to the optical slave mode. I've used this controller for 25 years with beautiful results, but a line-of-sight must exist, though the signal can bounce off nearby obstacles and still work.
MT-24EX Macro Twin Lite	$770	Best dual-flash setup for outdoor photography
MR-14EX II Macro Ring Lite	$500	Not as versatile as the one above, but it works fine if you prefer flat, low-contrast light.

NIKON

The deluxe Nikon flash is the SB-910. It is overflowing with useful features and the most powerful in the Nikon flash line at the time of writing. Nikon also offers less powerful flashes that include the SB-700, SB-500 and SB-300. To save money, the less expensive SB-700 performs well and does a lot while it costs about $350, which is about $200 less than the SB-910. However, if you intend to use frequent flash in landscape photography, then having the most powerful flash is, without fail, always desirable. You can never have too much power when lighting the landscape.

For dedicated close-up photographers, the Nikon R1C1 Wireless Twin Flash system works suitably when you are using flash as the only light source, because the two flash heads are adjustable to allow lighting from different angles and the outputs are easily varied and controlled. Many dedicated close-up shooters tout the Nikon R1C1 Wireless close-up Speedlight System as a most valuable tool to manage the intensity and direction of two flashes. This permits excellent control of shadows and texture.

Nikon, a recognized leader in flash technology, offers pop-up flash units generally having the commander feature for use with off-camera flash(es). A remote flash in a wireless system must, of course, be set to its remote mode.

Some Nikon cameras—the professional D4 and D4S, for example—don't have a pop-up flash to use as a commander. With those and other pop-up free cameras, one can use remote flashes by using a Nikon flash unit in the hot shoe as an optical commander, which you can set to contribute to the exposure or not. If not, one can still see the flash of the commander when it sends the signals to the remote(s), but the emitted light is too weak to affect the exposure.

Here's Nikon's product line of Speedlights as of this writing:

Nikon Model	Approximate 2016 price	Comment
SB-910	$550	Nikon's most powerful and feature-filled flash. This is the best one for using flash in landscape photography.
SB-700	$226	
SB-500	$246	
SB-300	$147	
4804 R1	$470	Two-flash Wireless Close-up Speedlight System for use with cameras having pop-up flashes.
R1C1	$700	Two-flash Wireless Close-up Speedlight System for use with cameras not having pop-up flashes.
SU-800	$222	Wireless Speedlight Commander Unit

DEDICATED FLASH CORDS

To move the flash away from the top of the camera, all flash makers offer dedicated cords (cables)—either coiled or straight—that connect the flash to the hot shoe. Dedicated cords enable all of the automatic flash features just as if the flash was mounted in the camera's hot shoe.

Dedicated cords are inexpensive, reliable, and many flash users are partial to them. We use them from time to time, but prefer wireless controls for most of our flash photography. We save them mainly for backup in case our wireless options malfunction.

Attaching the flash to the camera's hot shoe with a cord creates several problems which usually outweigh the two major good points. The advantages with dedicated flash cords are that they are not too expensive, and no line-of-sight is required for them to reliably work. That said, here

Barbara used a dedicated cord and placed her Nikon SB-800 a foot away from the camera to add light to some shadows and better reveal the detail in this fungi. Nikon D300, 18mm, ISO 200, f/16, 1/5, Manual ambient exposure with auto flash at FEC −1.

- Most dedicated flash cords are designed for a single flash. Multiple flash requires more cords.
- It is extremely awkward to move a tripod-mounted camera that has an attached remote flash. The remote flash perilously dangles from the cord, endangering both flash and camera, unless you laboriously disconnect it and reconnect it. You need two hands to adjust your tripod legs at the new spot which precludes being able to use one hand to hold the flash while you make the move.
- If you stretch the cord excessively, it will put tension on the camera and cause a loss of sharpness due to vibration, or perhaps even pull the camera over.
- Dedicated cords have several electrical contacts on each end that must be properly mated to the camera and the flash. They have been keyed to prevent improper fitting, but strong, determined photographers might attach them backwards and do expensive electrical damage.

are some of the negatives in accordance with the well-known Murphy's Law:

- Whatever the length of your cord, it will always be a foot too short.
- When backlighting, the cord will be too close to the subject, may irritatingly bump the subject and may annoyingly show in the image.

FLASHING MANUALLY (OPEN FLASH)

Photographing the night sky involves long exposures of 20 to 30 seconds or longer. Even when the flash takes six seconds to fully recycle, there is time for two or more *open flash* shots to light up different areas of the foreground or to multi-expose one area needing a great deal of light.

a) The Speedlite is zoomed to 200mm to light the rocks beyond the one in the foreground.

b) Zooming the flash to 24mm lights the foreground in the second exposure.

c) The in-camera result of the double exposure in which both exposures are added together in the camera. Canon 5D Mark III, 24mm, ISO 500, f/14, 1/60, Cloudy WB, Manual ambient exposure and auto flash using FEC +.7.

Most flash units have a test button. Press the test button to fire the flash in what is called *open* flash. You don't have the benefit of automatic metering, but full power is needed when shooting extended ambient light exposures, perhaps several seconds or more. On some flash units, the test flash button may only fire a portion of the charge stored in the capacitor. Check for this and set the flash to shoot at full power when doing open flash.

MORE FLASH UNITS

Many photographers are not aware that a flash mounted in the camera's hot shoe, or even a pop-up flash, can control one or more remote flash units. For example, a Canon 600EX-RT in the camera's hot-shoe and configured as a master can wirelessly control another 600EX-RT, a 430EX, or even the discontinued Canon 580EX II when these units are set to optical slave mode. Note: Although the Canon 600EX-RT flash is a radio flash, it has a mode that works with optical signals. Nikon's flashes work the same. A Nikon SB-910 set to commander mode and mounted in the hot shoe can control one or several Nikon SB-910's, SB-800's, and other models in any combination when they're set to their remote mode.

It was very helpful to remember all that when I was once enjoying some spectacular hummingbird photography at the Tandayapa Bird Lodge in Ecuador (www.tanday apabirdlodge.com). I was using off-camera Canon 580EX II slaves with an on-camera ST-E2 master. My ST-E2 requires one 2CR5 battery and all my spares were dead from intensive use. These batteries were impossible to find in the wilds of Ecuador, but after some pondering I recalled that I could use a flash as a master and still fire the slave flashes. I did so and I was back in business because all of my flash slaves and master were powered with the rechargeable AA batteries I favor!

PC CORDS

The PC cord (aka cable) is a simple wired-cord that connects the camera to the flash. PC cords come straight or coiled and in various lengths. We commonly use them for hummingbird photography in our workshops, and use eight-foot-long cords. One end of the cord plugs into the PC terminal in the camera. The other end plugs into the PC terminal in the flash. Some cameras, however, do not have a PC terminal. In that case, you can buy a PC to hot shoe adapter that slides into the camera's hot shoe, providing the PC terminal. If the flash also lacks a PC terminal, once again an adapter that attaches to the hot shoe on the flash provides the facility to use PC cords.

PC cord operation is easily understood. When the camera is fired, an electrical signal travels along the cord and fires the flash. Certainly, this all happens instantly. PC cords do not offer any automation. There is neither through-the-lens flash metering nor automatic exposure compensation, so few photographers use them. However, for photography when you know the exact spot where the subject will be, they work quite well. Photographers generally think of PC cords when using only one flash, but with one or more 3-way flash sync adapters, one can use PC cords to fire multiple flashes.

Searching the Internet for 3-way Flash Sync Adapter or some combination of those words will uncover several. Listed below are three types of adapters I have used successfully, along with the approximate prices:

- Medalight 3-Way Flash Sync Adapter $20
- Kaiser—Male to Triple Female Adapter $20
- Samigon—Multiple PC Terminal Adapter $17

Each of the adapters listed above has one male and three female terminals. That's the desired configuration when working with a Canon 600EX-RT and the required PC cord is male at both ends. Other flashes might require the opposite sex PC connector. In fact, most PC cords have one male end and one female end.

There are many three way flash connectors like this Hama model. It allows you to connect up to three flashes to the camera. The device has three female connections and one male.

SEX OF PC CONNECTORS

Making a PC-wired system fit together and work properly requires practicing safe sex which, in this case, means that the various fixed-connectors on cameras, flashes and connectors must always be fitted with the correct (opposite) mating connector on the PC cord. It's simple to tell which is which and this makes the wiring straightforward. The female PC connector has a hole in the exact center of the terminal. The male PC connector, of course, has a pin in the center which slides into the female terminal.

The connectors are easy to identify. Again, some gear is equipped with male connectors and some with female connectors. One must be alert to whatever PC terminal hubs, extensions, adapters, extenders and other PC accoutrements might be in use. Every PC user should think about every configuration that might be needed, and have various lengths of PC cables and adapters for each.

We started our incredibly productive hummingbird photography workshops in 2003, and throughout them have worked extensively with PC cords. Although they work as advertised, their lack of automation capabilities compels me to prefer wireless systems. During the workshops, we operate six flash stations simultaneously. Each station has three flashes for a total of 18 flashes in use at one time. I would rather use wireless, but what happens if there

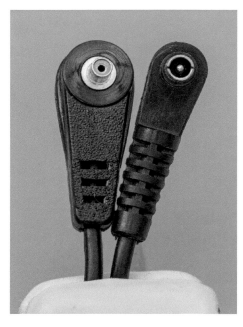

PC terminals are male or female. If you decide to use PC wires to connect flash units and the camera together, it is important to be able to quickly tell the sex of the terminal. The one on the left with the hole in the middle is the female and the right one with a center pin is always the male. Now you know!

is a Nikon wireless system set up on station #3 and the next student is a Sony or Canon shooter? They cannot use the dedicated Nikon wireless system. I could replace the flashes with Sony flashes for the Sony shooter or Canon flashes for the Canon shooter, but that would be prohibitively expensive and unbearably time-consuming.

Using PC cords, any camera system can hook up to the flash setup as long as a PC terminal is on the camera. It is simple to mix and match cameras and flashes with our many inexpensive PC cords and adapters and it doesn't matter what makes and models are involved. Even when a student's camera has no PC connector, a simple hot shoe to PC adapter solves the problem in a moment.

I prefer wireless systems to cords because PC cords are frequently unreliable. Occasionally you must press them together firmly and intermittently twist them a bit to ensure good connections. I don't want to call them flimsy per se, but PC cords are not the most rugged connector ever designed. I even keep a PC conditioner tool for reshaping those that become malformed. One good practice is to press them together firmly and tape them into place with electrical tape. I find that using tape to hold them in place where possible makes them far more dependable.

Some caustically sneer that "PC" stands for "poor connection." Not being quite that cynical, and being a camera ol' timer, I know that it really stands for "Prontor-Compur", which is the name of a camera shutter made decades ago that was equipped with such a connector. Here's a quick summary for you:

PC cord advantages:

- Inexpensive.
- Easy to use.
- Does not require line-of-sight to fire all of the flashes.
- Not brand sensitive. Any camera or flash with a PC terminal can use them. You could even use one Canon, one Nikon, and a Sunpak flash and make them all fire simultaneously.
- Another photographer cannot inadvertently fire someone else's flashes.

PC cord disadvantages:

- Reliability! They do not always fire all of the attached flashes.
- Offers no automation.
- Takes time to wire extensive systems.
- They are a tripping and entanglement hazard.
- Liquid spillage can make the connections fail.
- Physical deformation can make the connections fail.
- Normal aging can make the connections fail.

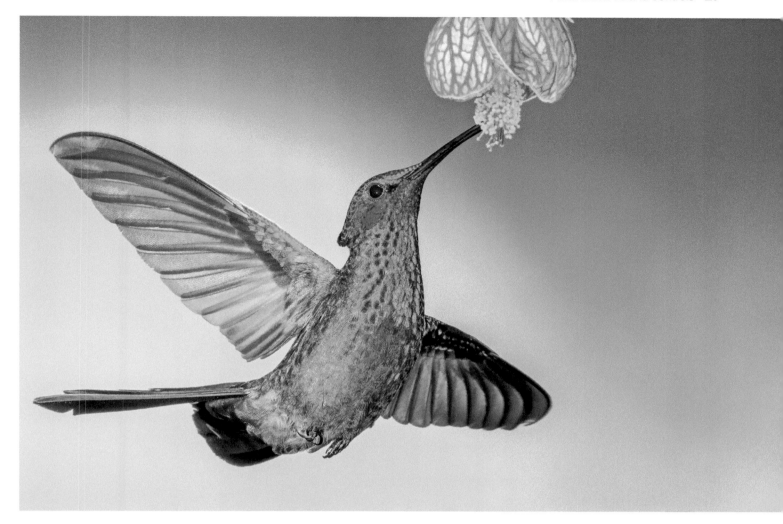

After we ran out of the 2CR5 batteries that run the Canon ST-E2 Master controller in Ecuador and could not buy any locally, we went to our backup plan and wired all four Speedlites together using male to male PC cords to the three-way flash connector and then a female to male PC cord to the camera. After several hours of photographing sparkling violetear and other hummingbirds, I finally remembered I could mount a Canon Speedlite in the camera's hot shoe and make it the master to control the four slave flashes in front of it. Since all of the gear now took rechargeable AA batteries, we went back to wireless control. Canon 1D Mark III, 300mm, ISO 200, f/20, 1/250, Flash WB, Manual exposure, four Canon 580 Speedlites set to 1/16 power.

- Inadequate fastening pressure can make the connections fail.
- They sometimes fail for no reason that I can detect—then two hours later they work just fine. PC cords can work though, and may be the optimum way to mix different flashes that aren't dedicated to the camera. Still, a dedicated wireless system is normally the best.

ELECTRONIC SLAVES

There's that word again. But this time it is not referring to a remote flash. This type of slave is a small (a dozen fit in your shirt pocket) electronic device. It contains an electronic photo-detector watching for a flash emitted from somewhere, and when so triggered, the slave in turn triggers the remote flash to which it is attached. No PC cords or complex radio controls are needed! Slaves differentiate between a brief pulse of light emitted by a flash and continuous ambient light. Slaves do not react to continuous light but require a brief burst of light to fire the flash to which they are attached. What keeps my slaves from improperly responding to your flash? Nothing! When a flash is fired, every flash that is attached to a slave that detects the triggering flash will fire! When I used slave devices to trigger my flashes when I first began to photograph hummingbirds, I noticed that a hummingbird momentarily shading a slave and then instantly having continuous light illuminate it once again fired the slave flash.

The light from one or more slaved flashes can be augmented by the light from an on-camera flash, either a

Attaching an electronic slave to a flash, either through a PC terminal or the hot shoe on the flash, is an easy way to fire one or more flashes. They do require line of sight and anyone firing a flash will fire your flash, so it works best when you are the only one using flash.

pop-up or a mounted flash. If desired, the on-camera flash can be compensated down (minus) so that its light is adequate to fire the slave(s), but too weak to affect the exposure. The optical system is not bidirectional though, so while the camera's flash can issue instructions to the slaves, the slaves can't "talk back." This unidirectional behavior eliminates the automation offered by cable, radio and some other optical systems. Absent automation, the output power of the slaved flash(es) must be set at the flash(es) and not at the camera. Line-of-sight is generally required. The optical sensor in the slave(s) must be able to "see" the burst from the on-camera flash. However, slaves will detect the light from a triggering flash when it bounces off a nearby obstacle.

Using photoelectric slaves is now old-school. At one time, we used slaves to photograph hummingbirds, but abandoned using slave systems when we started using several multiple-flash systems close to each other. If you want to visualize chaos, imagine six hummingbird stations spread over fifty yards. When the ambient light dimmed in the evening, when anyone fired a shot every flash on all six stations fired!

A few words of warning!

When using multiple flash setups with several people handling flashes, it is very important to ensure no accidental firing of some flash unit that is being adjusted and is pointed at the handler's eyes.

Less dire is a common problem affecting the uninitiated when using the triggering slave devices with modern flash units. Fortunately, the problem is solved when it is understood.

Consider this:

You laboriously set up your well thought out slaved flash or automatic multi-flash system. You fire a test flash and the slaved flash(es) dutifully fire in a gratifying blast of brilliant light. You look at the image on the camera's LCD and it is black. What happened? You fire another shot and it is black too! You tug your earlobe and furrow your eyebrows as you ponder the black problem. I'm glad you can't see me snickering a bit as I write this. It is because only a few short years ago, I was the one with the black image and the red face. But I figured it out, so here is the explanation:

Modern dedicated flashes mounted on camera or controlled with wired or wireless devices emit a weak preflash when used in the automatic flash exposure mode. The weak preflash is intended to light the scene somewhat to allow the camera to set the optimum exposure when this mini-light is reflected back to the camera. The preflash enables automatic flash metering to be far more accurate. The weak preflash comes and goes, as it were, before the shutter opens. Once the camera sets the exposure with the information it gets from the preflash, the camera shutter opens, and the main burst of light exposes the subject. However, your slave triggering device short-circuits (pun intended) the sequence. In your setup, the automatic flash emits its preflash and the remote flash(es) respond by immediately flashing, *well before the shutter has opened.*

Oops! All of this has happened in a fraction of a second, and the resulting black image can defy explanation. Now that you have an explanation, you know how to solve the problem, by ensuring that your commander or master, be it flash unit, pop-up flash or a dedicated controller, is in the Manual mode. In the Manual mode, no preflash is fired and your next shot will be okay. Another "fix" is not to use an automatic flash or device as the commander. Use instead, either in the hot shoe, or alternatively connected to the camera by a PC cord, some simple manual old flash found in the back of a drawer. Being non-automatic, it doesn't fire those pesky preflashes. Yet one more option. The folks at www.flashzebra.com offer a bushel basket of

different configurations of slave triggers, some of which, like the Sonia Optical slaves, are themselves smart enough to ignore preflashes.

THIRD-PARTY CONTROLLERS

PocketWizards are arguably the king of the radio-based flash controllers. They have a terrific reputation and are widely used by serious photographers. However, their sophisticated features make them a bit on the expensive side, and moreover, you need one at the camera and one at each flash to be controlled, so the price of running a set of flashes with PocketWizard devices is considerable.

PocketWizards work over long distances and are wonderfully reliable. Some units can be set to be used on camera as a transmitter or set to be a receiver on a remote flash—a very convenient dual use and versatility feature. The whole PocketWizard system is versatile too. Barbara has used, and continues to use, PocketWizard equipment to remotely fire her cameras.

PocketWizard is the gold standard for radio flash and camera triggering control. They offer numerous high-quality products. Now that camera makers are offering their own wireless controls, there is less need for PocketWizards, but many still find these products to be highly useful.

Little by little, though, camera manufacturers are drifting away from the present-day optical flash systems, and are themselves going to radio control. Still, if you are looking for wireless controls and enough reliable information on how to use them, plenty of information is available at www.pocketwizard. com. Look closely at the Plus X and Plus III products.

CUSTOMIZING THE FLASH

Modern flash units offer many features, and most allow the user to customize how the flash works to better suit their needs. Although some settings might be on a button or dial, usually flash custom functions are available in menus. Be sure to carefully review these capabilities and options. In the beginning you may not need, and may not even understand, how this setting or that helps you use your flash, but it will not be long before they are visibly improving your photography.

At the risk of talking too much about my flash gear, I would like to point out some of the custom functions that I use and explain the reasons I find them helpful. It is likely that your flash offers some of these custom function options, so they may help you too.

My Canon 600EX-RT flash offers a whopping 24 custom functions and seven personal functions—more than enough to fill every need! Likewise, Barb's Nikon SB-910 has plenty of custom functions too. Rather than painfully tell you about all of them and put you (further?) to sleep, permit me to describe just four of the most important and useful ones.

1 Distance measurement

Each allows our Canon and Nikon flashes a choice of distances being expressed in meters or feet. Like you, we know what a meter is, but our gut feelings are oriented toward feet, so that is our choice.

2 Power conservation

Barb's Nikon *Standby* mode allows the flash to "hibernate" after a certain time of non-use, to save battery power until the flash is needed. Barb has her choice of several options. My own Canon offers its *Auto Power Off* for the very same purpose, although the mode is fixed at 90 seconds. I disable this feature to keep my flash ready to fire at all times. It is easy enough to have spare batteries available should they be needed.

3 Flash exposure compensation

Each of the two flashes we are discussing offers the absolutely essential ability to control the exposure caused by

A Walt Anderson Betterbeamer attached to the Nikon SB-800 flash head lets Barbara precisely expose this ruffed grouse on a very cold gray day. Nikon D3, 400mm, ISO 3200, f/4, 1/160, Cloudy WB, Manual ambient exposure, auto flash with +1 FEC.

the flash relative to that of the camera. It is called *flash exposure compensation* (FEC).

My Canon flash allows me to select whether FEC is accomplished by one control or by two. A default two-control change that first requires the flash set button to be pressed and then the dial turned helps prevent inadvertent changing, causing a ruined exposure. Instead, setting custom function #13 on the Canon 600EX-RT allows me to adjust the flash exposure compensation by directly turning the dial. Photo opportunities often come and go quickly, so my flash is set to do FEC with one control.

Barbara's Nikon flash actually uses three controls to perform an FEC. I push one button to display the current FEC value, turn a dial to change it if needed, and push the "OK" button to enter the new value. It all sounds very complicated, but she has nimble fingers and because we use FEC on nearly every flash shot, we can do it fast!

4 Color filter detection

Color filtering of the flash itself offers a valuable way to control the subject lighting either for achieving excellent white balance under unfavorable ambient light color, or for enhancing an image by deliberately changing the color of the flash emission. More often than not, I use colored filters over my Canon flash head to modify the color of the light. The Canon flash unit comes with a set of color filters, and when one is installed, the flash automatically detects the presence of the filter in order to alter the flash exposure. However, I achieve far greater flexibility by using third-party filters I buy from HonlPhoto. I use mostly CTO (*Color Temperature Orange*) filters in various strengths to make the color tones of my flashed subject "warmer." Because my flash does not know how to properly compensate for them—since they are not the standard Canon filters—I disable the auto-detection feature.

The Nikon SB-910 ships with color filters. The SB-910 has filter detection, an icon on its display to show the type of filter in use, and displays a warning if the filter is not properly attached.

The pueblo ruins at the Chaco Culture National Historical Park are incredibly photogenic and fascinating to walk through. On this gray and dark day, the ambient light was underexposed about one stop and a single Canon 600EX-RT Speedlite with a 1/2 CTO gel filter over the flash head warmed up the light. Using the double exposure strategy, the flash was fired twice to light both the foreground and the background. Canon 5D Mark III, 40mm, ISO 500, f/16, 1/200, Cloudy WB, Manual ambient and flash exposure.

Becoming in sync with flash sync

THE CAMERA'S SHUTTER

The camera provides three controls for changing the exposure. The cameras ISO setting controls how much or little the sensor data is electrically amplified. The aperture controls how much light is emitted through this small hole in the lens and the shutter speed determines the amount of time light is permitted to excite the sensor.

The three controls work together to establish the final exposure. If the optimum exposure is achieved, and then one of these factors is changed for any reason, one or both of the other ones must be altered to compensate for the change in exposure. For any given sensor sensitivity (ISO setting), the relationship between the aperture and the shutter speed follow the basic photography *Law of Reciprocity*. The law states that to maintain a particular exposure—be it too light, too dark, or just right—when the aperture is enlarged (to let in more light), then the shutter speed must be increased the appropriate amount to reduce the length of time light is allowed to strike the camera's sensor. The law specifically refers to aperture and shutter speed, but the principle applies equally well to any *pair* of the three exposure controls—ISO and aperture, ISO and shutter speed, and aperture and shutter speed.

Readers familiar with the concept of *stops* in photography will recognize that to maintain any particular exposure, a change of x stops in any of the three controls must be accompanied by a change of $-x$ stops in either of the other exposure controls singly or in combination. If I change something by adding two stops of exposure, then I can change the other two by one stop each to reduce the exposure. Moreover, it all works in a negative direction as well. If I change one exposure control by -5 stops, I can compensate by changing the other two by $+2$ and $+3$ respectively, or by any combination that yields five more stops of light to the sensor.

The native ISO of the camera is important to know. The digital sensor's inherent sensitivity to light is a significant factor, but not the entire story. The engineer designing a new sensor does a juggling act balancing the sensor's light sensitivity and digital noise as well as the

Mocha is a Wired-hair Pointing Griffin who loves to romp in the tulip fields. A Canon 600EX-RT Speedlite adds light to open up the shadows in her face. Canon 5D Mark III, 180mm, ISO 800, f/11, 1/200, Shutter Priority, Cloudy WB, FEC –1.

a) John lit these rocks with flash by using the maximum sync speed of 1/200 second to reduce the bright ambient light. Using a 1/2 CTO gel on the flash, John lit the shaded side with a full-powered flash. Canon 5D Mark III, 32mm, ISO 320, f/10, 1/200, Cloudy WB, Canon 600EX-RT Speedlite triggered with an on-camera ST-E3-RT.

b) Ambient light only version.

dynamic range before a native ISO rating can be assigned. Moreover, the native ISO must be close to, or be modified to, a standard ISO number. What are some of the native ISO numbers? Most of today's DSLRs have a native ISO of 100 or 200. In selecting an ISO for quality images, less is best.

The photographer is provided with ISOs higher than native by electronic amplification of the electrical signals from the sensor. In practice, there is a top limit to how high an ISO can be achieved, mostly because of the laws of physics and the behavior of available electronic components. Either or both is subject to change, and our great-grandchildren photographers will undoubtedly enjoy performance we presently can't imagine.

THE SHUTTER AND THE FLASH

The key goal of this chapter is to equip you to answer some flash/shutter speed questions correctly. The concepts will be explained and the answers will be at the end of the chapter. Be prepared for a pop quiz here and there!

To use flash skillfully and efficiently, it is incredibly helpful to understand how camera shutters and flash operate together. Consider these questions:

1 How many shutter curtains does the camera have?
2 Why must the camera have that number of shutter curtains?
3 Why do cameras have a maximum sync speed for flash?
4 If you change the shutter speed from 1/4 second to 1/1000 second, do the shutter curtains move faster?
5 Do shutter curtains move horizontally or vertically, and why?
6 What is high-speed sync?
7 How does high-speed sync work?
8 What is rear-curtain sync (aka second-curtain sync)?
9 When using high-speed sync, does the ability of the flash to light a larger object or one at greater distance diminish?
10 Exactly when does the flash fire when using first-curtain sync? Second-curtain sync? High-speed sync?
11 Bonus question! Can first-curtain, second-curtain, and high-speed sync be used together in any combination?

To get our mind in sync with flash sync, you need to know about shutter operations and the relationship of the flash to the shutter. Not to worry, little by little every aspect will be made clear.

The shutter mechanism is mechanically complex. To answer the first question, the shutter has two curtains. Why two? Reflect on the operating sequence of a hypothetical (and mythical) single curtain shutter:

- The camera is quiescent, and the single shutter curtain blocks all light from the sensor.
- The shutter button is pushed, and the curtain begins to move downward. In this imaginary camera, it opens from the top.
- The curtain arrives at the full down position and remains there for the duration of the desired shutter speed.
- The curtain begins to move upward and stops when arriving at the top, having completed the exposure. We are back at the first stage

What's so unacceptable about one curtain? Two things come to mind:

One problem is that there will be an exposure gradient. In our hypothetical single shutter, the top of the sensor will be exposed for a longer time than the bottom. That causes the exposure to vary smoothly and evenly (linearly) between brighter at the top and darker at the bottom. There is no visible image degradation at shutter speeds so slow when the curtain full open times (exposure times) are long compared to the curtain travel times, but as shutter speeds get faster, the effect becomes first noticeable and eventually unacceptable.

A second reason is that the mechanical speed of the one curtain shutter is limited by several factors. It is so limited that we photographers would live in a world of slow shutter speeds inhospitable to action photography. When shutter speeds get higher and higher and the curtain begins to bounce when striking bottom and striking top, it causes camera vibration and consequently soft images. At this point, curtain materials can deform and must be made heavier. Accordingly, the return spring must be made stronger and it too gets heavier, and now the vibration problem becomes greater.

You might be questioning the reason I described the curtain as moving from the top to the bottom and not from side to side. In the rectangular frame camera, which we customarily use these days, the top-to-bottom or bottom-to-top travel distance is shorter, so the shutter curtains can travel over the sensor faster. We appreciate faster shutter speeds for their ability to produce sharper images.

The two problems above, nuisances to photographers and camera engineers alike, are entirely solved by the use of a two-curtain shutter mechanism. The two curtains, one behind the other, are called the *front curtain* and the *rear curtain,* though at times they are called the *first curtain* and the *second curtain.*

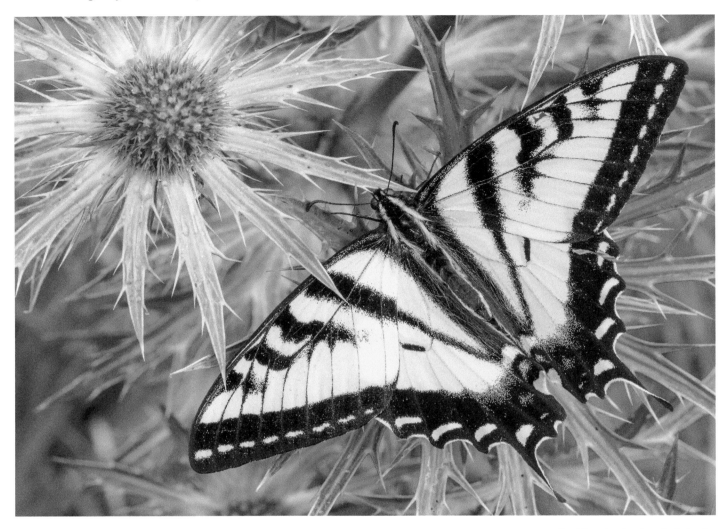

This resting western tiger swallowtail tries to warm up on a cool dark afternoon. Barbara uses main flash to better light the butterfly while using the short flash duration to secure a sharper image. Nikon D4, 200mm, ISO 100, f/22, 1.6 seconds, Cloudy WB, SB-800 off-camera with a dedicated flash cord, Manual exposure for the ambient, but auto flash exposure with the FEC set to +1.

Here is the operating sequence:

- The camera is quiescent. Both curtains are closed, and no light is admitted.
- Upon initiating an exposure by pushing the shutter button, the rear curtain immediately opens, but the front curtain remains closed. Still, no light is being admitted.
- Now the front curtain quickly opens, and the sensor can see the light!
- After the designated exposure time, the rear curtain closes ending the exposure.
- Lastly, the front curtain closes, terminating the sequence.
- Both curtains are closed, awaiting the next exposure.

That sequence is all well and good, but it too, is limited to slower shutter speeds. As shutter speeds get faster, the fully open time unavoidably gets shorter. At some unspecified shutter speed, the fully open time has fallen to near zero.

Instantly we have a new problem. The shutter speed at which near-zero *open time* occurs is the fastest shutter speed at which we can fire a flash and still illuminate the entire sensor (We have a trick up our flash sleeves that we'll talk about in a bit). That fastest shutter speed is about 1/200 second for most full-frame cameras and perhaps 1/250 second on some smaller sensor cameras. Because conventional flash cannot be used at any higher shutter speed, it is known as the *maximum synchronization speed* or *maximum sync speed* or simply as the *sync speed or x-sync*.

Summarizing:

At all shutter speeds up to and including, but not beyond, the maximum sync speed, the first (front) shutter curtain fully opens to expose the sensor and then the second (rear) shutter curtain closes to complete the exposure.

How does a camera achieve shutter speeds well beyond the maximum sync speed, say up to a blazingly fast 1/8000 second, as does both Barb's Nikon D4S and my Canon EOS 1DX Mark II? The answer is not with more curtains. It is the clever way in which it uses two curtains. Here it is:

- Both curtains are closed. No light can enter.
- The shutter button is depressed to initiate an exposure.
- Curtain 2 fully opens.
- Curtain 1 begins to open.
- When Curtain 1 is slightly open, Curtain 2 begins to follow it but is a little bit behind.
- The effect is that of an open slit—a gap between the two curtains, allowing light ingress to expose the sensor region just behind the slit.
- As both curtains continue their travel, the slit travels downward across the sensor, exposing the sensor as it goes.

- When both curtains have ended their travel, the slit has covered the entire sensor to achieve the exposure.
- Curtain 1 returns to its closed position, terminating the sequence.

That is the precise way a two curtain shutter works. Achieving different shutter speeds is simplicity itself. *We do not change the speeds at which the shutter curtains travel.* We merely change the width of the slit. How? By timing the second curtain departure. In the above sequence, we demonstrated that Curtain 2 began chasing Curtain 1 by beginning its travel after Curtain 1 had started. That inter-curtain delay controls the width of the slit, thus controlling light ingress and giving control over exposure. A short delay provides a narrow slit and the exposure of any segment of the sensor is short. A long delay gives a wider slit and a correspondingly longer exposure. Note that as the shutter speed is controlled, the actual speed is not changed, but only the width of the gap

When using flash to light the landscape, the most difficult problem is having too much ambient light. In this image, I did everything I could to reduce the ambient exposure so my flash could add light to the dark side of Mesa Arch at dawn. Canon 5D Mark III, 27mm, ISO 800, f/22, 1/200, Cloudy WB, one Canon 600EX-RT Speedlite with a Full CTO gel filter was fired once on manual at full power to add some light to this arch to bring out more color and detail. F/22 and 1/200 second were used to lower the ambient exposure.

between shutters. The actual speed of the curtains remains constant!

Mechanical complexity (cost and reliability) is vastly improved resulting in benefits over fiddling with curtain speed. The shutters move at the same speed all of the time, we change only the time elapsed between two events. That time is simply, reliably, accurately and precisely controlled by the quartz-controlled microprocessors in modern cameras.

The two shutter technique for exposures faster than the maximum sync speed disallows conventional flash use because the traveling slit never offers a time when the shutter is completely open, and accordingly, never offers a time when the sensor could be exposed with a flash burst. That is to say the flash won't work above the maximum sync speed, unless the "high-speed flash trick" is implemented.

The first five questions have been answered! Please go have a coffee, a Coke, a bottle of beer, a nap, or whatever, and then we'll press on.

In my perfect world, all noisy and vibration causing, flash-limiting mechanical shutters would all just go away. Fortunately, electronic shutters are on their way and already beginning to be included in some cameras, mainly the point-and-shoots. Conceptually simple, one would surmise that a quick electrical sampling of the sensor data would do the same as a mechanical shutter, and so it would. Realistically, problems in sensor design and associated sampling electronics (and their cost) still make mechanical shutters the better choice for most cameras. That said, I recall the story of a United States Commissioner of Patents, in approximately 1902, purportedly but famously saying that everything that could be invented had already been invented. That slightly short-sighted opinion always makes me laugh, and comforts me that the fully electronic shutter is not far away. When electronic shutters do away with mechanical shutters, tremendous increases in the capabilities and ease of outdoor flash photography will be accomplished and finally realized.

TWO SYNC MODES: FIRST-CURTAIN SYNC AND SECOND-CURTAIN SYNC

We have a lot to say regarding the two times at which we can fire a flash. They are certainly applicable to all shutter speeds *up to* the sync speed. If you'll permit an aside, I dwell on the *up to* part because so many shooters think of sync speed as being only the one speed, and entirely forget that the sync speed of a shutter is a maximum speed,

and similar flash behavior occurs at all slower speeds as well. In fact, I think 90% of my outdoor flash photography uses shutter speeds slower than the maximum sync speed to achieve a favorable ambient exposure. An abbreviated sequence for first-curtain (front-curtain) sync follows:

- The shutter button is pushed.
- Rear (second) curtain opens.

a) Barb's Boo Bear was delighted to run for small dog treats. The default flash mode is first-curtain sync where the flash fires as soon as the sensor is fully exposed. That usually works well, but when photographing action with flash, having the flash fire at the beginning of the exposure means the sharp image of Boo is behind the blurry ambient light image creating confusion.

b) Selecting second-curtain sync changes the time when the flash fires. Instead of firing the flash at the beginning of the exposure, the flash fires at the end of the exposure. This produces a sharp image of running Boo Bear ahead of the blurry ambient light portion of the exposure for a more natural looking image. Canon 1DX, 70–200mm at 144mm, ISO 400, f/16, 1/5, Cloudy WB. Canon 600EX-RT Speedlite with +.7 FEC.

- Front (first) curtain opens.
- The flash fires as soon as *the first shutter curtain fully opens.*
- The curtains remain open for the designated exposure time.
- Both curtains close.

Abbreviated sequence for second-curtain (rear-curtain) sync:

- The shutter button is pushed.
- Rear curtain opens.
- Front (first) curtain opens.
- The curtains remain open for the designated exposure time.
- The flash fires at the *end* of the ambient exposure.
- Both curtains close.

The flash fires either at the beginning or at the end of the exposure time. Why should it matter? Nearly all of the time it doesn't. The default setting for every camera I have worked with is front-curtain sync and most users never change it. It is especially well-suited for still subjects. There is, nonetheless, one classic use for rear-curtain sync.

At the Gerlach homestead, nestled deep in the uncharted wilds of Idaho (okay, maybe not that deep), the reigning monarch is unarguably Boo Bear, referring to Barbara's feisty Pomeranian. Boo Bear, who is handsome enough to be one of our regular photographic subjects, can usually be seen leaping and scampering in every direction simultaneously. Once more, let's look at a time sequence:

- Boo Bear is running at top speed across the yard.
- The light is dim. I need a long exposure for the ambient light.
- While shooting at lower than sync speed, perhaps a half second, both shutter curtains open.
- The flash fires immediately upon both curtains being fully open.
- Boo Bear's image is "frozen" by the very short duration of the flash.
- With curtains still open, Boo Bear continues his romp and gets a bit blurred.
- The exposure time ends and the curtains close.

My image has a blurred Boo Bear with a sharp "frozen" Boo Bear at the rear of the blur. His blur precedes him. Oops! A good motion image should be the other way around, with the sharp rendition at the front of the blur and not the rear. A classic example of the problem would be a forward moving car with its taillight streaks in *front* of the car. I immediately changed my camera to rear-curtain sync and was rewarded this way:

- Boo Bear is running at tippy-top speed across the yard.
- Because it is a dimly lit day, I need a long exposure for the ambient light.
- I'm shooting at something lower than sync speed, both curtains open.

- Not being in front-curtain sync, there's no immediate flash.
- With curtains still open, Boo Bear continues his romp and gets a bit blurred.
- The exposure time ends, the flash occurs, and Boo Bear's image is frozen by the very short duration of the flash.
- The curtains close.

Now I have the classic picture of a sharp image of Boo Bear with a trailing blur. You must already realize that even without your own Boo Bear, the technique applies equally well to birds, planes, Superman, as well as any other fast moving subjects you may well encounter.

There are a couple of potential problems with rear-curtain sync. All modern automatic flashes, when triggered, quickly fire a preflash to measure the exposure, and then follows with a proper main flash burst. In ordinary circumstances, the main flash follows so closely that our eyes cannot discern two flashes as they meld into one. Assume though, we are using rear-curtain sync with a long shutter speed of one second. The preflash is emitted before any shutter motion, so immediately upon triggering the camera, the preflash is fired. There is a full second before the main burst fires, and our eyes quickly distinguish the two bursts. The preflash does not affect the exposure, but it might alarm a subject or cause an eye blink.

Another potential rear-curtain sync problem is that if the flash-to-subject distance is materially changing during a long exposure, the time between the exposure determining preflash and the actual exposure might make the exposure measurement incorrect. This may result in over-exposure for subjects racing toward the flash and underexposure for subjects moving away.

HIGH-SPEED SYNC

Wanting to obtain a portrait, an attractive woman poses for you outdoors in mid-morning. The bright sun creates dense shadows on her face and neck. If she faced more in the direction of the sun, the shadow density would be reduced, but now she would be squinting. If she turns away from the sun, she doesn't squint, but dark shadows appear on her side away from the sun. To manage the harsh light, use fill flash to add light to the shadows and reduce the unfavorable contrast:

- We set the ISO to the camera's native setting of 100.
- Her hair and clothing are of average tonality, so for the bright sun ambient light, a probable exposure is 1/100 second and f/16.

- To de-emphasize and blur an ugly background, f/4 is needed.
- At f/4, the needed shutter speed rises to 1/1600 second, way higher than our sync speed.
- Fill-flash, superficially, is not possible.

Wait! Wait! There is still more. A while ago, I alluded to a trick involving the sync speed of the camera. That trick is no trick, though. It is simply intelligent use of technology that allows us to use flash beyond the maximum sync speed. The method is so far beyond our 1/200 second sync speed that both Barb's Nikon and my Canon can use flash all the way to their maximum shutter speeds of 1/8000 second!

a) Barbara holds the Nikon flash and triggers it wirelessly with the Nikon SU-800 Wireless Speedlight Commander.

b) Some fill flash opens up the shadows and brightens the wood lily. Shooting a selective focus image at f/4.2, the shutter speed had to be 1/500 second, faster than the normal maximum sync speed. Barb went to HSS to allow her flash to fire multiple bursts of light to successfully add fill flash to the flower. For the Nikon shooters, Nikon actually calls this mode Auto FP, but it is the same thing as HSS. Nikon D4, 200mm, ISO 100, f/4.2, 1/500, Cloudy WB, SB-800 Speedlight.

This mode of operation is known as the *high-speed sync* and is entered by selecting this flash mode within the camera. A Canon camera displays a small icon comprising a lightning bolt and the letter "H" in the flash display to indicate high-speed sync is set. The lightning bolt is a relatively standard camera icon to indicate flash, and the "H" indicates the *high-speed sync mode*. Barb's Nikon cameras display their high-sync mode by the letters "FP" prominently in the flash's display. What does FP mean? In all probability, Nikon uses FP to display that the flash operates over the entire range of the Focal Plane shutter.

Any shutter speed beyond the maximum sync speed depends on a two-curtain moving slit shutter. In high-speed sync there is never one time when a fired flash can expose the entire sensor. Now you know the reason why a flash cannot be used above sync speed. The flash in HSS mode fires an extremely fast series of bursts, timed so that each burst of the series occurs during the time a particular segment of the sensor is exposed by the moving slit. After the slit has completed its travel and the subject has been "flashed" throughout the exposure, the series of small flash bursts stop. The sensor has not only been exposed to the ambient light, it has also been fully exposed to the flash! Wow, that is terrific and a win-win situation! With high-speed sync, flash can be used at all the shutter speeds of our Canons and Nikons as well as all other cameras.

High-speed sync allows flash use at wide apertures in bright light, no matter how fast the shutter speed, a former impossibility for flash photography. To attain proper background control when shooting outdoors to make the subject "pop", use an f/2.8 or f/4.0 aperture. High-speed sync is equally effective when a wide aperture isn't needed, but we do need a high shutter speed to arrest subject motion.

Always remember, there are details!

One consideration is that the energy storing capacitor is full of electrical charge. In high-speed sync, instead of transferring the majority of the energy to the flash tube in one big burst of light as normal, transfer occurs, instead, little by little in a fast series of short-duration flashes. The series is so quick that the human eye sees them as but a single flash, whereas there were indeed many separate flashes. Each short flash slightly depletes the energy of the capacitor, which must be divided between the flashes because they occur so rapidly the capacitor cannot possibly recharge between them.

Consequently, each flash of a high-speed sync series is much weaker than a full-power flash and the overall

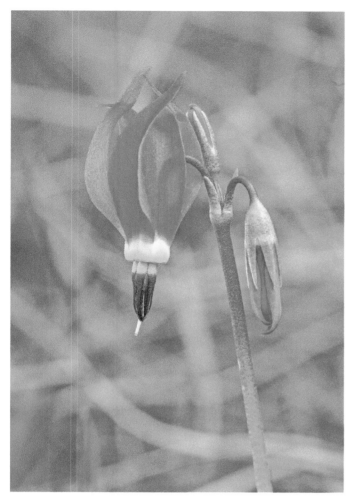

a) Stopping down to f/14 at 1/40 second captures far too many dead grass distractions in the background.

b) Shooting at f/4.5 doesn't provide the DOF to get this flower sharp, but the background is far less chaotic. John focused stacked through only the shooting star flower to get it in sharp focus, but that required using a shutter speed of 1/400. By using high-speed sync (HSS), John used his Canon 600EX-RT Speedlite to backlight this shooting star. Canon 5D Mark III, 180mm macro, ISO 200, f/4.5, 1/400, Cloudy WB, FEC –.3, eight images focus-stacked with Helicon Focus.

illuminating power in high-speed sync shooting is significantly reduced, perhaps by two or more stops. It is not a problem when the subject is not too far from the flash. The issue occurs at greater distances. Outdoor photographers, typically use flash for shadow fill when making human or animal portraits at closer distances, so we are not often concerned by the loss of flash power.

Here is an important issue. The camera setting could remain in high-speed sync mode without any disadvantages. At shutter speeds higher than the sync speed, the high-speed mode is activated as needed. The camera automatically switches to normal sync mode at the maximum sync speed or below.

REVIEW, ANSWERS, AND MORE QUESTIONS

I once read that the learning process is enhanced by an occasional brainteaser, so permit us to deliberate some of the most esoteric flash and shutter behavior and answers to the previous questions.

Assume a PC cord attaches the camera to flash while you're using a shutter speed above the maximum sync speed. We are using a PC cord because the camera can't detect a flash is being used when a PC cord connects the flash to the camera. This allows you to actually fire a flash with a shutter speed above the maximum sync speed while high-speed sync is not invoked.

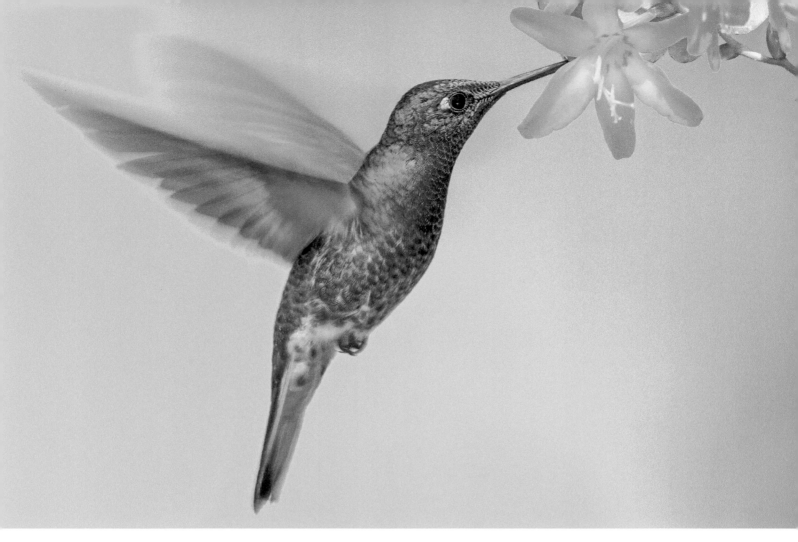

The buff-tailed coronet was photographed using high-speed sync in order to allow its wings to blur from the ambient light. The flash froze the wings a little and filled in shadows under the bird. Canon 1D Mark III, 500mm, ISO 320, f/5.6, 1/400, Flash WB, one Canon 580 II Speedlite.

Question: Is it possible to have dark areas on both sides of the area exposed by the slit?

Answer: The flash fires when the first curtain opens entirely. Above the sync speed, as here, the second curtain follows behind. When the flash fires, only that part of the sensor obscured by the second curtain is dark. Thus, only one side of the image can be dark!

Question: In high-speed sync mode, does the size of the gap between the two shutter curtains vary in size according to the selected shutter speed?

Answer: The shutter speed is determined not by the actual travel time of the curtains, but by the width of the moving slit between the two curtains. Yes, is the correct answer!

It is quite unlikely that you will ever be plagued with partially exposed images, though. Most of our modern cameras, upon detecting a flash unit physically mounted on the camera, or connected by a dedicated cable, or

If you ever see a partial image like this when using flash, you are using too fast of a shutter speed. Unless you evoke high-speed sync, the second shutter curtain is closing when the flash fires preventing a portion of the image from being exposed. The camera knows when a flash is attached (usually) and will default to the maximum sync speed if the shutter speed is set too fast. However, when using PC cords, the camera does not know flash is being used which can create this problem.

communicating via a wireless system, or upon detecting deployment of a pop-up flash, will automatically default to the maximum sync speed. For example, if your camera is set to a shutter speed of 1/800 second, upon turning on the flash unit, the shutter speed will be automatically lowered to the sync speed of, say, 1/200 second. (Note that in the above question with the PC cord, the flash was attached with a PC cord, and thus invisible to the camera.)

Consider the answers to the questions posed earlier. Revisit those questions at the beginning of this chapter before reading the following answers. If you get eight or more correct, you are well on your way to becoming a flash master!

1 How many shutter curtains does the camera have?

 Answer: Per discussion, two curtains.

2 Why must the camera have that number of curtains?

 Answer: To provide even illumination across the image and to provide for fast shutter speeds.

3 Why do cameras have a maximum sync speed for flash?

 Answer: The sync speed is the fastest shutter speed that allows both curtains to be simultaneously open so a single burst of light can illuminate the entire sensor.

4 If we change shutter speeds, do the curtains change speed?

 Answer: The curtains travel at only one speed. It is only the width of the gap between them—the slit—that changes with shutter speed.

5 Do shutter curtains move vertically or horizontally and why?

 Answer: Vertically, to allow faster transit times for the curtains and make a slightly faster maximum sync speed possible. With a square sensor, it would have no significance.

6 What is high-speed sync?

 Answer: A method of providing flash illumination at shutter speeds above the maximum sync speed.

7 How does high-speed sync work?

 Answer: The flash provides a swift series of flash bursts, occurring at timed intervals with the moving curtain slit to illuminate all of the sensor.

8 What is rear-curtain sync (aka second-curtain sync)?

 Answer: To fire the flash at the end of the exposure rather than the beginning. It is useful for exposing moving subjects with simultaneous use of ambient light and flash.

9 When using high-speed sync, does the ability of the flash to illuminate a larger object or one at a greater distance diminish?

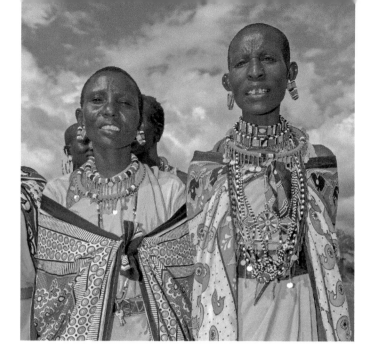

Masai ladies pose proudly when Barb photographed them under extremely difficult overly bright sun conditions. Barb used high-speed sync to open the shadows in their faces. Nikon D4, 26mm, ISO 400, f/6.3, 1/1600, Exp. Comp. +.3 and Flash Comp at +3. Using FEC +3 forced the Nikon SB 800 Speedlight to emit all of the light possible.

Answer: Yes, to both of the above questions. The flash unit provides a series of "mini-flashes" as the curtains travel, so each part of the sensor receives considerably less light than would occur with a full-power flash. The degradation in illuminating power varies with the shutter speed, so the flash is stronger at, say, 1/400 second than it is at 1/8000 second.

10 Exactly when does the flash fire when using first-curtain sync? Second-curtain sync? High-speed sync?

 This is a bit of "gotcha" question and I do want to "getcha" to think about the way flash systems work. Begin by thinking more about the "how" of flash systems so when all that becomes second nature and instinctive, you will be able to spend more time thinking about the "when."

 • First-curtain (front-curtain) sync? As soon as the first curtain is fully open, the flash fires.
 • Rear-curtain (second-curtain) sync? At the end of the exposure time, just before the curtain begins closing.
 • High-speed sync? The flash fires a continuous series of bursts during the time the traveling slit is transiting the sensor.

11 Bonus question! Can first-curtain, second-curtain, and high-speed sync modes be used together?

 Answer: The old song, *Love and Marriage*, claims "You can't have one without the other." Here, you *must* have one without the other! They are mutually exclusive—only one works at a time.

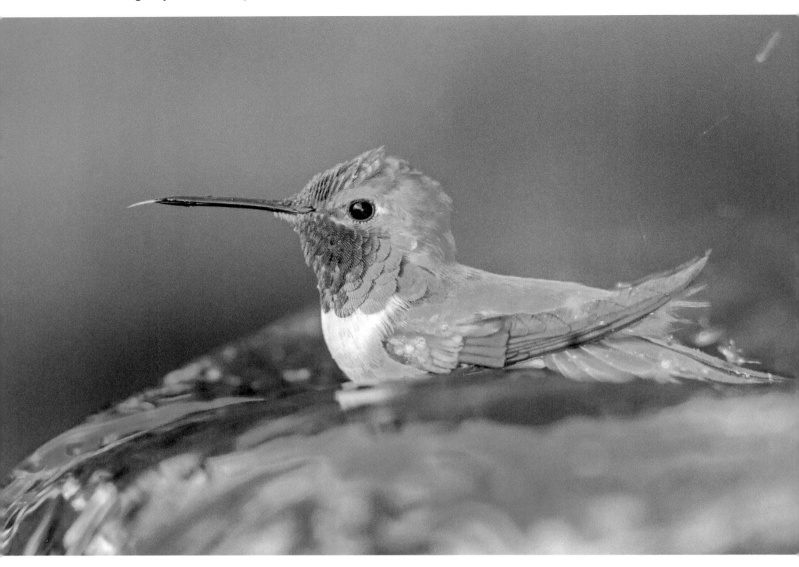

Nothing can possibly be cuter than a rufous hummingbird taking a bath. Canon 5D Mark III, 300mm, ISO 3200, f/4.5, 1/200, Auto WB, FEC −.7. The fill flash is used to add sparkle to the hummer's eye and to brighten the feathers.

A weak fill flash opens the shadows while adding sparkle to frosted winterberry holly berries on a bitter cold northern Michigan morning. Canon EOS-1D Mark III, Canon 180mm macro, ISO 100, f/20, 1/1.2 seconds, Shade WB, FEC -1.7 stops, ST-E2 flash optical controller with a Canon 580 II Speedlite.

Flash and ambient light exposure

Because you are into a book on relatively advanced outdoor flash techniques suggests you are probably up to speed, but a short review follows. Stops are not only fundamental; they are extremely crucial. Aperture settings are arranged so that changing from one "standard" f/stop to another causes either doubling or halving of the admitted light. The same applies to shutter speeds and ISO settings and exposure compensation dials.

Examples to bring you up to speed:

- A one-stop change from f/5.6 to f/4 doubles the light on the sensor.
- A one-stop change from 1/200 second to 1/400 second cuts the light in half.
- A two-stop change from f/11 to f/22 cuts the light to one-fourth.
- A one-stop change from ISO 400 to ISO 800 doubles the camera's sensitivity to light.
- A one-stop change in ISO is the same exposure change as a one-stop change in aperture or shutter speed.

Note that I said "the camera's sensitivity," not "the sensor's sensitivity." That's because the sensor always operates essentially at its native sensitivity (native ISO rating) and other ISO sensitivities are achieved by electronically amplifying or attenuating the sensor's native data.

Be sure you are fluent in the language of stops. It's an outstanding way to think about, talk about, and work with exposure changes as we tweak camera controls.

GUIDE NUMBERS (GN)

The guide number system was the primary way of determining how to place multiple flashes years ago when all flashes were manual. Although modern TTL flashes effectively take care of flash exposure quickly, understanding the concept of guide numbers remains incredibly helpful in placing flashes to achieve different light ratios. In all cases when I use Manual flashes for hummingbirds, or multiple automatic flashes for other situations, I nearly always use the concept of guide numbers to help me determine the approximate flash-to-subject distance.

This colorful eroding rock and many more like it reminds many of a gnome perched on a pedestal at Devil's Garden near Escalante, Utah. John darkened the sky by underexposing the ambient by about 1.7 stops. Then he fired a single 1/2 CTO filtered Canon 600EX-RT Speedlite on manual twice using the multiple exposure mode to get enough light. Canon 1D Mark III, 24–105mm lens at 65mm, ISO 500, f/8, 1/100, Cloudy WB.

The *guide number* of a flash unit is a means of describing the flash's ability to produce light. The guide number of many flashes assumes that the camera in use is set to ISO 100. Flashes equipped with a zoom function will assume the particular zoom setting at the specified guide number. Moreover, the guide number is shown in both feet and meters and one should ensure the proper unit is used.

The basics of the system require the f/stop to be used for a mostly mid-toned subject, and is determined by dividing the proper guide number by the distance from flash-to-subject. That's flash-to-subject distance. It only means camera-to-subject when the flash is on the camera, very near to the camera, or otherwise at the same distance from the subject as is the camera.

Here's the formula:

GN = FD × Aperture.

Another way to put it is:

GN/Aperture = Flash Distance.

Examples: Suppose your flash at a certain ISO and zoom has a GN in feet of 150 which, translated, means 40 meters. If you're shooting at ten feet, merely divide 150 by 10 and get a calculated aperture of f/15. How about if you're shooting at 20 feet? Divide the "feet GN" of 150 by 20 and get an aperture of about f/8. Yes, it is f/7.5, and if your camera allows, set it. Otherwise, a third of a stop or so below f/8 is good enough. And if you're shooting at a distance of six meters, divide the "meters GN" of 40 by 6, and use an aperture of f/6.3.

Here's a table of six popular flash units, at identical ISOs and identical zoom positions:

Make	Model	ISO	Zoom position	GN (feet)	GN (meters)
Canon	600EX-RT	100	105mm	190	58
Canon	580EX II	100	105mm	190	58
Nikon	SB-800	100	105mm	184	56
Nikon	SB-910	100	105mm	162	50
Canon	430EX II	100	105mm	141	43
Nikon	SB-700	100	105mm	121	37

The flashes are listed in order of zoom levels of 105mm. Many flash units are specified with a maximum zoom of 105mm, but some are specified at zooms as high as 200mm. Thus, some flashes in the table can produce even higher GNs when used at higher zoom levels. This listing allows easier comparison of the six flashes.

Think carefully about the meaning of guide numbers. We have long suffered a frequently argumentative and often provocative perennial student. He recently showed symptoms of having succumbed to pride-of-ownership disease. He was gloating that his new Canon 580EX II with its GN190 was more powerful than his buddy's Nikon SB-800 with its measly GN184. But if he were shooting a subject ten feet away, he would set his aperture at 190/10 = f/19, where his buddy would have used 184/10 = f/18.4. The difference was less than 1/3 stop and by itself is no reason to favor a particular flash.

Power can be an important factor when selecting a flash, but other issues arise as well. If the flash is used solely in

This striking caterpillar was quietly snoozing on a cool dewy morning. Due to its many hairs, John selected the shooting angle to take advantage of the backlight. A 1/4 CTO Canon 600EX-RT Speedlite set to −.7 FEC opened up the dark shadows facing the camera while not overpowering the ambient backlight. Having a powerful flash is not important for close-up photography due to the short subject to flash distances. Canon 5D Mark III, 180mm macro, ISO 100, f/16, 1/2, Manual ambient exposure and ETTL flash.

macro work, high power isn't that important. Cost, size and weight may be a factor to consider. Consider whether the flash can serve as a commander or remote, and if so, whether it's optical or radio. Output power is a primary concern for the outdoor flash landscape photographer. Barbara and I have several flashes, but she selects her Nikon flashes and I my Canon flashes. Knowing that outdoor photography requires plenty of light to illuminate portions of the landscape, the higher the guide number the better.

Another use of GN is to compare the output of flash units. Flashes with higher guide numbers, all else being equal, produce more light. If your flash has a GN of 200, and mine has a GN of 100, then your flash is twice as powerful as mine. Right? Nope, not this time. Flash guide numbers are related like an aperture's f-stops. In the standard f-stop series, we have f/2, f/2.8, f/4, and so on. These numbers allow a halving or a doubling of the admitted light but are not related by 1/2 or by 2. They are linked by 1.4, a number involved in the geometry of the circle of the aperture opening. For certain, $2 \times 1.4 = 2.8$ and $2.8 \times 1.4 = 4$. Yes, I know that one is really 3.92, but 4 is close enough. Rounding numbers, like letting 3.94 be called 4, are commonly made in juggling aperture numbers and flash guide numbers. Flash guide numbers are related to light output by the 1.4 factor. My hypothetical flash had a GN of 100, and yours had a GN of 200. However, a doubling of the light output of mine would give a GN of $100 \times 1.4 = 140$. Another doubling would be $140 \times 1.4 = 196$, but we round it to 200. The bottom line here is that your hypothetical flash, with GN 200, is four times as powerful as mine with its GN of 100. It can emit two stops more light!

Re-visiting GN-calculated exposure, the leading usage of guide numbers is in calculating the correct flash exposure. With your GN 200 flash and a subject ten feet from the flash, you would use an aperture of $200/10 = $ f/20, perhaps rounded to f/22. However, with a GN 100 flash I can use an aperture of $100/10 = $ f/10, or perhaps f/11. Voila! That you can use an aperture two stops down from mine means your flash emits four times as much light as mine.

Think back to when you were a beginning photographer. Some ogre such as myself was constantly nagging you to not blindly accept your exposure meter when using Manual exposure, nor allow your camera's unfettered acceptance of the meter reading when using automatic exposure. The ogre reminded you persistently to think about the tonality of your subject and possibly override what the meter had

to say. The overriding was called exposure compensation, and when it finally became second nature to you, you took a major step up the ladder from newbie to savvy shooter.

Now consider a modern flash unit and camera system. The simpler of them use the light reflected from the subject to directly control the flash output and thus control the exposure. Today's more sophisticated and more standard TTL systems allow light reflected from the subject to enter the camera through the lens. The camera determines when it has received the correct amount of light for the exposure, sends an electrical signal to extinguish the flash and terminate the exposure. Either way, the light reflected from the subject is, all else being equal, controlling the exposure. Reflected? Whoops! Here comes that ogre again, ranting and raving about high-tonality smiling brides in their whiter-than-white (high-key) gowns (add a stop or two!) and about low-tonality judges in their ominous black (low-key) robes (drop a stop or so!).

But now, sayeth the ogre, it's the flash that needs the compensation, not the camera. A "Flash Exposure Compensation" (FEC) control is found on most modern flash units, and provides a way to adjust the flash for subjects of different tonalities. A typical FEC control might offer these compensation stops: $-3 . . -2 . . -1 . . 0 . . +1 . . +2 . . +3$. This set of adjustments depicts intervals of 1/3 stop, but the interval in some flash units can be user-selected as 1/2 stop or as shown, the more precise 1/3 stop. So our high-key bride might need an FEC of, say $+2$ and our low-key judge might need an FEC set to about $-2/3$. FEC is not needed and would be left at "0" for a subject in a red robe, green gown or blue bustle, or any hue whatever as long as it were mid-toned. It is easy to remember that $+$ FEC levels add light to the subject and $-$ FEC levels diminish light. The difficult part is remembering to think "FEC" every time you're shooting a flash image.

There are times when plus ($+$) values of FEC are not available and times when $+$FEC is only partially available. Assume that one night you're shooting a landscape at dusk and you want to light a tree about 20 feet from the flash. You're using flash in TTL mode. Despite being at the widest aperture the needed DOF permits, and highest ISO you deem allowable, the tree is a stop or more too dark. The flash is fired at full power so the capacitor's entire bank of electrical energy is used. A subsequent flash burst cannot be more powerful than that, so raising the FEC would not help. Not to worry though, we'll discuss some "workarounds" shortly.

The next night, you arrive earlier and the ambient light is a bit brighter. With the same camera parameters as above, your tree is still a little underexposed. The increased ambient light allows the flash to fire at something less than full output, so now you can use at least some + FEC available to increase flash output, hopefully enough to properly expose your tree. The amount of flash energy available for the increased exposure on the next shot is related to the full output capability minus the uncompensated flash output of the last shot.

The opposite problem is no problem. Lowering the flash output with FEC is always easier than raising the flash output with + FEC. If your camera offers − 3 stops of FEC, and the flashed subject is still too bright, simply move the flash further from the subject or zoom the flash head to a wider focal length to spread the emitted light over a larger area. *Reminder: the effect of a flash is always related to the flash-to-subject distance, not the camera-to-subject distance.* Naturally, with an on-camera flash they are identical!

FLASH METERING

Unlike the awkward flash systems of yesteryear, the modern through-the-lens (TTL) flash metering schemes make flash exposure as simple as a modern camera's ambient-light metering. The most effective of today's flash metering uses through-the-lens (TTL) flash metering. When you push the shutter button:

- Under guidance of the camera, the flash unit sends out one or more very weak "preflashes" that are used only for metering, not for making an exposure.
- The light of the preflash is reflected by the subject and enters the camera through the lens.
- Electronics within the camera measure the strength of the reflected preflash and calculate the amount of light necessary for a proper exposure.
- The camera sends an electronic command to the flash unit, defining the proper flash duration.
- The flash unit emits the light burst that exposes the subject correctly.

The flash workload and uncertainties of flash decades ago are solved. As always, there are things to remember. One is that the above sequence happens instantly. The non-scientific minded observer might say that it all happens immediately when the shutter button is pushed. The truth is that it takes time, but only a few milliseconds.

Response time is so fleeting that the observer just pushes the button, mentally records a single big flash, and it's all over. Thinking it instantaneous is natural. Second is that the light measurement and calculations are made based on light reflected from the subject. The trigger-word here again is "reflected." The high-key bride and the low-key judge? They're here again. The camera doesn't know, the flash doesn't know, but the alert photographer knows and compensates a flash unit for subject matter of any color that is darker or lighter than mid-tonality. Third is that a preflash can upset an optical slave system. Although it appears to be one flash, TTL flash systems typically fire a small preflash to determine the exposure and then the exposing flash is fired. The preflash can trigger the remote flash if using a photo slave, causing it to fire before the shutter curtains are open. The fourth FEC matter you need to remember: some camera systems can introduce flash compensation by settings on the camera and also settings on the flash unit. To avoid confusion, it's a good idea to set consistently one FEC control to zero and consistently use the other control to introduce the desired FEC. You don't need to wonder what is set or where it is set.

The *very last* FEC thing to remember: in some systems just mentioned, when there is more than one control capable of adjusting FEC, you should know how they interact. Typically, one FEC is located on the camera and one on the flash. The two controls may be additive (Nikon for instance) in the sense that + 1 FEC on one control and + 2 FEC on the other control will give an overall + 3 FEC. Likewise, + 2 FEC on one control and − 1 FEC on the other results in a net + 1 FEC. With other systems such as Canon, the two FEC controls are not additive. One of the controls overrides the other. Perhaps the flash unit FEC control is predominant. Whatever non-zero FEC is set into the flash unit, that number will be the effective FEC irrespective of what is set into the camera's FEC control. If it is more convenient for a particular shooter to use the camera FEC input, then just leave the flash FEC control at 0 and use the camera FEC.

And the *very last* thing to remember is that I told a tiny white lie. There is always more to remember. Diligent students and practitioners of flash photography are continually

Barbara and her mischievous dog Boo Bear make splendid subjects, especially when northern Michigan's autumn color peaks. John underexposed the ambient exposure by .7 stops and used through-the-lens flash metering with +1 FEC to light them. Canon 5D Mark III, 176mm, ISO 400, f/6.3, 1/160, Cloudy WB, and Canon 600EX-RT Speedlite with 1/4 CTO gel filter on the flash head.

seeking and finding new and different ways to apply this handy light source to the enormous benefit of their images and the self-satisfaction of mastering a skill. Yes, more to learn and more to remember, but with the increased skill comes better and better images and way more fun as well.

WHAT EXACTLY IS OPTIMUM FLASH EXPOSURE?

In one sense, light from a flash unit is no different than ambient light. We think of metering similarly. Like every day ambient light exposures, we do in-camera image evaluation of exposure with RGB histograms and highlight alerts. If you like to look at the image on the camera's rear LCD, feel free to discern whatever you can about the image appearance, but *do not* evaluate exposure that way. Shooters checking image exposure by the monitor are doomed, because the LCD's presentation of an image is so strongly affected by user-adjustable brightness controls and by the ambient light while viewing.

EXPOSURE FACTORS OF DIFFERENT FILE TYPES

Most shooters these days use RAW files or JPEG files. The two file types are exposed slightly differently to achieve the best results. The differences are that a JPEG file has a format designed to be easily read by a broad range of digital devices. The JPEG file which appears on your monitor is derived from the RAW data collected by the camera's sensor. The derivation is done under rules established by the camera designers, but many cameras allow some user customization of the process to fit personal tastes.

The RAW data from the sensor contains greater detail than is specified for a JPEG file. For the math geeks among us, the sensor might be of a 12-bit or 14-bit format. For the rest of us, that means that the brightness of each and every photosite, irrespective of color is divided into 4096 or 16,384 different brightness levels. The large quantities of brightness levels produce very fine and very smooth tonal gradations in the image.

The JPEG file is designed such that the data of each photosite is divided into only eight bits, producing 256 brightness levels which deliver *slightly* less image quality. Incidentally, in the JPEG file, an entirely black photosite, one which has received zero light, has a digital value of "0" and an entirely pure white photosite has a digital value of 255. Yet those 256 tonality levels (0 to 255) are more

than adequate for most photography and provide satisfactory quality for small prints, projectors, computer displays, printing, and Internet transmission.

RAW FILES

A RAW file is the largely unprocessed data captured by the photosites in the camera sensor. The fine divisions made of each photosite's data, as set by the bit depth and the ever increasing number of photosites in our modern cameras, allow RAW files to contain colossal amounts of data. This larger amount of data is valuable for several reasons. The main reason is that the RAW file contains considerably more editing flexibility than any other type of data file. The more substantial amount of data is highly desired by professional and advanced amateur photographers who seek to refine images by post-capture editing in Photoshop, Lightroom or other photo editing software. The RAW file allows editing of color temperature, white balance, exposure correction, contrast and several other image parameters in a manner non-destructive to the original image.

A downside of RAW files is that, irrespective of what corrections or enhancements of the original image may be desired (or even if none), the RAW file must be converted by software to some other format to be usable for printing, projecting, and/or Internet transmission. When you shoot a large number of pictures, it takes time to process, although only those images you need to use need converting. Remember the old-time sports photographer? They snapped a photo, jumped onto a motorcycle and sped through dense traffic on their way to the newspaper building. They jumped off the bike, ran into the building, up the stairs to the darkroom, and frantically developed a picture to meet a press time deadline only two hours after they had snapped the shutter. Today's sports or news photographer shoots their picture, in two seconds extracts a JPEG file needing no processing, sends it to a tethered laptop computer in another two seconds, and transmits it via Internet to the picture editor who has it 15 seconds after it was shot. The moral is that a JPEG file, unlike a RAW file, needs no post-capture processing. Thus JPEG is the preference for photographers in a big hurry, photographers not interested in bothering with computerized picture editing to optimize their images, or beginners not yet aware of the advantages of RAW files.

The decision whether to shoot JPEG files or RAW files involves considering the needs of a specific image, the needs

a) Strive to shoot the best possible image in the camera. At best, all images will benefit from some digital processing. Color adjustment, contrast control, sharpening, and a small amount of cropping usually improves an image. The image here is the unprocessed alpine forget-me-not. Nikon D4, 200mm micro, ISO 200, f/22, 1/8, Manual ambient exposure, Sunny WB. Fill flash with SB-800 at −1.3 stops.

b) the same image processed in Photoshop CC and Lightroom.

of a specific shooting session, the abilities of the camera at hand, or perhaps just the preferences of the shooter. To help make the selection, consider many of the differences:

RAW advantages

- The inherent characteristics of the file and its considerably larger file size allow greater flexibility in the digital darkroom. One can even occasionally correct a shooting blunder.
- Large prints benefit from the larger file size and the better processed RAW file.
- Picture color and exposure can be heavily modified with no loss of quality.
- Image processing is less likely to create undesirable digital artifacts.
- Contrast and noise are more easily managed.

JPEG advantages:

- The camera itself processes the image which saves time.
- Any image viewing software can accurately read a JPEG image.
- JPEG data files are much smaller than RAW files, so many more images can be written onto a given memory card space.
- The smaller file allows a faster in-camera processing of the image, in turn allowing a longer "burst rate" before the camera's buffer fills to capacity. The camera's ability to shoot fast and long is much prized by action shooters, any photographer working horse races, galloping deer, flying birds and so on.

Are you not able to decide between the two file types? Sometimes I use JPEGs so the in-camera processing allows me to immediately show images to workshop groups. For photo books and brochures, we are required to provide the finest image. Luckily, my camera, and probably yours, allows easy choice of file types. Your camera lets you choose the file types and fortunately both file types can be chosen simultaneously. By shooting both types, there is

an immediate JPEG image to use and a RAW file that later allows the greater editing flexibility. I shot both files types simultaneously until May of 2015. Now I shoot only a large RAW file. Not shooting the JPEG keeps the camera buffer from filling so quickly and allows more images to be stored on the CF memory card. Using Canon's free Digital Photo Professional 4 software—a major upgrade from previous versions—it takes little time to optimize the RAW file.

a) Barbara used main fill flash to brighten this Alpine Sunflower relative to the background on Mt. Evans in Colorado. Nikon D4, 200mm micro lens, ISO 200, f/22, 1/5, Manual ambient exposure with auto flash at +.3 FEC.

b) Since the flower is bright yellow, notice much of the histogram data is close to the right wall.

THE HISTOGRAM

The LCD displays a histogram on recent cameras which shows exposure info, a graph giving exposure information of the last shot taken. A histogram is an excellent way to judge an exposure. Countless beginning shooters use the image on the rear of the camera as an indicator of proper exposure. Never do that! I could have used immensely larger type, except my editors would complain. Instead, I will repeat it loudly! Never ever do it! The image on the LCD may or may not look good because it is so affected by the ambient light and how the display brightness is set within the camera, ensuring you just can't judge exposure by the LCD. Actually, any underexposed image can look quite fine if the camera LCD is menu set to "very bright." Furthermore, a severely overexposed image can look okay when viewed in a dim LCD setting. If the light is bright outside, the image looks dimmer and vice-versa. Too many things are in play that you just can't count on the image's LCD appearance, so one last time: *Don't do that!*

Enough of what not to do. Now is the time to decide what to do. Use the histogram to get a highly accurate and reliable display of the exposure quality of your image. A histogram applies to images produced by any kind of light, including ambient light, as well as the flash produced light discussed in this book. What is a histogram? A histogram is a graphical presentation of different tonalities within an image represented by a bar chart.

Most writers we know discuss histograms in terms of shades of black, gray, and white. They ignore color. I think it is better to involve color right from the beginning. You will read about histograms dealing with a great many colors. After all, the histogram graph deals in tonalities, not colors per se, but colors have tonalities and most images have colors! The tonalities of the color or combination of colors are what form the histogram. Only tonality is important, not the hues.

The histogram curve is derived from the relative quantities of image pixels of each of 256 tonalities. I say "relative" because absolutely no numerical data is involved. The histogram displayed on the camera LCD is derived from a JPEG image. JPEG you ask? But I shoot RAW or TIFF! Irrespective of which image format is provided to the user, the innards of the camera first process the data to produce a JPEG image for internal calculations and for image display. It is from that JPEG image that the histogram is developed. All JPEG images are 8-bit images. Every photo site's electrical data is divided into 2^8 segments. Two to the

8^{th} power is $2 \times 2 \times 2 \times 2 \times 2 \times 2 \times 2 \times 2$, which totals 256. Because a histogram provides data on 256 different tonalities of an image, we receive exposure data that forms nice smooth transitions, or gradations, between shades of colors or shades of gray.

WHAT IS THE CONCLUSION?

Fact: There is no such thing as an ideal histogram.

A histogram is able to reveal underlying good or bad exposure but like fingerprints, snowflakes, and excuses for bad pictures, every histogram is dissimilar. The histogram reveals whether your image has too many black tones which indicates the image may be underexposed. Far worse, there might be far too many white tones and be an overexposed image. Perhaps the image might have too many black tones *and* too many white tones, in which case the high contrast is too great for the camera to handle with a single exposure. Consider returning when the light is softer, use HDR techniques, or use flash to add light to the shadows.

HISTOGRAM CHOICES—THE AVERAGING HISTOGRAM

Like roses, a histogram by any other name is still a histogram. The averaging histogram is the "default" histogram of most cameras, but might be called a "luminous" histogram or a "brightness" histogram, depending on what your source is. Histograms are all the same and derive their information from the blue, green, and red color channels of the derived JPEG. Although the photographic philosophies and mathematical algorithms used in building an average histogram is surely complicated, I don't use them at all. I encourage my students and readers to move beyond them. A significant problem of the average (aka luminous or brightness) histogram is that by averaging the color channels and giving more weight to the green channel than the others, the LCD will render misleading exposure information. A red rose bush with its green leaves is a prime example. The image contains both red data and green data. A little too hot exposure on your part can render the green leaves correctly exposed but the red roses so overexposed that they become a mushy red blob in your picture. You didn't realize the red was overexposed because the green favoring average histogram show that the exposure was okay. There are numerous occasions where a dominant color or colorcast in the light causes another color to be overexposed following the averaging histogram.

A tiny amount of flash reduces the contrast under the killdeer. Since many tones in the scene are light, you can expect a large amount of histogram data to be clustered near the far right histogram wall. Nikon D4, 200–400mm at 360mm, ISO 1000, f/6.3, 1/200, Nikon SB-800 set to FEC −1.3.

Fortunately, the averaging histogram problem is easy to solve. Simply do not use it. If your camera permits, switch over to the red-green-blue (RGB) histogram. The RGB histogram displays separate data from each of the camera's three color channels. It provides infinitely more information, and when properly read, practically guarantees exceptional exposures. Gone are the days of waiting two weeks for the drugstore to return your slides so you can see how well (or otherwise) you exposed your outstanding images. Say goodbye to filling half your library with books on exposure technique!

THE WONDERFUL RGB HISTOGRAM

The RGB histogram shows simultaneously, but independently, a histogram for each of the red, green, and blue (RGB) color channels. Some manufacturers even add an averaging histogram into the same display. Let's revisit the rose garden picture. Get close so one of the bright red roses is large in the frame. The background is green. There's very little blue light. The averaging histogram, heavily weighting the green channel as we said, might suggest that the exposure is satisfactory, but now look at the RGB histogram. The histogram of the blue channel shows little area and low vertical development. The high and wide histogram of the green channel shows a significant amount of green light has affected the image because of the preponderance of the green background leaves. Both green and blue channels are contained within the confines of the graph area even though the green channel is higher. Trouble shows in the red channel. The vertical development of red is due to the large close-up red rose and the

red-channel's histogram is high and jammed against the right wall of the graph area, showing substantial over-exposure of the red channel. The included brightness histogram shows a decent exposure, but now you are no longer duped. You understand why the average histogram looks okay, but you have mushy red roses lacking detail. You merely reduce the exposure by tweaking your camera or tweaking your light source (or both) as needed, to bring the red channel back home to prevent it from climbing the right wall of the histogram. At last, an excellent exposure is achieved.

EXPOSURE GUIDELINES

The well-trained photographer knows that while funda-mentally the same, there are subtle differences in how best to use the histogram for RAW files and JPEG files. The basic procedure is called ETTR, or "Expose to the Right." It means that one manages camera controls and lighting such that the rightmost part of the brightest channel of the RGB histogram graph just touches the right boundary (edge, wall, etc.) of the graph space. By "just touches," we mean that the vertical development is essentially zero at the wall. The right side of the histogram represents total whiteness without detail, and climbing the wall there is nearly guaranteed to indicate overexposure in the highlights. Just reduce the exposure enough to eliminate climbing that right wall and all will be well. JPEG shooters

Dew-laden dragonflies are easy to discover in the cool dawn meadows of Michigan's Upper Peninsula. There are many dark tones in this image where digital noise can reside. By exposing to the right (ETTR), noise is reduced in the shadows. Nikon D300, 200mm micro lens, ISO 200, f/14, 1/80 on a tripod of course, Shade WB, and fill flash set to −.3 with a Nikon SB-800.

should routinely back off slightly from stringent ETTR, and shoot so that the rightmost edge of the histogram data is a half-stop or so, away from the right wall of the graph.

WHAT IS SO OUTSTANDING ABOUT ETTR?

The ETTR approach to image exposure guarantees excel-lent exposures for any image in the scope of this discussion. It solves three critical problems:

Overexposure

Consider a delicate white flower. Perhaps it has regions of pure white. It also has a few light veins approaching, but not quite white. It shows a few slightly darker veins of one color or another. A closer look reveals some even darker veins of some color. Tonality differences only give detail to the petal. Now raise the exposure a little bit. The bright-ness of the pure white areas cannot be made any whiter. But the brightness of the veins that had been approaching pure white, as exposure increases, become pure white. Some amount of exposure increase will make everything pure white and we'll have lost every bit of detail in the petal. Our formerly delicate white petal will render as just a white, detail-less blob. By using the right edge of the his-togram for the brightest channel, and by using blinkies, we can avoid any detail destroying overexposure of the image.

Closely related to the histogram and crucial to the shooter are the "highlight alerts." Frequently dubbed "blinkies," highlight alerts reveal overexposed areas of the image by an alternating blinking of white and black on the LCD image. Blinking alerts must be menu activated in many cameras, so be sure to do so. One positive feature of blinkies is that by being able to precisely pinpoint which portions of the image are overexposed, the shooter can adjust exposure or adjust lighting to the most appropriate. The trained shooter will ignore blinkies when they are in areas where overexposure is acceptable, such as the sun in the sunrise image or the specular highlights reflecting from a glistening waterfall. Reasonably, if you expose to not overexpose the sun, everything else in the image will be totally black!

ETTR maximizes detail in the image

Now you understand the reason that detail losing overex-posure should be avoided. But if not "climbing the wall" of the histogram and not allowing significant blinkies are such critical issues, why follow the ETTR technique at

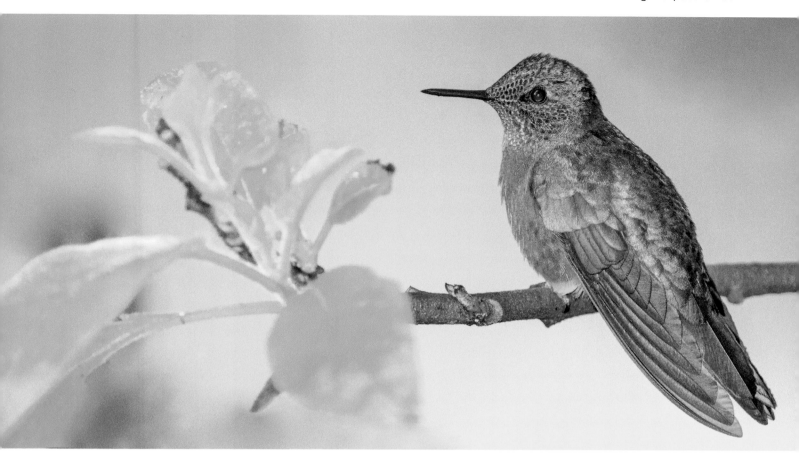

Flash is especially useful for highlighting fine details like the feathers in the chestnut-breasted coronet. Short flash durations, even when used at full power, tend to freeze camera and subject motion producing overall sharper images than can ambient light alone. Canon 1Ds Mark II, 300mm, ISO 320, f/11, 1/200, Canon 580 II Speedlite at +.7 FEC.

all? Why not just darken the exposure so that there is no chance of being anywhere *near* overexposure? Why not let the right edge of the histogram graph lie at one of the fixed vertical lines in the Canon's or the Nikon's graph display that is well-removed from the right edge of the graph? There is no danger of overexposure then. Reasonable in theory but incorrect in practice.

The histogram display on the camera covers a certain number of stops, essentially the dynamic range of the sensor. In the digital system, the right-most stop of dynamic range contains fully one-half of all data collected. The next stop to the left collects only one-fourth of the data. Then one-eighth and so on. If we try to avoid overexposure by ignoring ETTR, we would not be capturing much of the available picture data by the amount we avoid the right wall of the histogram graph. Preservation of data is proverbial motherhood and flag, especially for the RAW shooter doing a lot of editing to make fine-art prints. So use ETTR as suggested and don't exceed ETTR! Don't allow the

histogram data to "climb the right wall" of the graph space, and don't allow blinkies where data is desired.

Reducing noise

Noise in digital cameras arises from the fundamental behavior of electronic systems. It's electrical noise, undesired little blips of electrical signals present by the workings of the natural universe. Our images are built from electrical signals and these unavoidable little noises in the signals are like weeds in your garden. They cause image artifacts and errors. "Luminance noise" causes light spots in dark areas. Chrominance noise is the type of noise that appears as little colored spots: green, red, or blue usually. Both noises reduce the apparent sharpness of an image.

Noise is predominantly a disease of the dark areas of images. To minimize image noise, keep needed dark areas to a minimum for the image. The dark areas of an image

are represented by the left side of the histogram graph, so all that is needed is to expose so that the *left* edge of the histogram graph is as far *right* as practicable. Just as we avoid right-side wall-climbing, we would also like to avoid left-side wall climbing. Following ETTR will reduce image noise.

THE INVERSE SQUARE LAW

This law of physics describes how light diminishes over distance. It defines the mathematical relationship between our flash output and the light on our subject according to the distance between them. It thus helps to determine a proper exposure. A physics student might recite: *"The intensity of light from a point source falling on a subject is inversely proportional to the square of the distance from the source to the subject."* The language isn't particularly favorable for some photographers, but because the meaning is crucial, we will adapt it into 'shootin' talk.

Let's assume my flash is the light source, I am using it on manual, my subject is ten feet away and my histogram showed a perfect exposure. My next subject is 20 feet away. Twice the distance, but I want the same lighting as on the first subject. I just double the light output by raising the flash by one stop. Oops! Underexposure! I forgot about the Inverse Square Law! I doubled the flash-subject distance and the light diminished by the *square* of the distance change. Two squared = 4 ($2^2 = 4$). Inverse that figure and my 20-foot subject has only 1/4 the light of the ten-foot subject. To maintain the same exposure as in the first picture, I must increase my light by four times, not two times, so I have to raise the flash output by four times! The aperture can be opened two stops to quadruple the light or the ISO raised by two stops. Or a stop here and a stop there, using flash output control, ISO control, and/or aperture control in any combination adding to two stops.

If, instead of increasing a flash-subject distance, we lower it, the same rule applies in the opposite direction. If we cut a flash-subject distance in half and don't change anything else, we would be applying four times the light on the subject and must make a two stop change in flash output, ISO, or aperture, or some combination to maintain proper exposure.

Be alert to remember light rules in macro photography. Don't fall in the trap of thinking your flash or subject movement was only few inches, so no need to worry about it. With flash on camera, if your flash-subject distance had

been about a foot, but now you want a higher image magnification, so you move the camera to about six inches, you have cut the flash-subject distance in half. You get four times the light and need a two-stop exposure reduction. Again, the situation will suggest what combination of aperture, ISO, and flash output you should implement when using the flash on manual. Of course, when using flash for nearby subjects, it is best to use TTL automatic

While driving to the Mara Intrepids Camp late one evening, this lion was scanning the horizon looking for prey. John used a 1/2 CTO on his Canon Speedlite to expose this fine subject. Notice how the background gradually darkens according to the Inverse Square Law which explains the way light diminishes as it spreads out over distance. Canon 5D Mark III, 400mm, ISO 800, f/4, 1/200, Auto WB, +1 FEC using auto flash and Manual ambient exposure.

Auto flash is almost mandatory when the subject is only a couple of feet away. Why? The Inverse Square Law is at work again. If one tried to use Manual flash and the ideal exposure was at a flash to subject distance of eight inches, holding the flash merely three inches further away at eleven inches from this grey treefrog would cause a one stop flash underexposure. With auto flash, when the flash is held at slightly different distances, the flash emits light until it gets back to the flash exposure as set by adjusting the length of the flash duration. Canon 5D Mark III, 180mm macro, ISO 200, f16, 1/6, Flash WB.

foreground rocks you want a flash to illuminate. Your trial exposure shows the rocks are a bit too dark even with full flash output. You need to raise the exposure about a stop. You don't want to change the aperture or ISO because of their own effects, and the flash is already at full power. One answer is to take the flash off the camera and move it toward the rocks but out of the frame. How far? If we halve the flash-subject distance to ten feet, we'd add two stops of light to the rocks which is too much. Zero feet is a stop too dark. The answer is to put the flash 14 feet from the subject. Such things are easily calculated from the math, but here is a little table to copy into your field notebook.

Change in flash–subject distance	Change in light	Change in f/stops
Farther or closer by 40%	2 times	1 stop
2 x as far or 1/2 as far	4 times	2 stops
3 x as far or 1/3 as far	8 times	3 stops
4 x as far or 1/4 as far	16 times	4 stops

flash exposure. If the flash distance changes from one shot to the next, the camera automatically adjusts the flash exposure by varying the flash duration.

Let us use flash to shoot a potted flower when the plant is ten inches from the flash and the background is a bush three inches behind that. By being close to the subject, the background gets nearly as much light as the subject, and becomes an annoying distraction in the image. The quickest fix is to separate the flower and the background. Make that distance also about ten inches. With the background twice as far from the flash as is the subject, the background will receive only 1/4 the light and will be gratifyingly dark.

A single flash can produce only a certain amount of light at a given distance. As the distance increases, the light must cover a *greater area* and the *brightness* of the light diminishes. At some distance, the area lit is so great and the light so dim that regardless of aperture, ISO, or flash output, we just don't have enough light to achieve an optimum exposure. Strategies to eliminate problems will be explained.

We have discussed handling cases when flash-to-subject distances change by factors of two. We've doubled the distances and we've halved them. But what about other distance changes? It's extremely helpful for the flash shooter to have a good "gut feel" for the Inverse Square Law, so play with the arithmetic until you get a feel for it. Another example could be when you are shooting a waterfall and 20 feet from the camera are some shaded

A few feet from a window of my house is a horizontal log. The log has several holes drilled where they can't be seen by the camera in my window, but large enough to be filled with bird seed. I often see a bushy-tailed and apparently famished squirrel perched on the log, munching happily on some black oil sunflower seeds that had somehow found their way into the log with a little help from me. I'm going to use f/16 for plenty of depth of field so I can sharply render the fine hair over the squirrel's whole body. My main flash is four feet from the squirrel and well to the right side of the camera. But if only one flash were used and it's off to the right of the camera, it'll throw ugly dark shadows on the left side. To soften those shadows, we can add a fill flash on the left side of the camera. We don't want the fill flash to remove the shadows, only lighten them. The first attempt is with fill flash two stops under the main flash. The flashes have a fixed output on manual so I vary the light by moving the flashes. To reduce the fill light to two stops below the main light, the table tells me to move the fill flash so that it's twice as far as the main light, so I move it to a distance of eight feet from the squirrel to achieve the desirable light ratio. We'll look much further into multiple flashes in a later chapter.

AUXILIARY FLASH METERS

The handheld flash exposure meter provides another means of measuring the light from a flash. I've used them

in running flash tests to be used in this book. They must be set for flash use because they also serve as ambient light meters. Simple to use, place the meter at the subject location, point its white dome toward the flash, fire the flash, and read the meter. The readings are in f/stops and tenths. Therefore, an 8.7 reading, for example, means f/8 plus 0.7 f/stops. The 0.7 is two-thirds of the way from f/8 to f/11, so a camera set in its menu system to resolve 1/3 stops would be so set. If the camera were set to resolve 1/2 stops, one would in this example, round off to f/11.

Flash meters are expensive but were very helpful back in the days of guide numbers, Manual flash, and film. They are useful today in complex multi-flash systems. However, the modern camera's dedicated flash systems offer so many advanced exposure determining features that the flash exposure meter is no longer necessary for 99% of all shooters.

I annually run an exceptionally popular hummingbird photography workshop in Canada's lovely British Columbia. Hummingbird photography needs three to four flashes to obtain extremely short flash bursts simultaneously with adequate light. With several shooting stations, more than 20 flashes are in use at one time. When I need to make the main flash brighter or darker, adjust the fill or background exposure, I do it way more quickly by adjusting the flash-to-subject distance and then shooting an image to check the lighting results. Although I own two flash meters, I never actually use them. Using the Inverse Square Law to adjust Manual flashes, or TTL flash when automatic flash works best, is always more efficient. Today's shooters typically no longer need flash meters.

Flash nicely brightens the face of Barbara's Boo Bear during his puppy days. Canon EOS 7D, Shutter Priority, 70-200mm at 200mm, ISO 400, f/11, 1/160, Cloudy WB, FEC -1.3 stops.

Yellow maple leaves beautifully surround the pristine paper wasp nest. To brighten the nest and add fill light to the shadows, John held a Canon 580 EX Speedlite close to the nest while using an optical trigger to fire the tripod-mounted camera that was much further away. Why use a 500mm lens to make this image? Had John photographed the nest with a shorter focal length lens, but kept this image size, he would have been shooting upward toward the unappealing white sky! Canon EOS-1D Mark III, 500mm, ISO 400, f/9, 1/60, Cloudy WB, Canon 580 II Speedlite, FEC − .3, ST-E2 optical controller.

Combining flash
with ambient light

The key to producing images beautifully illuminated with flash is to properly blend the light from the flash with ambient light. Occasionally, though, a photographer elects one or more flash units as the sole light source, ensuring that the flashes are set to a brightness that overwhelms any effect of the ambient light.

Countless photographers are convinced that combining ambient and flash is hard to understand and manage. But, combining both is straightforward, and we'll talk about logical procedures that make it understandable. Most problematic is the tendency for beginners to shoot ambient light and flash at the same time for the initial exposure. Because they initially used flash, they are unable to discern whether some part of the image needing exposure change requires a change in ambient exposure, flash exposure or both.

THE SECRET KEY FOR MIXING AMBIENT LIGHT AND FLASH

The formula, if you will, is below but, in practice, it is less complicated than the eight steps imply. For clarity and coherence, read the following:

- Decide what effect you want the ambient light to produce.
- Set the camera to produce the correct exposure and shoot a test frame.
- Check the result for effect and exposure.
- If the result is unsatisfactory, go back to (1), otherwise proceed.
- Decide what effect you want the flash to produce.
- Set the flash to produce the correct exposure and shoot a test frame.
- Check the result for effect and exposure.
- If the result is unsatisfactory, go back to step 5, otherwise smile and move on.

Here it is in only two steps!

- First, think of the ambient exposure and make it happen.
- Then, think of the flash exposure and make that happen.

The essence of the super-secret key in one step:

- Begin by making a correct ambient exposure and next make a correct flash exposure.

The cave behind Scott Falls is a dark place indeed. Barb used her Nikon SB-800 Speedlight to reveal the color and detail at the top of the cave while shooting out to show Scott Falls and the autumn color in northern Michigan. Nikon D300, 18mm, ISO 200, f/16, 1/3, Cloudy WB, Manual ambient and flash exposure.

What does it mean to get an accurate ambient light exposure? Ask yourself several questions to fix the roles of the light sources in your mind. Some typical questions might be:

- Do I visualize the main light (the key light) as the major source of illumination with the flash acting as a fill light?
- Do I visualize it just the other way, with the flash providing the primary part of the illumination with the ambient light acting as a fill light?
- Assume the ambient is the main light, do I visualize it as frontal lighting? Sidelighting? Backlighting?
- Assume the flash is a fill light, what should be the exposure for the desired effect, relative to the main light? Two stops down? Down one stop? What direction should the light come from?

When you're comfortable that you know what you want in terms of lighting, go to the eight step list above or whichever abbreviated version works for you. Simply remember to determine the role of the ambient light first, then bring in the flash. Now you know the mysterious secret to blend ambient and flash light together.

KEY REASONS FOR USING FLASH

- Flash used as a fill light is enormously helpful in lightening offensive dark shadows created by high-contrast ambient light. By reducing the darkness of those shadows, i.e. by "opening up" the shadows, a contrasty dominated image can be reduced to produce a pleasing image.
- Flash can be used to add some backlight or sidelight to an already nicely illuminated subject. Use these techniques to add a bit of contrast as desired.
- The light from an unfiltered flash has a color temperature close to

The red sky at sunrise colors the landscape. Remembering that the bare flash produces color similar to bright sun, John used a full CTO gel on the Canon 600EX-RT Speedlite to warm the light on the highly eroded foreground rocks at White Pocket in northern Arizona. Canon 5D Mark III, 24–105mm lens at 35mm, ISO 400, f/14, 1/8, Flash WB with FEC +2.

that of sunlight. (5500 K give or take a few Kelvins). Light from the flash can help subdue an objectionable colorcast caused by the ambient light.

- An invaluable use of flash is to make a subject stand out or "pop." A technique in macro work to make the subject stand out from the background is proper use of flash. Set the ambient exposure with camera controls so the background is satisfyingly dark, but usually not black. Next, add flash to illuminate the subject properly. Be sure to practice this fantastic technique!
- The short duration of a flash burst helps to freeze subjects (hummingbirds!) and also freeze camera motion, both making it easier to shoot sharp images.
- Flash can easily be outfitted with a color filter to add color to the flash illuminated portion of an image.

EFFECTS OF CAMERA CONTROLS ON MIXED AMBIENT LIGHT AND FLASH

The ambient light and the light from the flash are added together to produce the final lighting scheme and the last exposure. Camera and flash controls affect the subject and interact in ways that you should ensure are clear. However, the behavior of the flash/camera system is dependent on whether the flash and ambient light metering system is in TTL mode or Manual mode. There are four possible combinations:

1 Automatic ambient and automatic flash
2 Manual ambient and automatic flash
3 Automatic ambient and Manual flash
4 Manual ambient and Manual flash

AUTOMATIC (TTL) AMBIENT AND TTL (THROUGH THE LENS) FLASH EXPOSURE

- A change to the ISO will not alter the outcome from either light source.
- A change in aperture will also not change the result from either light source.
- A change in the shutter speed will not change the result from either light source as long as the shutter speed is set to sync speed or slower.

The camera automatically compensates for ISO, aperture, and shutter speed changes. Ambient light exposure can be compensated with the exposure compensation control (EC) and flash is compensated with a separate flash exposure compensation control (FEC).

MANUAL AMBIENT AND AUTOMATIC FLASH

A change to the ISO, shutter speed, and aperture will affect the ambient exposure, but not the flash exposure. The TTL flash metering systems adjust the flash duration to maintain the flash exposure when the aperture or ISO is changed.

AUTOMATIC AMBIENT AND MANUAL FLASH

A change to the aperture or ISO affects the flash exposure, but not the ambient light exposure.

MANUAL AMBIENT AND MANUAL FLASH

A change to the aperture or ISO affects both the ambient and the flash exposure. A shutter speed change only affects the ambient exposure.

SHUTTER SPEED WITH FLASH IN EITHER TTL OR MANUAL MODE

A change in shutter speed will change the result from the ambient light, but will not change the result from the flash output. When using flash, our shutter speed would of necessity be at or under the camera's maximum sync speed—usually 1/200 second or 1/250 second. So a flash

a) This gorgeous flower is stuck with the unflattering name of bracted lousewort. John's image is the ambient light only version. Canon 1D Mark III, 180mm macro, ISO 100, f/10, 1/2, Cloudy WB.

b) John underexposed the ambient by one stop of light to darken the background and then used a Canon 580 II Speedlite with FEC +2/3 stop to ideally expose the blossom. Using this setting makes the flower stand out more and it is a perfect example of main flash. Canon 1D Mark III, 180mm macro, ISO 100, f/10, 1/4, Cloudy WB.

burst, which approximates 1/1000 second at full power, and is even shorter at lower powers, is nearly always shorter than the shutter speed. Accordingly, no matter what shutter speed we use at the maximum sync speed, the flash pulse comes and goes while the shutter is open.

When using Manual mode, shutter speed will affect the ambient light exposure. Shutter speed does _not_ affect the flash exposure.

Those two facts considered together give us a significant amount of creative flexibility. We can juggle shutter speed to change the relative exposures from the ambient light and from the flash light.

NOTES ON WAYS TO MIX FLASH AND AMBIENT LIGHT

Please do remember that the system controlling the flash exposure and the system controlling the ambient exposure are independent systems. Contrary to the old song on love and marriage, here you *can* have one without the other. With either, whether you use the system in a Manual mode or an automatic mode depends on the situation and on your preferences. Sometimes one combination works out to be easier than another and that that is what is next explored. Some beginning shooters lean toward automatic modes without any shooter control because of a misplaced belief that the camera is smarter than the photographer and the camera will make better pictures if left to "automatic." Remember that you heard it here: that notion is false almost all of the time.

A picture made in a properly implemented automatic mode and a picture made in a properly implemented Manual mode are identical images! They're exactly identical, exactly equivalent, exactly the same, are exact duplicates, and certainly no different!

AUTOMATIC FLASH EXPOSURE

The automatic TTL flash exposure is determined primarily by whether you are using the flash as a key (main) light or as a fill light, followed by the ISO and aperture settings of the camera. If your shutter speed is below the max sync speed (typically 1/200 or 1/250 second), then the shutter speed has no effect on the flash exposure. If your shutter speed is above the max sync speed, then depending on the camera, you either get the reduced power of its high-speed sync mode or the camera automatically reduces the shutter speed to the maximum sync speed.

User adjustment of the flash exposure is by the Flash Exposure Compensation (FEC) control, sometimes found on the flash, sometimes on the camera, and sometimes both. But if both, be sure to understand exactly how they interact. In some systems (such as Canon's), the flash control has priority. In other systems, the camera might have priority. The FEC control is represented by an icon showing a + / − sign and the lightning bolt symbol of a zig-zag arrow. Incidentally, I do much of my flash work by handholding the flash off-camera, so I prefer setting the FEC on the Canon flash. My own flashes provide an FEC range from + 3 stops to − 3 stops in 1/3-stop increments.

AUTOMATIC AMBIENT LIGHT EXPOSURE

The automatic exposure modes on many cameras are Aperture Priority, Shutter Priority, and one or more Program modes. When using any automatic mode, you lose much control over the exposure. Any changes made to the typical controls have no effect on the exposure because the camera merely changes another control to maintain what it "thinks" is a good exposure. Naive shooters, who think the camera knows better than the photographer, must remember that the camera doesn't know whether it's looking at a white polar bear or a black bear and thus can't make an accurate exposure. The photographer must know the difference, see the difference, and adjust the camera accordingly by using the Exposure Compensation (EC) control. That is a camera control generally depicted by a + / − symbol, but without the lightning bolt symbol. EC controls, depending on the camera, generally allow either + / − 2 stops of compensation or + / − 3 stops. So, the astute shooter using an automatic exposure mode will dial in about + 1 or + 2 stops for the polar bear, and dial in − 1 or − 2 stops or so for the black bear. Having made a change in EC, how does the camera respond?

- If in Aperture Priority, the camera will change shutter speed and perhaps ISO to provide the compensated exposure.
- If in Shutter Priority, the camera will change aperture and perhaps ISO to provide the compensated exposure.
- If in Program mode or one of its offspring, such as "Scenic," "Macro," "Flowers," or "Sports," the camera's response to a change in any exposure parameter is often unfathomable by the average photographer. A response is determined by the manufacturer's internal programming, but will always maintain the exposure the camera thinks is correct. The camera still has no knowledge of whether the subject is an albino deer in a light fog or a dark moose in a darker forest, so only an EC adjustment by an alert shooter will save the exposure.

MANUAL FLASH EXPOSURE

In Manual flash exposure, the output of the flash within its limits is totally determined by the user. The flash does not vary its light output according to the camera's exposure demands, but puts out either full power or some fraction from that point forward according to what was dialed in by the user. By "dialing in" full power, the user guarantees that the flash is supplying all the light it can, which is particularly useful in outdoor flash work because the subject is often far away. Full flash power is often desirable to produce a proper balance between the flash and the high level of outdoor ambient light.

Manual exposure is equally useful when shooting fast action because short flash durations are needed. At our popular annual hummingbird workshops, at each shooting station the three or four flashes are set to run at a fraction of full power (1/16 to 1/32 and sometimes 1/64) to obtain the very short burst durations needed to freeze the high-speed hummingbird wings. These short duration flashes have low light output, and that is the reason why several flash units are used to illuminate one hummingbird.

We manipulate camera controls to affect exposure. In the Manual flash mode, changes in aperture and ISO indeed affect exposure. Shutter speed, remember once again,

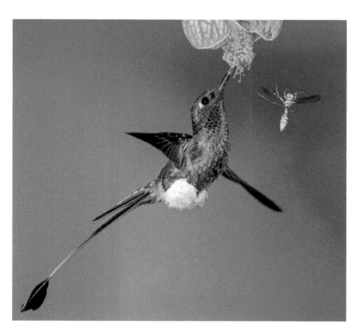

a) Everyone loves the white "booties" on this booted racket-tail hummingbird at Tandayapa Lodge in Ecuador. Nikon D3, Nikon 200–400mm at 290, ISO 200, f/20, 1/250, Flash WB, no ambient and Manual flash exposure to make sure the power ratio is identical on all four Nikon SB-800 Speedlights.

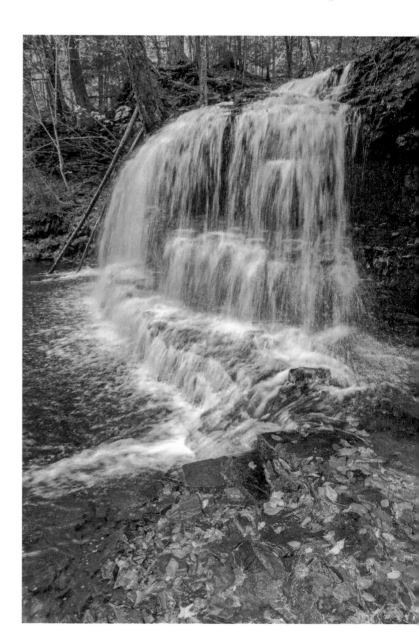

b) Rock River Falls dark foreground required two full-powered blasts of light from John's two Canon 600EX-RT Speedlites. To ensure the flash put out everything it could, he set the flash to full power and Manual exposure. Canon 5D Mark III, 24mm, ISO 400, f/8, 1/20, Cloudy WB, 1/4 CTO gels on the flash heads.

does not affect exposure regardless of its setting below the max sync speed. However, it will cause the flash to be at reduced power if in a high-speed sync (FP) mode.

The light output of a flash unit in Manual mode is typically adjustable in several steps, each step representing about one stop of light. Common fractional settings, called "power ratios" are 1, 1/2, 1/4, 1/8, 1/16, 1/32, 1/64, and 1/128. Regarding hummingbird photography, we might select a power of 1/32, thus giving a light pulse duration of an extremely short 1/20,000 second to freeze the wings, but an exposure that is five stops less than full power.

An important benefit of Manual flash is that no preflashes are emitted. An essential part of the TTL systems, preflashes can become a nuisance when using optical slaves on remote flashes. The preflash can make the remote flash fire before the camera shutter opens. When you set up an optical system, and the remotes fire okay, but the image is black, look to preflashes as the culprit. Any time the image is black, change the flashes to Manual mode to eliminate the preflash.

Besides adjusting the power ratio of a flash unit, one can also employ camera controls to manipulate the exposure. Aperture and ISO are both effective, but shutter speed changes, below the max sync speed, will not change exposure. Another exposure control for Manual flash is one most photographers never think of, but it is often the first one I go to. If the flash head is zoomed to 105mm and there is too much light on the subject, zooming the flash head to 24mm will reduce the flash exposure considerably, perhaps by as much as two stops. Hold on, let me check this and run a test with my flash meter right now. The Manual flash exposure dropped by 1.5 stops when the Canon 600 EX-RT flash zoom position changed from 200mm to 20mm because the light is spread out over a much larger area at the 20mm zoom position.

The bright sun created some dark shadows under this yellow pine chipmunk. John set his fill flash to only −2/3 stop to open up those shadows significantly. Canon 7D Mark II, Canon 200–400 at 350mm, ISO 400, f/10, 1/250, FEC −.7, Sun WB.

REVIEW

AUTOMATIC FLASH EXPOSURE AND AUTOMATIC AMBIENT EXPOSURE

Next, look at examples of the ways different combinations of flash and ambient light might be used to obtain impressive shots.

On one of our Kenya photo safaris in Masai Mara National Reserve, a cheetah was ambling through the grass in search of a gazelle for dinner. The cheetah wasn't looking for companionship, but I digress. As the cheetah made its way through vegetation thick and thin, the ambient light falling on the cheetah was rapidly changing, thus suggesting an automatic exposure mode. At any second the cheetah was likely to burst into a high-speed run, so I selected Shutter Priority at 1/2000 second. Noting that the cheetah had relatively light fur, and was filling much of my viewfinder, I entered + 1/3 stop of exposure compensation via the EC dial. Meanwhile, the bright midday African sun was producing harsh and unattractive shadows on the cheetah, so I wanted to use fill flash to moderate hot spots. I didn't want the fill flash to overpower the ambient light and cause a peculiar lighting, so I set the flash exposure control (FEC) to − 1.3 stops.

Both my camera and my flash were operating in an automatic mode. But I knew that to obtain good results, I must override the camera's exposure decisions, even when the subject tonalities weren't as extreme as either a white stork or black Cape buffalo.

AUTO FLASH EXPOSURE AND MANUAL AMBIENT EXPOSURE

Auto flash and Manual exposure are extremely useful for many close-up and macro images, and Barbara and I both use the combination often. This mixture solves a common problem that warrants everyone's attention.

Consider this:

Your tripod-mounted camera is in an automatic exposure mode as you study a splendid butterfly perched on a pristine flower. The incoming light is metered and the camera determines the exposure. Satisfied with your composition, you back away from the tripod to make sure your body doesn't wiggle the camera during the exposure. While your eye blocked the viewfinder, your backing away now allows ambient light to enter the viewfinder. The additional light added to the ambient light entering the lens

and the camera responds to increased light by reducing the exposure. You are perplexed by the butterfly being so dreadfully underexposed.

By using Manual exposure, you meter the butterfly while your eye is still blocking the viewfinder. When you remove your eye and allow the stray light to enter the viewfinder, the camera does not, and will not, change the exposure because Manual exposure prevents any of those changes from happening.

For those obsessed with automatic exposure, some cameras have a mechanism to be able to block light from entering the viewfinder. Some companies provide a little plastic shield, or blind, about half the size of a postage stamp, which you insert to block light from entering the viewfinder. Me? I'd be buying them by the millions and causing severe ecosystem damage by dotting the landscape with irretrievably lost viewfinder blinds. More refined cameras have a built-in shutter with a tiny actuating lever. It won't get lost and it blocks light from entering the viewfinder but only when you remember to use it.

Manual flash is another matter. The often-encountered small distances between flash and subject make the flash position critical. If, for example, your exposure is correct with an eight-inch flash-to-subject distance, then moving the flash only about two and a half inches closer or further will upset the exposure a full stop. Auto flash setting shines here, so to speak. Once you've set the TTL flash to the correct exposure, perhaps using FEC, then you can move the flash back and forth considerably without upsetting your exposure. The flash monitors the exposure and adjusts the flash duration accordingly to compensate for reasonable changes in the flash-to-subject distance.

MANUAL FLASH AND AUTOMATIC AMBIENT LIGHT EXPOSURE

We don't use this combo very often, but we occasionally find it helpful to light up foreground areas or objects in a broad landscape. One die-hard student insists that the only valid time to use an automatic exposure mode is when the light is changing so fast that he can't keep up with it. In this circumstance, he's right on because often the sun and cloud interaction is so fast and so frequent that the ambient light changes between light and dark very abruptly and very often. Aperture Priority is, as a rule, better only because it maintains a fixed depth of field, and shutter speed is not often a factor in landscape photography.

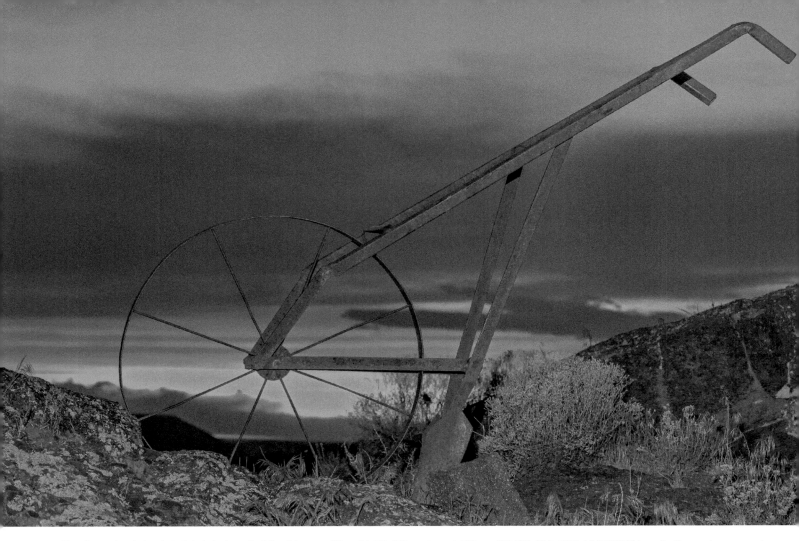

The vintage hand plow is isolated nicely against the rising sun. Nikon D4, 70–200mm lens at 102mm, ISO 200, f/11, 1/20, 10,000K WB to make the sunrise more red. SB-800 Speedlight set to Manual exposure.

Another useful application is for sunrise and sunset shots. Using flash to accentuate foreground detail is often an excellent idea, but the sunlight's intensity can change very quickly, again justifying the use of the Aperture Priority automatic exposure mode.

MANUAL FLASH AND MANUAL AMBIENT LIGHT EXPOSURE

Manual flash is a particularly useful mode when using flash to shoot landscape images under steady ambient light or for photographing any subject that is in much dimmer light than its background. Barb and I live in Idaho and enjoy riding our horses (Even photographers need occasional relaxation!). When riding in early July, we often hear baby woodpeckers clamoring to be fed. Barb's superior hearing picks them up first, and we ride towards the nest until we find it. We like to photograph the bleating open-mouthed chicks, but the low-to-ground

nests are in dense shade compared to the sunlit blue sky background.

We set the camera's controls to the Manual exposure mode and dial in an appropriate aperture, ISO, and shutter speed to correctly expose the brighter background. We confirm the ambient exposure using histogram and highlight alerts. We do that first. Next, we set the flash to Manual mode and by experience and gut feel, select a power ratio. We inspect the JPEG image on the camera LCD and, if a large change is needed, we select a different power ratio. If only a slight change is needed, we can just move the flash back and forth, changing the flash-subject distance until we are satisfied with the flash exposure. Changing the flash zoom position is another way to make a modest exposure change.

Several different methods to combine ambient light and flash light to make superior images have been presented. You must know by now that in photography,

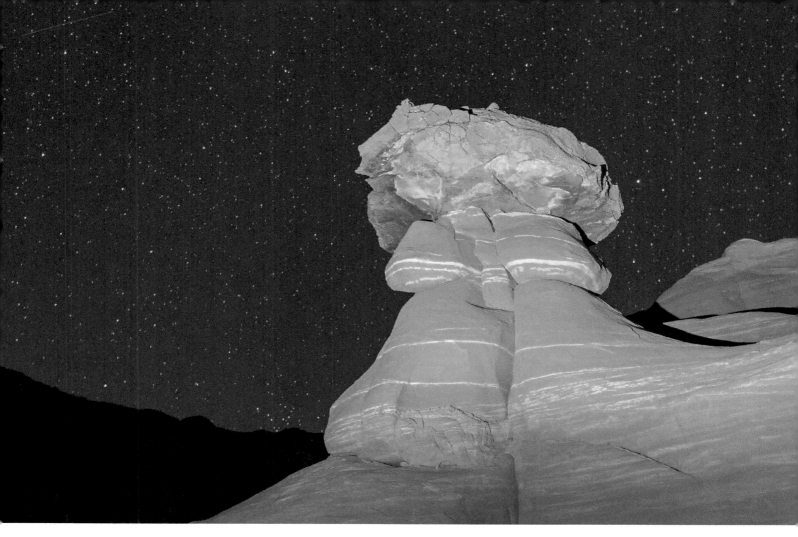

Hoodoos are fun to photograph against the stars. This attractive specimen is found next to the Toadstool Hoodoo east of Kanab, Utah. Canon 5D Mark III, 16–35 f/2.8 lens at 29mm, ISO 3200, f/3.2, 20 seconds, 3000K WB, Manual ambient exposure and auto flash using one Canon 600EX-RT Speedlite with a 1/2 CTO gel.

there's a million things to remember. Permit me add three more:

1 Don't fall into the trap of becoming familiar with just one combination, and in your new found comfort, forget the others.
2 Do embrace them all and practice them all, knowing that each has one or more applications in which it alone shines!
3 Continue to explore new ways to combine flash and ambient light. The possibilities are endless.

Flash techniques continually evolve. Even as I work on the final edit of this chapter, I realize there is still more to add to this as new experiences force me to try new methods. I was recently photographing geysers in Yellowstone National Park at sunset, and two hours later the sky was full of twinkling stars. Using four Canon 600EX-RT Speedlites simultaneously, I determined the flash exposure for the foreground before the sunset turned crimson. Setting up the flashes on light stands is much easier to accomplish when it is still daylight, and I needed some-

thing to do while I was waiting for the sunset. When the ambient light dimmed at sunset, I used automatic flash to light the foreground and manually adjusted the ambient exposure to make a pleasing red background and correctly expose the stars two hours later. Notice, in this case where the ambient light will gradually make large changes in brightness, it makes far more sense to set the flash exposure first and then adjust the ambient light second. While I typically set the ambient first, there are times when doing it the other way is more sensible. The one concept that doesn't change is to set the flash and the ambient exposure independently, so you know exactly what each is contributing to the image.

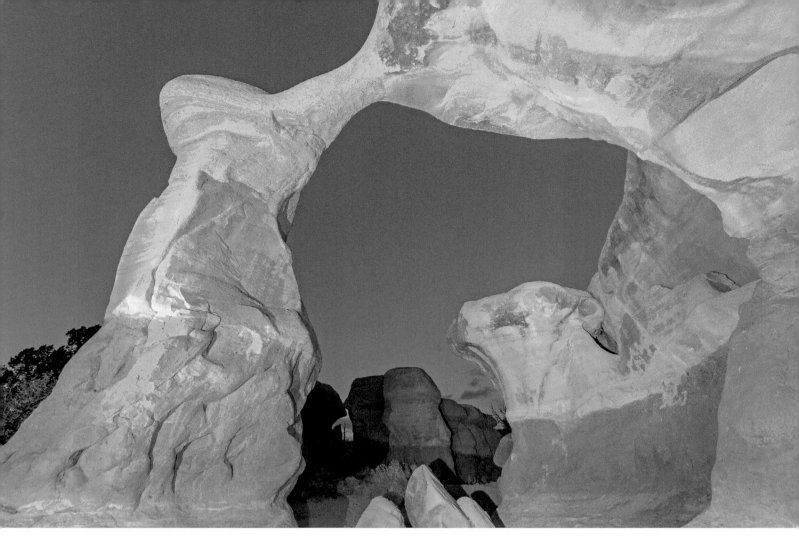

Anyone looking for really weird rock formations and opportunities for combining flash with the night sky should make a visit to Devil's Garden (near Escalante, Utah) a top priority! John composed and focused Metate Arch and then waited for the sky to darken in the evening. He used four Canon 600EX-RT Speedlites and set the flash exposure for the arch first, since that would not change. This is an exception to the guideline of determining the ambient light first, and then the flash. In this case, the ambient light changes considerably as dusk approaches, so it makes sense to set the flash exposure first, and then adjust for the changing ambient. Canon 5D Mark III, 16–35mm f/2.8 at 16mm, ISO 640, f/9, 1/60, Manual ambient and flash exposure.

Balanced flash is enormously useful. Here ambient light illuminates the background while a Nikon SB-800 Speedlight optimally lights the white pine tree in the foreground. Nikon D300, ISO 200, 18mm, f/16, 1/5, Cloudy WB, SU-800 to trigger the Speedlight.

The crucial role of light

6

Many photography writers introduce light by discussing the roots of the word "photography" and discuss light as a critical component. Instead, I am telling you a truism forcefully taught to me in a 1975 workshop by the late acclaimed Michigan nature photography pioneer Larry West, who was one of the first to earn a living at it by shooting incredible images. Paraphrasing Larry, and expressing his axiomatic truism as an equation:

(X) Light = (X) Pictures

where X is any *uncomplimentary* adjective you can imagine, the harsher the better!

Larry was categorically correct in pointing out that terrible light produces terrible pictures, and his light-mantra is every bit as valid today as it was those 40 years ago. Since first hearing his mantra, I've sought to use the most attractive light I can find, modify or create. Electronic flash became important early in my career but it's so much more important now.

Because countless beginning photographers are obsessed with the quantity of light available, they do not remember to consider the importance of light quality and direction, two other major characteristics of light. Being able to produce appreciably better images at higher ISOs in lower light results in not being as dependent on ambient light. Experienced photographers know that attractive light is a good combination of all three factors. Oh, indeed, Larry's equation is entirely valid with whatever *complimentary* adjectives you can think of as well.

CHARACTERISTICS OF LIGHT

QUANTITY OF LIGHT

One question of light quantity is whether you are able to enjoy high enough shutter speeds to shoot handheld, and not be required to use your tripod. Yes, today's higher ISOs might so allow, but please remember that camera motion is not the only reason to use a tripod. The most

Barbara is an avid gardener while John is a huge fan of wildflowers because they take care of themselves. Barb first set the ambient backlight exposure from the sun, and secondly used her Nikon SB-800 Speedlight to illuminate the dark side of this hollyhock facing the camera. We call this cross-lighting, when two light sources coming from opposite directions are used. Nikon D4, 200mm micro lens, ISO 100, f/13, 1/160, Cloudy WB, Nikon SB-800 Speedlite with FEC +.7

ignored reason, but an excellent reason, is the improvement in composition achieved by not hand holding. When the camera is mounted on a tripod, there is ample time to study the composition. Also remember that shooting at high ISOs is not without its trade-offs in image noise.

Remember the classic "Sunny Sixteen Rule"? The rule tells us that on a bright sunny day, we can get a proper exposure at ISO 125, f/16, and 1/125 second. Whereas, on a moonless night, it might take f/2.0 for 20 seconds or more to record landscape detail. It amounts to an enormous difference of around 17 stops of light that a shooter might encounter!

Fortunately, the flash offers the convenience of being always at hand. You can easily control the quantity of light, either by TTL electronics magic or by manual control. The flash emits light of a color like mid-day sunshine,

and the short duration of a flash burst helps arrest subject movement and camera movement. The full power of a flash though, is limited. You cannot properly light objects too far away or any object too large. The pervasive Inverse Square Law causes a swift spreading out of the light and rapid reduction in the intensity of the light.

DIRECTION OF LIGHT

Frontlight

Light that approaches the subject along, or close to, an imaginary line from camera to the subject is called "frontlight." Frontlight produces few shadows on the subject and thus is known as "flat lighting." Also, shadows not on the subject, but of the subject, mostly fall behind the

a) The midday sunshine brings out the natural colors in this penstemon, but the inner parts of the flower are too dark. Canon 5D Mark III, 180mm macro, ISO 400, f/18, 1/20, Daylight WB.

b) Since unfiltered flash is the color of midday sun, using it here blends nicely with the colors produced from the ambient light and opens up the shadows to reveal more color and detail. Canon 600EX-RT is pointed nearly directly at the flower and +.7 FEC is set to light the inside of the blossoms.

subject and are invisible to the camera. Without much in the way of shadows, frontlighting produces low-contrast images. An on-camera or in-camera flash creates this flat lighting, generally unpleasant because any texture and/or depth created by shadows has been lost. When used for wildlife or people, on camera flash produces the dreaded "red-eye" or "steel-eye" effect. Off-camera flash reduces these negative factors.

I seldom use frontal flash as a main light due to the loss of shadows. Shadows are needed to reveal the shape and texture of a subject, but when they are excessive, proper use of a fill flash will moderate shadows. Shadows produced by bright ambient light (think "sun") can be dark and unpleasant, and the on-camera flash effectively weakens them by adding light to the shadows. In some cases, it may make perfect sense to use on-camera flash.

Sidelight

Sidelight strikes the subject from either side, of course, but also from above or below. Sidelight is especially effective to enhance texture in tree bark, animal tracks in the

a) John's cooperative western white butterfly spent the night sleeping on this leaf. John underexposed the ambient light by a little more than a stop and then front-lit the butterfly with a Canon 600EX-RT Speedlite set to +.7 FEC. The color patterns in the wings are nicely revealed, but the flat front light doesn't reveal texture. Do the butterfly wings have texture? Canon 5D Mark III, 180mm macro, ISO 100, f/18, 1/1.7, Cloudy WB.

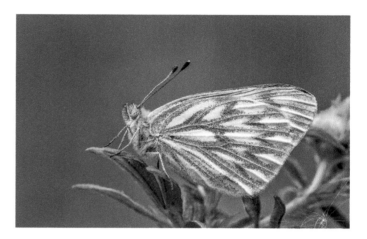

b) Hand-holding the Canon 600EX-RT Speedlite above the butterfly so that the light will skim across the wings at a right angle creates the small shadows that clearly reveal the texture.

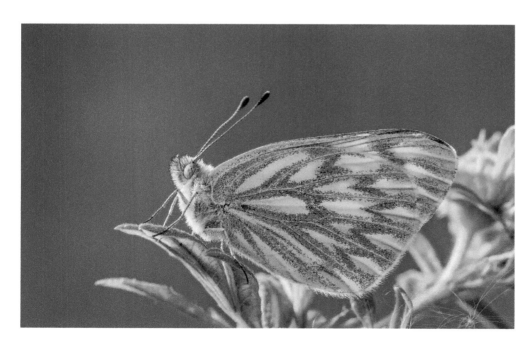

Let's now backlight the western white butterfly. Take note of the way the backlight from the flash beautifully rims the butterfly with light and bleeds through the thin parts of the wings. For close-up images, we combine flash with ambient light to sidelight or backlight the subject.

snow, butterfly wings, and the hair and feathers of wild-life. Portrait photographers might use it to enhance the ruddy skin texture of an outdoorsman. Here's a great tip on how sidelighting can enhance your images:

Underexpose the ambient light between 1/3 stop and one stop. Use the flash to skim its light along the surface of the subject, either from a side or from above or below while adjusting flash power for optimal exposure.

Backlight

The direction of this light is evident from its name. Backlight used well produces delightful images. Unfortunately, even experienced photographers often underuse backlight. Backlight is particularly useful with translucent subjects as it emphasizes detail within the subject. The effect is certainly attractive with subjects that are hairy (sure leaves me out!) or fuzzy because the backlight produces a soft glowing rim around the subject's outline. Portrait pros routinely use a hair light to rim the subject's head with pleasing highlights.

Most shooters know that bright overcast ambient light is outstanding for close-up photography because of its low-contrast. Colors and details of the subject are not lost in deep shadows. Shadowless light does not reveal shape well. Here's an opportunity to help separate the subject from its background and provide a little contrast and, conceivably, texture. Shoot images where the ambient light is underexposed by 1/3 or 2/3 stops. Then use flash as a backlight to produce attractive rim lighting and optimally expose the subject.

Diffuse light

Ambient light under heavy cloud cover is highly diffused and low in contrast. Light modifying translucent diffusers, readily available and often used for smaller subjects, also produce lowered contrast. The light from a flash can be of much higher contrast because of the relatively small size of the light source. Combining those facts allows an astute shooter to easily control subject contrast by a judicial mixing of ambient light and flash.

COLOR OF LIGHT

Light forms a small portion of the electromagnetic spectrum, the domain of electrical waves that include AM and FM radio, TV, microwaves, visible light, x-rays and more. Inspection reveals that the portion of the spectrum

we call "light" begins with invisible infra-red light and progresses successively through the visible colors of Red, Orange, Yellow, Green, Blue, Indigo and Violet, then ends in the invisible ultra-violet light. Students of physics have long used the mnemonic "ROY G BIV" to remember the color sequence of visible light. A proper mix of all of those colors is what we call "white light."

Those same students would say that the "color" can be defined by its "color temperature" on the Kelvin temperature scale. For example, mid-day sunlight is often stated

This silver-bordered fritillary butterfly quietly rests on this blossom during a cool afternoon in the shade. Ambient light has a blueish colorcast in the shade. Since unfiltered flash is similar to bright sun, using flash as the main or dominate light tends to minimize the blue colorcast and enhance the browns, pinks, and oranges in the subject. Nikon D4, 200mm micro, ISO 200, f/13, 1/15, Cloudy WB, Nikon SB-800 Speedlight set to FEC +.7

as having a color temperature of about 5500K. Typical flash units have a color temperature slightly bluer, perhaps about 6000K. Some flash units are equipped with a pale yellow filter to modify the slightly blue light to near sunlight. The color of a flash burst can be significant when mixing ambient light and flash, as the flash can be used to subdue colorcasts of the ambient light.

When shooting in a thick forest, the light has a pronounced green colorcast because the green leaves reflect a high percentage of the green component of the ambient light. Adding light from a flash, either as a main light or a fill light, tends to reduce the green colorcast and provide a more agreeable color. Likewise, shooting under an overcast sky or in the shade on a sunny day are both cases where a blue colorcast prevails. The relatively warmer light from the flash moderates the blue cast. The RAW file shooter can of course easily tweak colorcasts on the computer, but the use of the flash allows pre-edit control of specific subject areas.

Alternatively, the light from a flash burst can be helpful in generating a colorcast. Consider a flashed shot of your friend during a sunset. The world is red, but your friend is unnaturally neutral in color. In this case, consider equalizing the colors by placing an orange filter over your flash head. Flash filters are available in different colors, and, not needing to be optically pure, they're inexpensive. Depending on the host flash, you can insert them into a built-in filter holder or attached with a Velcro strap. I routinely use the CTO filters in the Honl Warming Filter Kit. "CTO" is an abbreviation for "Color Temperature Orange."

CONTRAST

The term "contrast" is used by photographers to describe differences in tonalities and differences in color. "Contrast" refers to either a subject's tonalities or to an image's tonalities. Contemplate a bald eagle perched on a rock against a medium-toned mountain background. The tonality difference between its white head and black body gives us a high-contrast image. Simultaneously, the contrast between the eagle and the medium-toned background is low.

For subject material, the contrast becomes an essential part of the shooter's thinking. Suppose a relatively bright hayfield should be exposed at about f/22, but the dark moose wandering therein needs f/2.8. That six-stop difference, the contrast, is also called the dynamic range of the subject. The camera sensor also has a maximum dynamic range that it can accommodate. If the subject's dynamic

(left) a) Raccoon tracks in the mud under the low-contrast light of a shading maple tree form a pleasing design, but lack depth and texture due to the diffused ambient light and no flash. Canon 5D Mark III, 180mm macro, ISO 160, f/16, one second, Shade WB.

(right) b) A Canon 600EX-RT Speedlite with a 1/2 CTO Honl filter on the flash head held close to the ground to skim the light across the tracks creating texture revealing shadows. John changed the shutter speed to 1/4 second to underexpose the ambient by two stops and used FEC +.7 to optimally expose the damp sand. Closely compare the differences in the two images.

range exceeds that of the sensor, the sensor can't handle the contrast. Either the dark areas are underexposed, lack detail and are noisy, or the bright areas are overexposed and lack detail. Occasionally one may encounter an extreme case.

Assume a camera sensor has a dynamic range of nine stops. An outdoor scene in bright sunlight might have a contrast of 12 stops. The image could show both overexposure and underexposure, suggesting that the photographer come back tomorrow when the light could be better. In any event, always follow the ETTR technique to avoid overexposure at all costs, and take what underexposure we must as required.

Contrast is essential. No contrast means no image. If everything in the image were the same tonality or the same color, there would be no image. The contrast between subject parts and its shadows revealing both the shape and the texture suggest depth. Subjectively, excessive contrast is both harsh and unpleasant and should be suppressed to at least the desired degree. A conventional means of controlling offensive shadows is fill flash, either on-camera or close to the camera. Using fill flash is simple and uncomplicated. First expose the subject correctly for the ambient light using ETTR, and then add the amount of flash required to reduce shadows as desired. That's important! Fill flash augments but doesn't replace the ambient light. You should have a properly exposed picture without the flash. Then, ensure the flash does not overpower the ambient light and produce unnatural lighting. Most shooters will dial in about − 1 or − 1.3 stops of FEC as a starting point. Inspection of the image on the LCD monitor shows whether the flash contribution should or should not be changed to produce the most desired effect.

DETRIMENTAL CONTRAST

We have already discussed detrimental and damaging contrast several times, but to summarize, remember that both the sun and a flash unit are called "point sources" of light, the sun because of its distance and the flash because of its size. Point sources produce harsh deep shadows that are unattractive. Remember earlier when we said in effect that bad light equals bad pictures? Too many beginning flash users promptly abandon flash when seeing their first flash images. Hopefully, between reading this book and a little practice, beginners will quickly be on the path to splendid flash images.

BENEFICIAL CONTRAST

On the other side of the coin, some forms of ambient light are so diffuse that shadow production hovers near zero.

a) Bright overcast light is wonderful close-up light for most subjects including flowers such as this dahlia due to the lack of contrast. Canon 5D Mark III, 180mm macro, ISO 100, f/16, 1/3, Shade WB.

b) At least some contrast is highly beneficial to enhance the texture and shape of the subject. A Canon 600EX-RT Speedlite nicely backlights the dahlia revealing the translucent petals. Using flash to backlight or sidelight the subject is effective in nearly all instances or cases.

One example is when shooting under a heavy overcast sky or when shooting in the shade. Such lighting would produce flat looking images with minimum suggestion of depth. Using flash is quite effective in adding a little much needed contrast to the image. An excellent technique in these conditions is similar to what we discussed in side-lighting:

Underexpose the ambient light by 1/3 stop or so, and use flash from a side, top, bottom or behind the subject to add some contrast and better reveal the shape and texture of the subject.

LIGHT IS THE KEY

Always evaluate how the color, contrast, and direction of light impacts the image. Using gorgeous ambient light or modifying the ambient light with flash is crucial to shooting stunning images. Photographing with ugly light produces dreadful images—simple as that!

Lewis's woodpeckers are tremendously fun, but challenging, to photograph at the nest. John perched on two sections of construction scaffolding sixteen feet above the ground. Trusting birds, these woodpeckers paid no attention to him or any of his equipment including the flash. Due to the distance from the nest, John used a 500mm lens and a single flash fitted with a Betterbeamer to increase the reach of the flash to illuminate the woodpecker. Canon 7D, 500mm, ISO 200, f/16, 1/200, Flash WB, Canon 580 II Speedlite and ST-E2 optical controller.

Fill flash techniques

Flash is an extremely useful, if not essential, tool for taming dark shadows that ambient light often creates. Shadow moderation refers to "opening up" or "filling in" the shadows, or sometimes merely "reducing the contrast." Bright sunshine that is not directly behind or in front of the subject will create dark shadows on the side opposite the sun. Those dark shadows often appear when photographing a person or an animal in the sunshine. Consider a cowboy with his wide-brimmed hat—or even Indiana Jones. The brim of the hat causes deep facial shadows. The contrast between the shadowed side of the face and the lit side of the face can often approach six stops! Six stops is an enormous range in the brightness of the light that produces unsightly shadows in the portrait. Even without his hat, the cowboy can have a profound shadow under his nose, and his chin casts a dark shadow on his neck. Luckily, digital cameras do an outstanding job of handling that much contrast, especially with carefully processed RAW files and photo-editing software such as Photoshop or Canon Digital Photo Professional 4, which is usually able to rescue dubious images. It is almost universally recognized that the wise shooter does the best job possible in the camera, leaving minimum defects for corrective editing. Getting it right in the camera makes for less post-processing work, and produces better pictures. Visible noise is reduced when more light is sent to the camera sensor, filling in more shadows which results in improved signal-to-noise ratio.

When using fill flash, remember that the light from the flash is secondary. The primary light is the sunshine, whether harsh, diffused, shaded, or whatever other light might be present. The general rule is that the primary light is wholly responsible for producing a correctly exposed image. The fill flash only moderates the shadows caused by the major light.

Digger bees frequently sleep under flower blossoms. On a cool morning, they are immobile while awaiting the warming sunshine. Barb used fill flash at −1.3 FEC to add light to the shadows and make the bee more apparent. Nikon D3, 200mm macro, ISO 200, f/22, 1/3, Cloudy, fill flash with Nikon SB-800.

FILL FLASH PROCEDURE

SET THE AMBIENT LIGHT EXPOSURE FIRST

Indeed, I am undoubtedly badgering, but as I've repeated many times and always feel the need to emphasize, the first rule of mixing ambient light and flash is to temporarily ignore the flash. Determine exactly what you want the ambient light to do and expose accordingly. Use ETTR for your RAW files or a slightly less aggressive ETTR for your JPEGs. Check to ensure that there are no highlight alerts active in image areas where you expect to record detail.

A few readers may think I am beating a proverbial dead horse, but you have to buy into this. Far too many beginning students in our field workshops, and even some significantly more advanced, are prone to using both light sources for their initial shot. When getting an imperfect result, they are unable to determine whether to adjust ambient exposure or flash exposure.

Set the flash exposure compensation (FEC).

With a satisfactory ambient light exposure now established, now bring in the flash fill. The flash will serve to fill in the often-harsh shadows of the ambient light. Always remember that, when fill flash is used, be careful that the main light (ambient in this case) remains the main light. That is, do not let the fill flash overpower the ambient light (We will discuss letting the flash be the main light in the next chapter). Experienced shooters start with an FEC = − 1.3 stops and evaluate the image on the camera's LCD to determine whether more or less fill is necessary. If needed, then by trial and error, they find the best amount of fill flash to use.

It is worthwhile to think about the background as well. Some of the most sophisticated flash systems today are electrically cognizant of the shooting distance to reduce the influence of a background, but it can still be a problem. When metering a medium-toned blossom to use needed flash, be aware that a dark-toned or light-toned background can be an unwanted factor in determining the light output from the flash. The dark-toned background might cause the flash to overexpose the subject, while the light-toned background does the opposite. Also, sometimes, the subject is so small in the frame that it reflects little light and the bulk of the reflected light comes from the background. Consider a delicate spider web, glistening with early morning dewdrops where you are holding the flash to the side to emphasize the dew. The dewdrops and strands of the web are too small to reflect much light, so

a) Dark shadows conceal much of the color and detail in the captive bobcat at the www.minnesotawildlifeconnection.com. Canon 5D Mark III, 200–400mm at 310mm, ISO 400, f/13, 1/200, Daylight WB.

b) A Canon 600EX-RT Speedlite nicely lightens the shadows. Canon 5D Mark III, 70–200mm at 170mm, ISO 400, f/11, 1/200, Daylight WB, Canon 600EX-RT Speedlite on-camera using −.3 FEC.

most of the reflected light comes from the distant background, causing significant overexposure.

Any time the background is overly dark or light, that's what determines the flash exposure. On these occasions

you cannot rely on the TTL system, and the shooter must take over. Use flash in Manual mode, dial in a test power (say 1/4 of full power) and, if needed, adjust that power for satisfactory augmentation of the ambient light.

POSITIONING THE FLASH

Because fill flash is being used to add light to the darker shadows, the flash may be mounted either on the hot shoe or a pop-up flash may be used. It pays to not get too creative with the flash position. One student stated it well by saying "Good results are guaranteed if you make no new inventions!" The flash must add light to the deeper shadows of the image. If those shadows are on the left side of the subject, then the flash should be near to the camera and on its left side, and conversely.

REVIEW THE RESULTS ON THE LCD MONITOR

Short of tethering your camera to a nearby computer, the LCD on the rear of the camera is the way to review your image. In particular, study the shadows, because they are the most amenable to manipulation by flash. Do the shadows show pleasing detail? Are they too bright, reducing the appearance of depth or shape or texture? Pay particular attention to your highlight alerts—the blinkies that reveal in a flash (joke intended)—whether some area needing detail has been overexposed. If the shadows need more or less light, adjust the FEC as required. Keep the numbers straight, especially their signs. It can befuddle the careless, but simply remember examples, such as an FEC change from − 1.3 to − 0.7 adds a 2/3 stop of light, and an FEC change from + 0.3 to − 0.3 subtracts 2/3 stop of light.

OPTIONS FOR FILL FLASH

THE POP-UP FLASH

Many cameras provide a built-in flash on top of the camera. The flash pops up at the push of a button, and some cameras automatically sense that a flash might be needed. Irrespective of how activated, these often convenient light devices suffer from the flash frailty of little power. Still, the pop-up flash can be helpful. On the plus side, pop-ups can be used for fill flash work when the subject is quite close to the camera, or when only a small amount of light is needed. More useful is the pop-ups ability to function as a commander when using one or more optical remote flashes. In this case, the pop-up can be programmed to

Many cameras that have a pop-up flash built-in allow the user to make the pop-up flash either an optical commander or a master that will control remote flashes out in front of it. If your camera offers this, using the pop-up flash as the commander is an excellent way to get started in wireless flash photography.

itself add a little light to the subject as well as triggering the remotes, or can be programmed to output such little light that the remotes are properly signaled while the subject exposure is unaffected. As not all pop-up flashes can be programmed to be a commander, check the camera manual carefully to discover whether your camera offers it. Most recent camera models offer this important option.

On the minus side of the pop-up coin, the very position of the pop-up can sometimes be troublesome. Being so close to the camera–subject line, the light from a pop-up flash is often the culprit in producing the dreaded red-eye effect. The afflicted photographer now has another pain in the neck, either when shooting, or later when editing. Additionally, an on-camera flash can be objectionable to some, so don't torment them with on-camera flash!

Another minus is that the pop-up can be troublesome for close-up and macro shooting. When using a physically long length lens—often the choice of many macro mavens favoring the narrow field of view of long focal length lenses—the lens itself or the hood can shadow the subject from the pop-up's light and render the flash useless. The

brim of the wide-brimmed hats favored by many outdoor shooters can inadvertently push the pop-up down at precisely the wrong time or shield the light emitted by the flash. So why wear a hat? There are several reasons. A hat keeps your neck from getting sunburned. In my case, the hat shields the top of my head too. A hat prevents rain from running down your neck and provides a manually operated sun-shield when shooting so close to the sun that auxiliary shielding is needed to reduce flare and maintain image contrast. A hat can shield the lens when gusty winds or stampeding giraffes are raising a lot of blowing dust. It can also protect your delicate lens coatings from the always acidic aerial avian residue when shooting a dawn blast-off of 20,000 snow geese at Bosque del Apache National Wildlife Preserve in New Mexico.

Round-leaved sundew are tiny plants not much bigger than a quarter. A pop-up flash is useless for close-ups because the lens, lens hood, and the angle of the pop-up flash prevents it from striking such a close subject. Nikon D300, 105mm, ISO 200, f/22, 2.5 seconds, Manual ambient exposure, Cloudy WB, and fill flash at −1 FEC with a Nikon SB-800 Speedlight.

Returning to the matter of the pop-up power, following are some examples: the Canon 7D camera has a pop-up flash with a GN of only 12 meters, where the 600EX-RT flash unit sports a hefty guide number of 60 meters (ISO 100 and flash zoom set to 200mm). The guide numbers, in feet, are about three times those listed. In the Nikon line, the pop-up flash on the D810 also has a GN of 12 meters or 39 feet and Nikon's excellent SB-910 has a GN of 53 meters (ISO 100 and flash zoom at 200mm). Agreed, pop-ups are not all that powerful, but they certainly do offer some worthwhile conveniences.

Too many beginning photographers unknowingly pose people in bright sunlight, causing harsh facial shadows and forcing the subject to squint. Pose the subject so that the harsh shadows fall toward the camera and off the subject so the sun is used as a backlight. Now the subject enjoys soft light and can comfortably keep their eyes open. Unfortunately, the entire face is shadowed! Not to worry, your pop-up flash rides to the rescue. Start with an FEC of about +1 stop and check your RGB histogram, highlight alerts, and the general image appearance on the LCD. If the exposure is not quite perfect, making only one or two FEC adjustments will make your image perfect and you'll break into your great image happy dance!

ACCESSORY FLASH MOUNTED IN THE HOT SHOE

Nearly every camera has a hot shoe mounted on top of the camera. The purpose of the hot shoe is to mount and control an external flash. Even cameras with built-in pop-up flashes can often benefit from the greater power and increased controllability of the external flash. For example, pointing the flash at the ceiling often produces attractive bounce flash. Be careful that a colored ceiling doesn't add an unattractive colorcast! Another feature of the external flash, not found in pop-ups, is the second-curtain sync mode occasionally useful to the outdoor action shooter.

Always beware of red-eye. Red-eye is the photo aberration, not the booze. Note, however, that red-eye can be worsened in dimmer ambient light as the subject's eyes dilate to accommodate the lower light levels. Either way, the increased power of the external flash, albeit slightly more removed from the lens-subject line than the pop-up, exacerbates red-eye. The flash burst enters through the lens of the eye, bounces off the retina at the rear of the eye, and is reflected back to the camera in the full glory of the retina's blood vessel induced red color.

All of the modern flashes I am familiar with can be programmed to be the commander (master) which allows wireless control over remote (slave) flashes.

One more benefit is that the external flash, although much more power hungry than a pop-up, comes to the party with its own power supply. In a previous chapter, we've pointed to using disposable batteries and rechargeable batteries.

WIRED ACCESSORY FLASH

A "dedicated" flash is designed and manufactured for use within a specific camera system and is a marvelous way to make flash pictures. A "dedicated flash cord" makes using flash off-camera both inexpensive and reliable. Within the confines of its length—and some camera systems offer dedicated flash cords in various lengths—you have the freedom of pointing the flash this way and that to take advantage of lighting direction, subject shaping, texture enhancing and more. Use flash to deliberately add or soften a shadow here or there. One can eliminate the red-eye

nuisance. As powerful as they are, the dedicated cords have limitations of length, and they can get in the way of cameras, tripods, and subjects. Barbara and I both have a dedicated flash cord, but we use it only as a backup for our wireless flash systems. Here are some problems with dedicated cords:

- When the cord is three feet long, the needed position is always four feet away. One more proof of the widely known Murphy's Law—if anything can go wrong, it will.
- One can add dedicated flash cords "in series" to increase length, but it's cumbersome.
- In order to backlight the subject, passing the cord near the subject poses some risk of it either appearing in the picture or even disturbing the subject by its presence.
- One must be on guard to ensure the cords are connected correctly and firmly.

This red hot poker flower benefits from a little fill flash to open up the shadows, brighten the subject relative to the background, and improve the colors by masking the blue color cast. Canon 5D Mark III, 180mm macro, ISO 200, f/18, 1/6, Daylight WB, Manual ambient exposure and auto flash exposure using –.7 FEC.

- Dedicated flash cords, other than in heroically engineered setups, restrict their usage to only one remote flash unit.

A cord is another tool to remember to bring, and to carry, and adds to the "spaghetti problem." Hopefully, I will never have a photo workshop client who insists on using a dedicated flash cord, camera strap, cable release, and a lens with the lens cap dangling from it simultaneously. Careless photographers risk strangulation!

WIRELESS FLASH CONTROL

I have amassed oodles of experience in wiring flash units together. I continue to use wired systems in hummingbird photo workshops because it best accommodates clients with different camera systems. It eliminates any risk of wireless system "flash crosstalk," where A's flash inadvertently and unexpectedly triggers B's flash. However, when shooting for ourselves, Barbara and I invariably use a wireless system. Here's a (thankfully) short list why:

- Wireless is faster to set up
- Wireless has no wires to trip over, fuss with, and perhaps strike the subject or accidently appear in the image.
- Wireless nearly always works correctly the first time.
- Wireless is easier to carry in your camera bag.
- Wireless make you look like a pro!

Most pop-ups can be configured to be a controller of remote flashes. Nikon's pop-ups can operate in Nikon's *commander* mode and Canon's pop-ups can operate in Canon's *master* mode. Be sure to set them correctly, especially according to whether you want them to contribute to the exposure.

External flash units can be mounted on the camera, and themselves serve as a commander or a master with respect to one or more remote flash units. Like the pop-ups, they can be set to act only as triggers or controllers, or to themselves contribute to the exposure. If the latter, they will do a better job than a pop-up.

Dedicated flash controllers are available in most (perhaps all) camera systems. Canon offers the Canon ST-E2 (optical only) and ST-E3-RT (radio only). The ST-E3-RT is designed to work only with Canon Speedlites that accept radio control—the Canon Speedlite 600EX-RT and the 430EX-RT. It does not work with any other Canon Speedlite as of this writing. Both of the Canon radio Speedlites can be set to receive optical signals, so they do work with older Canon equipment such as the ST-E2. Nikon offers the SU-800 that fastens to the camera's hot shoe to provide optical

control. Nikon just came out with their first radio-controlled Speedlight, the Nikon SB-5000 as I was doing the final edits of this book. All of these units mount on the camera hot shoe and either optically, or by radio, operate and control remote flash units. They are reliable, and they are effective.

Radio systems are more expensive but are far more versatile and reliable. They operate around corners and from within photo hides. You know, naturally, not to use a copper-covered blind when all bets are off. And oddly enough, sometimes the ability to shoot around corners becomes a headache. I often just stick an optical commander or master into a pocket or behind my back when I want to work with the ambient light alone and not fire the flash. I can't do that with the radio systems, so I actually must turn the flash off. I have used the Canon ST-E3-RT with the 600EX-RT Speedlite for two years now. Bottom line— radio is far superior to optical flash control. I would never return to all-optical control, especially for multiple flash photography.

One must have a care about how the dedicated controllers are powered. If not powered by the host camera (pop-up flash), pay attention to their batteries! The ubiquitous AA cells are everywhere (perhaps even an ecological headache when discarded), but the less conventional 2CR5 used in the Canon ST-E2 may be impossible to find at a nearby drugstore.

Third-party systems are also available, ranging from widely accepted expensive ones that do everything correctly and do it reliably, down to the little known and inexpensive ones that do some things okay most of the time, and can be found on Internet auction sites. If you need something not offered by your camera system, the PocketWizard system is considered the gold-standard for third-party wireless flash and camera control. Barbara uses PocketWizard equipment to trip her camera, but we prefer her Nikon wireless and my Canon wireless system for triggering flashes.

By now I hope you are completely convinced that fill flash is an indispensable and valuable tool for lighting dark shadows, for reducing a subject's contrast, and for adjusting colors. Always remember, fill flash is secondary to the ambient light in both effects and the procedure. Add fill flash now to your growing repertoire of photographic skills!

When John was hiding in a blind while photographing birds drinking at a water drip, suddenly and unexpectedly the long-tailed weasel appeared on the scene. Using radio-controlled flashes is nearly mandatory for blind photography because the fabric blocks optical signals, but radio signals pass right through. Canon 5D Mark III, Canon 200–400 at 350mm, ISO 500, f/13, 1/200, Manual ambient and strong fill flash with Canon 600EX-RT at 0 FEC.

Barbara's handsome Boo Bear is a curious Pomeranian that loves to romp in the autumn woods. Using a 21mm focal length to show the autumn woods, she used her Nikon SB-800 Speedlight to brighten Boo-Bear's face. Nikon D4, 21mm, ISO 1000, f/13, 1/80, Cloudy WB, Manual ambient exposure with auto flash at FEC −.7

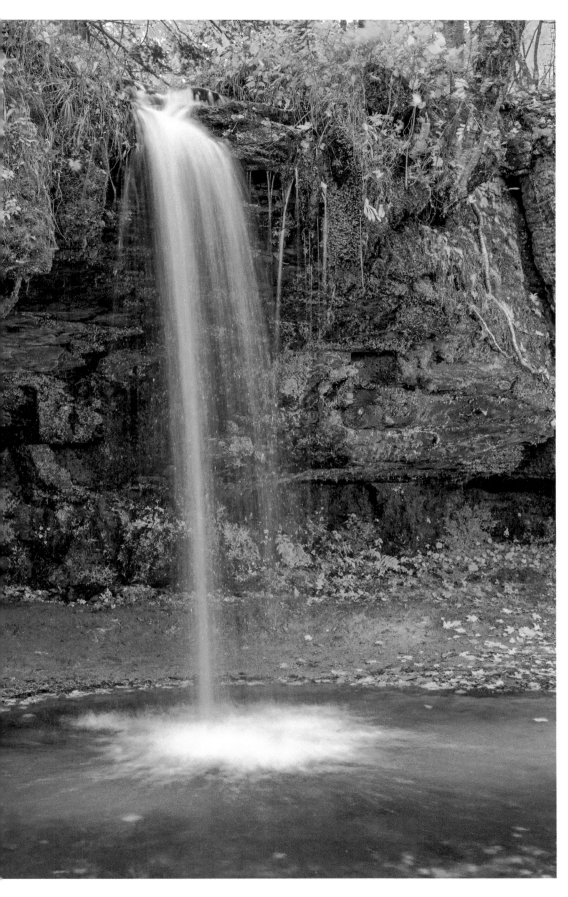

Model: Canon EOS 5D Mark III

The dark rock wall behind Scott falls is optimally lit by firing two Canon 600EX-RT Speedlites simultaneously with the ST-E3-RT radio controller. Canon 5D Mark III, 24-105mm at 55mm, ISO 400, f/13, 1/1.2, Cloudy, WB, and the Speedlites were filtered with Honl ¼ CTO gels.

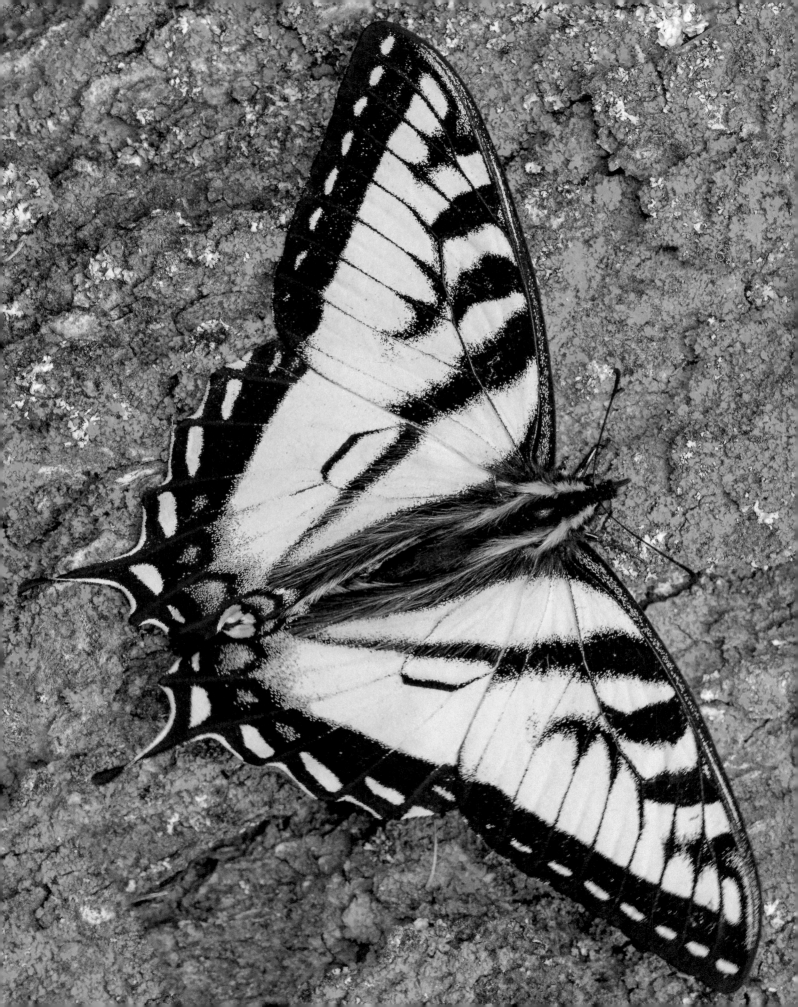

8

Main flash

A flash unit utilized as the dominant light on the subject is called the main flash or main light, and is also known as the key flash or the key light. Barbara and I consider "main" as more descriptive than the word "key," so we use main in our books.

Speaking of using terms, we will be using "ambient light" more. It's important to remember that ambient light is not just the commonly thought of outdoor light produced by the sun and its derivatives. We use the term "ambient light" to indicate any secondary light source that moderates the shadows caused by flash when used as the main light source. This ambient light is often bright sun, but could be diffused sunlight passing through clouds, reflected light off leaves, or light from artificial sources such as tungsten bulbs.

I've so often quoted *Hart's Law of Photography* because it is so often perfectly germane to our discussion. Hart's Law (named after Al Hart—one of my knowledgeable volunteer editors) states that there is nothing complicated about photography, but there are a million simple things to remember. We are adding two more rules to remember when using main flash:

- When using main flash, ambient light is determined by the role the light plays in illuminating the subject. It might be backlight, sidelight, and usually serves as a fill light.
- When using main flash, almost all of the light exposing the image comes from one or more flash units, whereas the ambient light, from whatever or wherever, fills in the shadows.

The roles were reversed between ambient light and flash from our prior discussion in Chapter 7. Think about the changed reversed role carefully. One or more flash units can be used as a *main or primary light,* and any available ambient light provides the *fill light*. The reversed roles of flash light and ambient light must be entirely clear, especially before we get to *balanced fill flash* in the next chapter.

Western tiger swallowtails spread their wings to absorb heat during cool periods. The red lichen-covered rock is an attractive background. The ambient light is underexposed by one stop and main flash optimally exposes the butterfly. Canon 5D Mark III, 180mm macro, ISO 200, f/16, one second, Flash WB, Manual ambient exposure one stop underexposed, Canon 600EX-RT Speedlite on auto at +1 FEC.

Using fill flash	Using main flash
Ambient light is dominant	Flash light is dominant
Ambient light produces the shadows	Flash light produces the shadows.
The flash is the minor light	The ambient light is the minor light.
Flash fills in the shadows	Ambient light fills in the shadows

Main flash is widely used by portrait photographers to provide better separation between a subject and the background. We do the same thing in much of our macro and landscape photography. The technique is the same whether the subject is your favorite person or a photogenic butterfly in your garden. Simply expose the background for a stop or two below normal to produce a darkened and subdued background, and then add flash that correctly exposes the subject.

It's simple to configure a camera and a flash for the so-called balanced fill flash mode, and more convenient to simply leave it there. Many beginning and intermediate shooters do precisely that. They remain blissfully unaware of the magic offered by the flexibility of main flash. Now is the time to ensure you are beyond blissful ignorance. You will discover that main flash is immensely useful for making beautiful images because of its versatile controllability. Indeed, I find main flash to be far more useful to outdoor photographers than fill flash. I say "versatile" because the main flash can be used to:

- Change the direction of the lighting, producing front, side, or back-lighting.

a) Cowboy John Roy always wears a hat to shield himself from the sun and rain. The large brim on the cowboy hat blocks the light causing his face to be significantly underexposed. Canon 7D Mark II, 24–105mm lens at 31mm, ISO 250, f/11, 1/4, Cloudy WB.

b) A Canon 600EX-RT Speedlite with a 1/2 CTO warming gel filter on the flash head set to be the main light at +.7 FEC brings out the cowboy's face while also warming skin tones simultaneously.

- Reveal textures and patterns, largely by side, top, or bottom lighting.
- Add contrast to otherwise flat images.
- Improve a subject's colors.
- Increase the appearance of sharpness.
- Control the brightness of a background.

SEPARATING THE SUBJECT FROM THE BACKGROUND

Refer to page 51. There's Barbara, patiently posing for me under an overcast sky in an autumn meadow. The light is soft and the contrast low. Barb and her little pooch are of similar tonality as the autumn foliage behind them. We want to emphasize the beautiful Barbara while at the same time subduing the leafy background. How? Should we try

Chestnut-crowned antpittas are trained to approach visitors offering worms at Guango Lodge in Ecuador. Underexposing the ambient light by two-thirds of a stop and using a Nikon SB-800 Speedlight as the main light works perfectly in this situation. The short flash duration helps to obtain a sharp image in the low ambient light. Nikon D300, Nikon 200–400mm at 330mm, ISO 1250, f/5.6, 1/200, FEC +1.7.

to find a different background? Should we shoot a stop darker? Should we just wait there, hoping the background will get a little darker? Wait for a dark cloud? Should we use reflectors to brighten Barb? "Light paint" her with a flashlight? How about flash? Ok, good idea! Let's use flash.

Flash can quickly and easily create a new lighting scenario where the subject is correctly exposed, and the background is a stop darker, two stops darker, or if it tickles your sense of creativity, entirely black. Think back to the exposure management roles of ISO, shutter speed and aperture. Each or any combination can be used to increase the exposure caused by the ambient light. The same can be said for decreasing the exposure. All three can reduce the light on the sensor, either alone or in combination.

It is important to remember that the burst of light from a flash is of very short duration. Flash unit behavior varies manufacturer-to-manufacturer and model-to-model, but the larger dedicated flashes operating on full power have a light burst duration of about 1/1000 second or slightly longer. At lower flash powers, the burst length gets mind-boggling shorter. For one example, the Nikon SB-910, operated at 1/32 of full power emits light for only 1/20,000 of a second. That's only 50 micro-seconds or a paltry 50 one-millionths part of a second! So as long as the camera shutter is open for a time equal to, or longer than that, of the maximum sync speed, the flash has plenty of time to do its work. I know it's hard to reconcile "plenty of time" when dealing with microseconds, but it is precisely what happens in the world of flash photography!

Just think about this:

The flash burst comes and goes so rapidly that as long as the shutter is at or slower than the maximum sync speed, the flash exposure is not affected by the shutter speed!

Let's get back to the very patient Barbara still waiting in the meadow. A flash discussion is relevant now. If Barb and the pup were correctly exposed with flash at a shutter speed of 1/200 second, they'll be properly exposed with flash at 1/100 second, 1/25 second, seven seconds, and anything longer than 1/200 second. Think about that! I can use many different shutter speeds and not affect the degree to which the light from the flash exposes Barb. Manipulating only the shutter speed, I am able to make the ambient lit background either lighter or darker, whichever I choose. Learn to use this powerful tool well. We can make some beautiful portraits indeed.

MANUAL AMBIENT EXPOSURE WITH TTL FLASH

Allow me to walk you through making this portrait. Ignore the flash for now. Place your camera into its Manual exposure mode and use your histogram and blinkies to find the optimum ETTR exposure. Use f/11 to ensure adequate depth of field for Barbara and whatever of the surroundings need to be in focus. Use an ISO of approximately 200 to ensure low noise and few artifacts. Your hypothetical shutter speed becomes 1/60 second.

Ok, but you don't want the conventionally well-exposed ETTR background. If you prefer a darker background, then you need an exposure which subdues the background detail and makes your primary subject "pop" from that background. You remember that a viewer's eye is virtually invariably attracted to the brighter parts of an image. So you accommodate that reality by changing the shutter speed from 1/60 second to 1/125 second, making the background one stop darker. The histogram data move a stop to the left, a proper response to your conscious decision to modify your routine ETTR technique.

Turn on the flash unit. Arrange the flash to trigger remotely by either a dedicated cable or by optical or radio means. Set the flash to TTL mode, being especially careful not to set it to Balanced TTL. Ensure that the flash exposure compensation (FEC) control is at 0. Hold the flash off-camera approximately a foot or two right or left of camera and slightly above the camera, and make sure the now positioned flash is pointed at the intended subject. The most carefully positioned flash won't help much if, in your rush, you have pointed it at the sky. Shoot! Check the histogram. It's a rebuttable presumption (my lawyer taught me that term and I've been looking for a place to use it) that the flash added enough light to change the histogram. The histogram, having moved leftward when setting up the background exposure, should now have moved back somewhat to the right. If the histogram is now in the ETTR comfort zone, you are all set. If not, introduce some plus-FEC or some minus-FEC as appropriate, and take another trial shot.

If you think the background still needs adjustment, change the ambient light exposure by twiddling the shutter

a) Using ambient light only to photograph this unusual metal sculpture a few miles east of Marquette, MI. The cloudy skies eliminate severe contrast, but adding a pinch of sunshine on the sculpture would help to separate it from the forest background. Canon 5D Mark III, 70–200mm lens at 105mm, ISO 400, f/11, 1/13, Cloudy WB, no flash. See many more of these intriguing sculptures at Lakenenland Sculpture Park. http://lakenenland.com/

b) Underexpose the ambient light by two-thirds of a stop. Both the forest behind the sculpture and the foreground are now darker.

c) Now bring out a Canon 600EX-RT Speedlite, add a 1/2 CTO gel on the flash head to add a little yellow to the sculpture, and use +1.3 FEC to pleasingly expose the sculpture while separating the sculpture from the background, and still leaving the sculpture a little underexposed. In this image, the flash is the main light and the ambient light serves as the fill light. Main flash is an incredibly useful technique! Canon 5D Mark III, 70–200mm at 105mm, ISO 400, f/11, 1/20, Cloudy WB.

speed a bit. As long as you remain under your maximum sync speed, you can use a faster shutter speed to darken the background or a slower one to lighten the background without making much exposure change to the subject.

When the result of the flash on the subject has returned a nicely muted background image with ETTR, the image is ready to be shot! Don't forget to disallow blinkies in any highlight regions of the image in which you want to preserve detail.

SIDEBAR: SOME QUESTIONABLE FLASH ADVICE

Ah! The good old days! Well, what was good then is not always so good now. Time has marched on and cameras and flash systems are different today. The flash shooter of yesteryear was taught that the flash exposure was controlled by the aperture, and the ambient light exposure was controlled by the shutter speed. Today's ability to put one or several itsy-bitsy computers with a few million transistors inside your camera and inside your flash unit has rendered that old advice mostly outmoded. Consider the portrait we just made. If I don't like the flash exposure because Barb was a little too light or a little too dark, I can't fix it by changing the aperture. If I change the aperture using a current TTL system, the flash unit ignores the f/stop change and modifies its burst duration so that the *exposure does not alter.* Such is the beauty of modern technology and such is the obsolescence of some old ideas. But not to worry, our versatile modern TTL flash systems can nevertheless provide several ways to make whatever adjustments and changes your artistic heart craves.

APERTURE PRIORITY AND TTL FLASH

Once again, first forget the flash and determine an appropriate ambient light exposure. Adjust in Aperture Priority mode—called "A" by the Nikon troops and "Av" by their Canon cousins. When exposure adjustment is needed for a subject, changing the aperture is essentially ineffective. The camera ignores any aperture change by promptly making a change in shutter speed ensuring that the exposure remains unchanged. The camera will produce the exposure it deems correct, oblivious to the tonality of the subject and all other factors influencing the TTL exposure, and quite ignoring any and all the skills of the shooter. In Aperture Priority mode, one must rely on "EC" control to force an exposure change on the compensation dial. Do not confuse the FEC on the flash or the camera with the camera exposure compensation dial. Remember, the EC control adjusts ambient exposure while the FEC does the same to flash exposure.

It is time to take a picture. Our hypothetical camera is set to ISO 200 and 1/60 second and f/11. Metering, we see that the subject matter has averaged out to slightly brighter than mid-toned, so we conclude that an EC of +0.3 stops would achieve a nicely exposed image with a classic ETTR histogram. Except that, in this instance, we do not want the background to be adequately ETTR exposed. We want the background to be nearly a stop darker to subdue/mute it in order to make the subject pop. Set the camera's EC to about −0.7, one full stop darker than our estimated "correct" exposure of +0.3. Now, shoot the image to make certain the ambient exposure is suitable by checking the resulting histogram to make certain the rightmost data is about one stop shy of the right histogram wall.

Next, turn on the flash. Set the FEC to zero. Hold the flash either left or right of and slightly above the camera. Point the flash at the subject and shoot. Would it be annoying to my treasured readers to remind them it is essential that the flash be pointed toward the subject? Nah, no such intent. I'm just sayin'…. Take a careful look at the image, both on the camera LCD and on the histogram. If a little correction is needed to the subject illumination, merely add or subtract some FEC until you're totally satisfied.

Need something more to remember? Ok, remember that EC (exposure compensation) and FEC (flash exposure compensation) are not the same thing. They are different controls, used for different purposes, found in different places and produce different effects.

OUR PREFERRED MAIN FLASH TECHNIQUE

USE THE MANUAL EXPOSURE MODE

Barb and I are always ardent advocates of adequate tripods. It is common knowledge that tripods reduce camera movement and vibration, but they also make far-reaching contributions to obtaining the best composition. Tripods allow an unhurried study of exactly what is contained in the viewfinder, which simply cannot be achieved under the physical challenges and resulting time pressures of handholding a camera.

One big caveat when using a tripod. The warning is that as soon as we are satisfied with the composition, we routinely

back our eye away from the viewfinder and then release the shutter. Leaving the viewfinder uncovered, the extraneous light immediately enters the eyepiece of the viewfinder. That light combines with the light admitted through the lens. In Manual exposure mode, the exposure has already been dialed in, so the camera completely ignores any extra light. In any automatic mode, the camera sees the additional light, but quite ignorant of its origins, the camera dutifully reduces the exposure. The picture is now woefully underexposed.

Cameras as a group flaunt a plethora of automatic modes. Barb's Nikons and my Canons both offer Manual, Aperture Priority, Shutter Priority, and Program modes. A number of cameras provide Sport modes, Flower modes, Macro Modes, Landscape modes, Fireworks modes, Pretty Girl modes, and do everything modes for the snap shooter too preoccupied to take command of their camera. Each and every one of these modes suffer from the same problem because it allows stray light to enter the viewfinder's eyepiece which will upset and may ruin the exposure.

The problem extends beyond the rantings of your author. The camera companies are excruciatingly aware of extraneous light and most offer various corrective measures. Most "pro" cameras are equipped with a mechanical shutter curtain which blocks extraneous light from entering the viewfinder. One needs only to remember to use it. Some low end cameras provide a small plastic shield about half the size of a postage stamp in order to block extraneous light intended to be removed. The device might work if and when you used it, and provided you did not forget to bring it, and you haven't unknowingly or irretrievably lost it. An additional workaround is to use Live View to compose the image. With Live View invoked, the mirror is already up and blocks the viewfinder. Then there is the hat trick, generally used for preventing lens flare. No matter which light blocking scheme is used, it's an undeniable nuisance of tripod work. At least when handholding a camera, your eye stays pretty much glued to the viewfinder until after the shutter is released. Score another point for using the Manual exposure mode!

Some among us (I wouldn't dare mention any names) believe cameras to be the offspring of geeky engineers who know nothing about, and care less about, the issues routinely faced by photographers. I, of course, take a more enlightened view. After all, some of my best friends are engineers! When I bitterly complain about some feature of a camera, I'm reminded that the camera is not designed for me personally. No? It was conceived as the best compromise for its target market, involving many people, many cultures, many habits, many photographic techniques, existing in-house tooling, manufacturing equipment and production systems, and to meet a specific budget on a particular schedule. So where a one-size-fits-all camera can't be designed, some versatility is built into a camera's menus to allow user personalization.

The above-written soliloquy is a lead-in. I want to mention that some cameras have their exposure meter scales reversed on the top or bottom LCD or in the viewfinder, and upside down if the meter scale is vertical and on one side of the viewfinder display.

I prefer turning a shutter speed or aperture dial to the right to add light and move the histogram data to the right, but I don't know about you. If you don't agree with me, all is well, but if you do agree, take a look at your camera's custom function menus to decide whether those scales can be reversed to suit you. Another area to consider is the direction of the aperture and shutter speed dials. When you rotate your aperture dial clockwise, do you prefer to increase the aperture number (toward, say, f/22) or would you rather increase the aperture size (toward, say, f/4)? When you rotate your shutter speed dial clockwise, do you want to see the amount of light increase (greater exposure) or do you prefer to see the numbers increase (a lesser exposure)? Do you want shutter speed increments to change in quicker 1/2 stop increments or the most precise 1/3 stop increments? Same question for ISO numbers and shutter speeds.

Your camera probably offers a way of tweaking scale orientations and dial directions to your liking, so consider it and configure your camera in the way that makes the most sense for your way of thinking. You are probably wondering about the way I have our cameras set up. We are from the simple school and figure that exposure controls should control light like numbers on a ruler. Everything gets larger to the right. Turning an aperture control clockwise should add light. Turning a shutter speed dial clockwise should add light. Turning an ISO dial doesn't control light per se, but monitors the effect of light, so we want its clockwise rotation to increase exposure the same as if it added light. Our cameras are set so that turning our exposure control dials to the right (as viewed from camera rear) increases the exposure and moves the histogram data to the right. We find this setup where turning the control dials one direction or the other moves the histogram data the same way. Sadly, on most cameras, this logical orientation is not the default!

After you have configured the camera in a way logical to you, its operation will become more intuitive and faster, making it more comfortable to use and allowing you to spend precious time thinking about the image while spending less time thinking about how to operate the camera. You will be able to operate your camera like a touch typist operates a keyboard. The speedy operation of Manual exposure mode on a comfortable camera can truly be delightful when rounding a corner and suddenly seeing Elvis and Bigfoot sharing a bottle of beer. Silly? Perhaps, but even landscape shooting can demand super speedy photographer action in transitory light, and wildlife, like proverbial time and tide, often waits for no man or woman.

FLASH OFFERS BACKLIGHT WHENEVER NEEDED

Photographers as a whole use frontlight most of the time. It's a meritorious shooting method because the shadows primarily fall behind the subject and don't degrade the image. Frontlight also shows colors nicely. If every picture were to be engendered with the very same lighting, then all of the images look pretty much the same, and photographic boredom is not far behind. It's good to remember that some shadowing is often beneficial to reveal shape and texture, thereby adding more detail to interest the viewer.

Diffused light on overcast days is useful for portraits, close-ups, macro work, and most other subjects. Diffused light is low in contrast, and occasionally may be too low. We are able to make the contrast challenged subject considerably more appealing by using our flash to add some pop or sparkle by creating a little contrast, and do a little rim-lighting with our backlighting flash.

Not long ago, walking through the woods near our house, Barb and I came across a gorgeous flower blossom in the softly diffused light. We talked for a moment about how so many incoming workshop students would be satisfied with the soft lighting, but how so many post-workshop

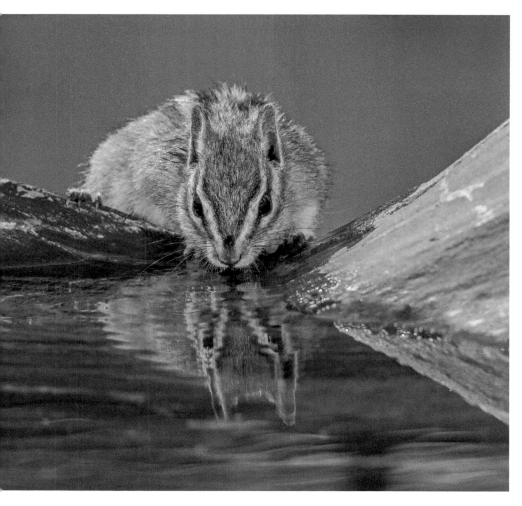

Yellow-pine chipmunks are readily attracted to sunflower seeds and fresh water. The thirsty chipmunk was illuminated with four Canon 600EX-RT Speedlites. What is the placement of the four Speedlites? The first Speedlite illuminates the artificial painted background. The second and third Speedlites light the front of the chipmunk while the fourth Speedlite backlights the chipmunk. Notice how the hairs on the back of the chipmunk glow from the backlight! Canon 5D Mark III, 560mm, ISO 320, f/16, 1/200, Flash WB, Auto Flash with +.7 FEC.

students would be comfortable applying their own creative lighting ideas. In this blossom, backlighting would bring out details in the translucent petals, would highlight hairs on the flower's stem, and would make the blossom itself glow. It seemed a situation tailor-made for main flash. We first established the regular ETTR exposure for the ambient light. Next, wanting to subdue the ambient exposure, we decided to increase our shutter speed by 2/3 stop. We knew that rotating our shutter speed dial clockwise would increase light, but here we wanted to decrease the light. We were also aware that the camera was set for exposure increments of 1/3 stop. With those facts deeply ingrained, one doesn't even have to cast a glance at the shutter speed knob. By feel, I rotated the dial two clicks counterclockwise. If you have stubbornly insisted on using an automatic exposure mode, then turn your EC dial to reduce the exposure by − 2/3 EV and be sure to cover the viewfinder. Either way, your histogram will be moved a bit to the left and the flower suitably subdued.

Using any convenient holder (a friend is always helpful), place a flash approximately a foot behind the flower. When alone, use a small flash stand to secure or hold the flash. We often prefer the flash slightly above the flower and off a bit to one or the other side to keep the flash unit from appearing in the image. Fire a test shot at FEC = 0 and check the histogram. If needed, adjust the FEC until obtaining a good ETTR histogram. You may just have transformed an average image into a spectacular image! We do this frequently because it works exceptionally well and want you to also!

Do you think that one shot just might be the most spectacular ever image? Probably not. So, as our mathematician pal would say, we'll try a "series of successive approximations" to see whether we can do even better. Pros say "Work the subject." We mix different quantities of ambient light, various amounts of flash light, different flash positions, perhaps a gel over the flash head, and we keep doing it this way and that way even right through breakfast

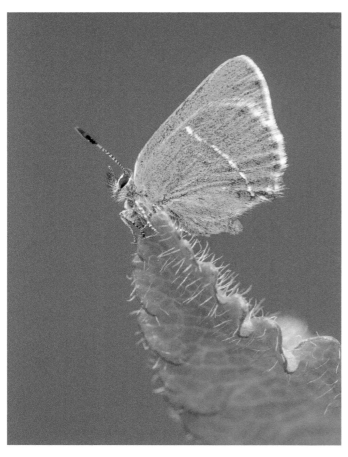

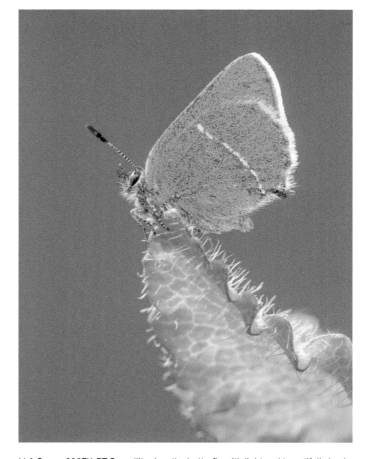

a) Sheridan's Hairstreak is one of the first butterflies to emerge in the spring. The ambient light is underexposed by about a stop while the flash position sidelights the miniature butterfly that truly can't be much larger than an American dime.

b) A Canon 600EX-RT Speedlite rims the butterfly with light and beautifully backlights the leaf. Canon 5D Mark III, 180mm macro, ISO 200, f/14, 1/2.5, Cloudy WB, FEC −.7.

time. We happily end up with dramatic images and some super spectacular images from which to take our pick. Please don't let this get out, but Barb and I regularly toss out perfectly fine images into the "bit bucket" located right in the computer. Since having "worked the subject," we've got several keepers that are just a little better.

In the flower example, the flash was held about a foot behind the flower and pointed at it. If the optimum exposure were found for the flash when the flash was about eight inches from the flower, what would be the result if the flash were moved to eleven inches? It depends. Using Manual flash would certainly change matters. Moving the flash from eight inches to eleven inches—a mere three inches' difference—causes a darker exposure by a full stop. Moving the flash two inches closer, to six inches, the Inverse Square Law increases the light by nearly a full stop. One can only conclude that Manual flash is not the best idea in close-up photography because even subtle changes in distance produce massive changes in flash exposure. The TTL systems allow such distance to be disregarded without so much as batting an eye, and will always keep the flash exposure as determined by your FEC control. When the flash is moved from eight inches to eleven inches to six inches, the flash compensates by changing the burst duration to keep a constant exposure. Because the flash-subject distance doesn't affect exposure, TTL shooters wanting more, or less, flash effect must use the FEC control.

Notice that the flash can only compensate for varying distance within certain limits. At some distance, the flash will

be operating at its full power. Moving the flash a greater distance is futile because there is simply no more power to be had. Conversely, moving the flash closer and closer causes the burst duration to get shorter and shorter.

BEING FLEXIBLE WITH AMBIENT AND FLASH EXPOSURE

We often hear that one should use Aperture Priority for the ambient light and use Manual flash guided by a flash

White-winged brush finch dwell in the Ecuadorian highlands and can be closely approached. To improve the light Barb set her auto flash to +1 FEC and used the short flash duration in order to make a sharp image as she followed the cute bird without a tripod. Nikon D3, Nikon 200–400mm at 290mm, ISO 1600, f/5.6, 1/250, Cloudy WB. The ISO 1600 and the f/5.6 aperture indicate how dim the light was for the shot.

John's image of the rocky Bryce Canyon foreground was shot at thirty yards using flash. John fired two 1/2 CTO filtered Canon 600EX-RT Speedlites he was holding using Manual flash exposure. This ensured all of the light both flash units could emit was achieved. Canon 5D Mark III, 70–200mm lens at 92mm, ISO 640, f/8, 1/100, Cloudy WB. Take note that John used f/8 and a higher ISO of 640 in order to extend the Speedlites capability for lighting distant objects.

meter. We disagree. Indeed, for ambient light, Aperture Priority works well in some situations but generally, Manual exposure is quicker and more precise. For flash, there are indeed times to use Manual flash, especially in landscape work, but most of the time our sophisticated TTL auto flash systems are more accurate and certainly much easier to use.

The "easier to use" part is the key reason to use automatic TTL flash metering. Use TTL especially when the subject is nearby and small movements of the flash constitute larger percentage changes. Manual flash operation is preferred when adding maximum power flash to a landscape and certainly in hummingbird photography where burst duration control is all important. As is often true in so many areas of photography, the concept of one-size-fits all needs to be abandoned forthwith!

THE FERN LEAF

Translucent subjects are ideal for backlighting. The backlit translucent subject reveals delicate details, separates very nicely from the background, and glows as if it was itself a source of light. The shooting procedure for backlit translucent subjects is procedurally identical to that for non-translucent subjects, but the ambient exposure should be even more subdued, perhaps up to two stops or so below the classical ETTR exposure. As always, take care to keep the flash from appearing in the image and take care to use a lens hood or some shielding of opportunity, perhaps a hat held in just the right spot, to keep lens flare at a minimum.

Here's an issue: if the translucent subject has a surface facing the camera that is well exposed by the ambient light, sometimes rim lighting or backlighting has no effect. The camera meter may assume that no TTL flash is needed and suppress the flash. An easy fix is either to reduce the ambient exposure some more, or put the flash into Manual mode so the exposure faithfully responds to your every power change or distance change.

CROSSLIGHTING

Crosslighting is a technique that relies on using two light sources in directional opposition. Here's an example: Arrange the subject or the ambient light source so that the ambient light is frontlighting the subject and to the left of the subject. Now place another light source, say a flash, behind the subject and to the subject's right. Point

Backlight works incredibly well for photographing any translucent subject because it accentuates details and makes the subject glow. Canon 5D Mark III, 180mm macro, ISO 100, f/20, 1/1.3, Cloudy WB, Canon 600EX-RT Speedlite set to +.7 FEC.

the two light sources at each other along a line diagonal to the camera-subject line. In the example above, the creative shooter can choose between numerous options:

- Orientation of the subject.
- Type of lighting source used for the backlight and for the frontlight.
- Relative intensity of the two sources—the lighting ratio.
- The angle between the ambient light and the flash light line and the camera-subject line.

Thoroughly working the crosslighted subject can involve several changes in any or all of the above four parameters.

a) Sticky geraniums are indeed sticky. Front light shows the shape of the leaf perfectly. Never be satisfied unless you have used flash because flash will often improve the image.

b) A Canon 600EX-RT Speedlite lighting the leaves from behind is far improved and more interesting. Canon 5D Mark III, 180mm macro, ISO 200, f/16, 1/8, Cloudy WB, ETTL flash with +1 FEC.

Crosslighting generates stunning results. Be sure to add it to your lighting kit.

USING AMBIENT LIGHT FOR A BACKLIGHT

Nowhere is it written (certainly not here!) that backlighting must always come from one or more flash units. Suppose instead, a subject is backlit by bright sunshine. All of the glowing beauty of backlighting is there irrespective of the source of light. Set the camera so that the ambient light and the sunlight produces a satisfactory backlit image. The front side of the subject, facing the camera, may be very dark. Fret not. Use your flash in TTL mode to provide a pleasing exposure of the front side. Use the FEC control to achieve a beautiful result. It is an effective lighting scheme for countless subjects so find opportunities to use it often.

Recognizing that either the ambient or the flash can be used as a backlight or a frontlight avoids several problems of subject orientation. Suppose one early morning you encounter a sleeping butterfly with its most photogenic side opposite to the sunshine. A sleeping butterfly is not to be awakened and instructed to turn his or her best side to the camera. No problem. Set the camera so the ambient light provides beautiful backlighting and rim lighting. Next use flash to correctly expose the side facing the camera.

We tend to shoot early and late in the day, when light color is golden. Since flash emits light that is similar to cooler midday sunshine, we commonly add a gel warming filter to the flash head—such as a 1/2 CTO (Color Temperature Orange)—to warm the flash so its light is similar to the golden sunshine.

Lake Superior waves rush to the beach on a dark autumn evening. Wanting to emphasize the storm, John underexposed the ambient light which, by darkening the background, made it still more menacing. Next, John used a 1/2 CTO gel on his Canon 600EX-RT Speedlite to highlight the pattern in the foreground rock. He held the radio-controlled flash several feet in front of the camera and off to the right to sidelight the rock emphasizing texture. Canon 5D Mark III, 16–35mm at 16mm, ISO 640, f/16, 1/800, Cloudy WB, +.7 FEC for the sidelight.

SIDELIGHT REVEALS SHAPE

Low-contrast light tends to make subjects appear two-dimensional. Indeed, literally, photographic images are two-dimensional, but they don't have to look that way when made by an experienced photographer. Soft shadows suggest depth while enhancing shape and texture. Contrast could be increased by underexposing the ambient light slightly—perhaps 2/3 stop—and then using an off-camera flash to light the subject from right, left, or top. When the flash exposure has been adjusted to ideal by proper FEC, the flashed side of the subject will be beautifully exposed and the ambient lit portions of the subject will be slightly darker. Understand? You've cleverly converted a flat subject to one of greater contrast, and consequently, of greater impact. You can manipulate the degree of contrast to emphasize shape by fiddling with the relative effects of the two light sources, or to use the fancier term, the lighting ratio.

Butterflies are exceptionally enjoyable to photograph. Barb and I live near Yellowstone National Park most of the year, but every summer and fall we conduct several weeks of photo field workshops in northern Michigan where we once lived. The summer weather in both Idaho and Michigan is often cool at dawn, well below the 55-degree temperature at which butterflies emerge from their overnight lethargic state and go about the day's business. While still in the lethargic state, insects are compliant photographic subjects. Sleeping butterflies are found at dusk as well. Shaded areas shield the butterflies from the morning's rising sun, thereby allowing photographers more time to compose and shoot before the slumbering butterfly awakens and flits off. Despite that, shaded areas are awash with blue light. When shooting JPEG images, add a little compensating yellow to the image by setting the white balance to "Shade." When shooting RAW, the unfavorable blue colorcast is readily correctable during RAW conversion. One complicating factor is that the diffuse light of shade is low-contrast and can mask the texture of the butterfly's wings.

Use flash to show and highlight the texture and three-dimensional potential of the image. Set the ambient light exposure to underexpose the butterfly by a small amount, say −1/3 or −2/3 stop. Now use TTL flash to correctly expose the butterfly. The position of the flash is critical. The flat frontal lighting from a pop-up flash or a shoe-mounted flash doesn't work because it won't reveal texture. Instead, hold the flash almost directly above the butterfly and skim the light across the wings. Because the flash is the main light, it will create detail in the tiny shadows along the veins of the wings on the side opposite to the flash.

Butterflies perch in different positions, but the best presentation of vein structure in the wings comes when the veins are at right angles to the flash beam. The goal is to skim light across the wings from the dorsal (top) because

a) The featherlike pattern created by water draining over a sandy Lake Superior beach is always an attractive subject. The texture is not readily apparent due to the low contrast of the overcast light. You find yourself wishing the sun would magically appear to sidelight the foreground and emphasize the texture!

b) Since dense clouds fully filled the sky, John used his Canon 600EX-RT Speedlite with a 1/2 CTO filter on it, and skimmed the light from the flash across the ground to create contrast and reveal the texture in the sandy pattern. We use a flash when we need a small sun which we can employ anytime we need a splash of bright sunshine. Canon 5D Mark III, 24–105mm lens at 47mm, ISO 640, f/16, 1/6, Cloudy WB, 1/2 CTO filtered Canon 600EX-RT Speedlite with +.7 FEC.

that is the direction butterflies are most often illuminated. A Plamp may be needed to move foliage or gain access to an advantageous position to shoot.

You may not be a butterfly fan, but apply the techniques we've discussed to other subjects. Let your unfettered imagination translate all of the above lighting techniques to any subject in which revealing texture would enhance your image. Think of animal tracks in the mud or snow or, indeed, any close-up involving snow. Think of lichens on a rock, of tree bark, and feathers. Keep thinking! Remember that sidelighting is able to bring out texture and detail in any subject when frontal lighting can't.

FLASH IMPROVES COLOR

The color of light from a flash is far more consistent than that of ambient light which might be the dim red in either an early sunrise or late sunset. It might be the blue light under blue skies and it might be the green light in the leafy forest. On occasion, the color of light is friendly and adds to the image. A blue colorcast might enhance the color in a blue wildflower. Periodically, the ambient light gives an entirely unpleasant colorcast. If the latter, consider what help your flash might offer. The light from the flash is similar in color to the mid-day sun, and when the flash is a main light, it can be very helpful in removing or subduing an offending colorcast. Always remember the role played by your camera's white balance control and your

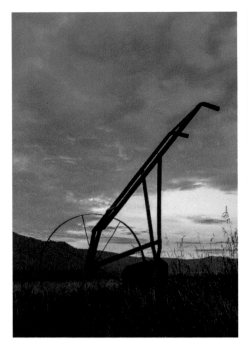
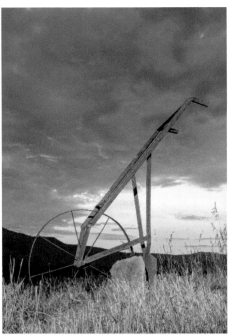
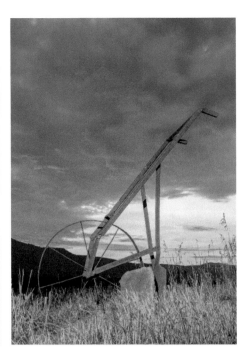

a) The wheel of the old plow is lost against the dark background. Canon 7D Mark II, 24mm, ISO 400, f/18, 1/5, Cloudy WB.

b) The unfiltered light from the Canon 600EX-RT Speedlite nicely illuminates the wheel, but the color between the flash and the dawn sky is too dissimilar.

c) A full CTO gel filter strongly warms the light emitted by the flash and makes it more similar to the golden light at sunrise that everyone expects.

options in post-capture editing. Do not forget inexpensive gel filters in many hues that can be attached to the flash head to alter the color of the emitted light.

FLASH SHARPENS THE IMAGE

It is handy to remember that control of a flash does not change its burst intensity, but simply changes the flash duration providing a handy benefit. It was previously mentioned that, at full power, a flash burst may be about 1/1000 of a second. Granted, we often shoot at considerably slower shutter speeds. Consider an excellent flower, one gently dancing in a light breeze. Various exposure considerations put our shutter speed at 1/30 second. When the shutter is open that long, the flower wiggles, producing soft images. This is the way to mask some of that softness: underexpose the flower by a bit more than a stop, and fire the flash at an FEC that produces a good ETTR exposure. The shortness of the flash burst will give the impression of a sharp flower because the flash portion of the exposure sharply records the flower. Experiment! The degree of masking the softness can be transformed by changing the degree of underexposure and corresponding flash output. In other words, within limits, the amount of ambient underexposure and the amount of flash contribution will improve the sharpness.

MASTER AND USE MAIN FLASH TECHNIQUES

Main flash is far more useful than fill flash because proper use of main flash offers a vast assortment of lighting schemes. The control the flash provides over the brightness of the background relative to the foreground allows spectacular lighting for many different situations. You are limited only by your imagination. Make main flash a frequently used tool in your lighting strategies.

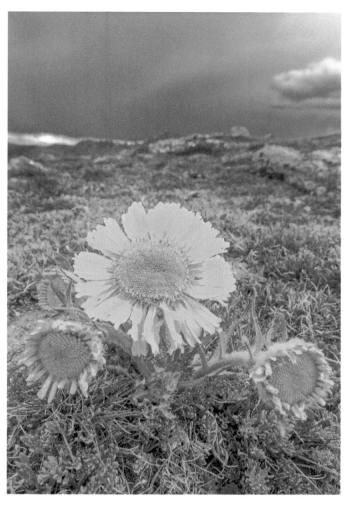

a) This alpine sunflower grows low to the ground to better survive the fierce winds that often blow at high altitude. Barb underexposed the ambient light a little to darken the gray sky and used her Nikon SB-800 Speedlight to optimally expose the sunflower. Nikon D4, 24mm to include the cloudy skies, ISO 200, f/16, 1/20, Cloudy WB, FEC +.3

b) While Barb shoots the image, notice the Nikon SU-800 mounted in her camera's hot shoe which gives her optical wireless control over the flash.

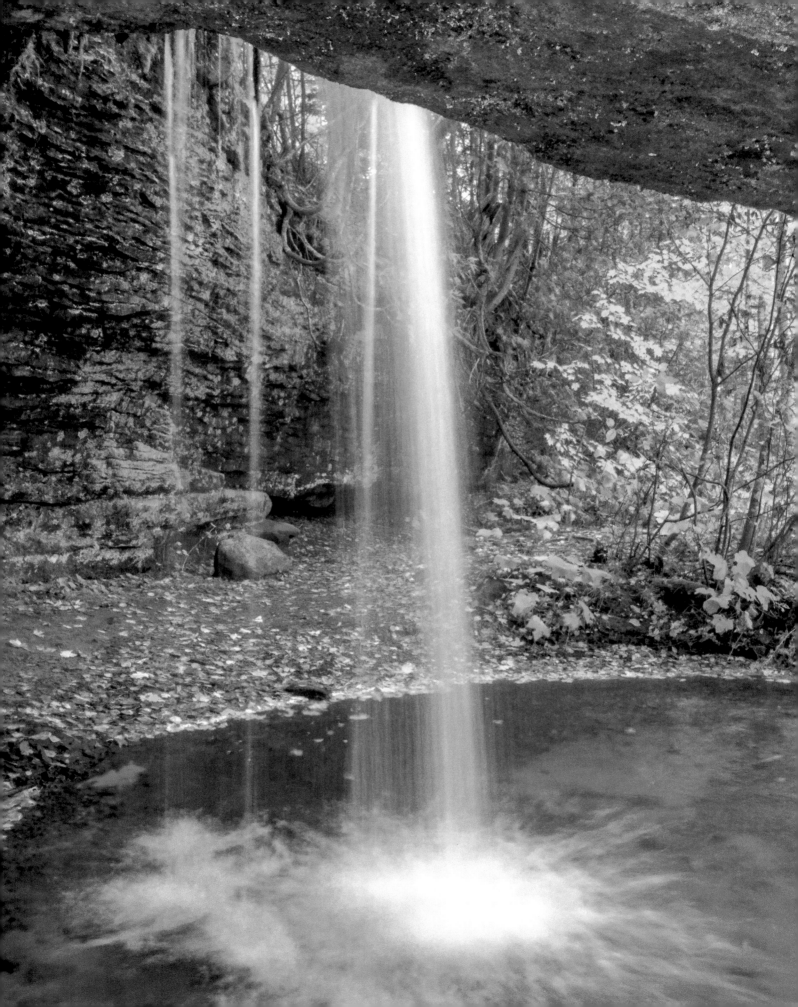

Balanced flash

The difference between the main flash and fill flash was discussed in previous chapters. Because that difference is so critical, a reflection is in order. Using fill flash, ambient light is the primary light source whereas flash is secondary. Using main flash, the ambient light is the secondary source and the flash is primary. Remember that the ambient light can come from any source, i.e. tungsten lamps, and not necessarily only from sunlight.

Nikon users should be aware of a terminology conflict. Some Nikon flash units offer an operating mode called "Balanced Fill Flash" or a similar variant. This Nikon mode is only a subset of the far more comprehensive balanced flash methods to be discussed. To begin, let us study the balanced flash techniques we recommend for *all flash users*, and then we will explain the Nikon differences.

All outdoor photographers find balanced flash to be an extremely useful technique. Because it is so incredibly useful we use it regularly and advise you to follow suit.

THE UBIQUITOUS BUTTERFLY

On a calm cool morning while strolling through a meadow near my home in Idaho, I spotted a lovely butterfly roosting on a shaded plant. As it happens, workshop students are often mystified by how I find so many "invisible" butterflies and dragonflies during a morning shoot in any meadow. The trick that I am able to teach them is the way to scan the meadow while looking toward the sun or the brightest part of the sky. Back-lit insects become more prominent than otherwise, and especially when dew-covered. Concerning the butterfly that I spotted on this particular morning, the sun of the golden dawn illuminated only the background. The resulting contrast between the bright background and the shaded butterfly was in excess of four stops of light! Four stops is far too much contrast to achieve good detail in both butterfly and background with a single exposure. I thought of using a reflector to brighten the butterfly, but in the shade, there was not

Shooting from the back of the cave behind Scott Falls through the waterfalls to the autumn color offers an unusual view. Barb fired two Nikon SB-800 Speedlights to light the top of the cave. The two flashes were necessary because Barb needed f/22 for more depth of field. Nikon D300, 18mm, ISO 200, f/22, one second, Cloudy WB, manual ambient and flash exposure.

a) Black-and-white colobus monkeys are active treetop dwellers. When traveling on our Kenya safari trip, we eat our meals at an outdoor restaurant where the staff feeds the monkeys nutritious food to encourage more visitor interaction. The monkey in the shade is far underexposed due to the bright sky background.

b) Recognizing the perfect time for balanced flash, John used Shutter Priority for the bright sky background and ETTL flash set to +1.3 FEC to add light to the monkey, and balanced the exposure between the monkey and the sky. Canon 7D Mark II, 24–105mm lens at 78mm, ISO 640, f/11, 1/250, Sun WB, Canon 600 EX-RT flash on camera set to +1.3 FEC.

even enough light available to reflect. Luckily it was not a problem because I had my very own "sun." I used my off-camera flash to lighten the lazing Lepidoptera. The secret to using balanced flash is as follows:

DETERMINE THE EXPOSURE FOR THE BRIGHT BACKGROUND IN THE AMBIENT LIGHT BY TAKING A TRIAL SHOT.

I used f/16 to provide enough depth of field to ensure all parts of the butterfly would be sharply focused. Always avoid f/22 and f/32 because the diffraction using those small apertures would produce an overall reduction in image sharpness and quality. Using Manual exposure, I metered only the background with the Canon 180mm macro lens due to its narrow angle of view. The meter indicated that at my native ISO 100 and my chosen f/16, my shutter speed should be 1/30 second. I confirmed that with a test shot and critical inspection of the RGB histogram and the blinkies. I had achieved the best exposure for the background.

COMPOSE AND FOCUS THE BUTTERFLY

I studied the image in the viewfinder and moved the camera only a few inches so the composition would be composed with no objectionable mergers or any intruding elements. Remember to always check all four corners of the image. Compositionally satisfied, I then locked the tripod ball head. Next, I used the Live View feature to manually and critically focus on the exquisite detail of the butterfly scales nearest the thorax.

FLASH!

Certainly you anticipated (hopefully) that I would use flash, and voila, you were right on! The procedure applied uses flash to bring the currently underexposed butterfly up to ETTR standards. In order to accomplish that, I used a Canon remote flash triggered by radio, although triggering either by cable or by optical would do adequately. I positioned the flash approximately one foot above and slightly to the side of the butterfly. With the flash in TTL mode, I fired a test shot or two to achieve ETTR via FEC adjustment. Recall I used the term "successive approximations" which is simply geek-speak for trial and error, or as photographers say, "working the subject!" Do you recall the photography law stating that there are a million points to remember? Included are a few more of that million:

- My shutter speed of 1/30 second was considerably under the flash sync speed of 1/250 second.
- The slow shutter speed allowed me to manage my background exposure by adjusting shutter speed with no effect on the butterfly. A flash burst of less than a millisecond illuminated the butterfly—less than the thousandth part of a second!
- Anytime I unthinkingly use too high a shutter speed, (i.e. 1/500 second) the camera detects a flash in use and automatically defaults to the maximum sync speed.
- Despite that, I could use the higher shutter speed thus invoking my camera's "high-speed sync" mode already discussed.

Think of balanced flash as a technique where:

- Ambient light exclusively (or nearly exclusively) illuminates one portion of the image.
- Light from the flash(es) exclusively or almost exclusively illuminates another part of the picture.

On first glance, balanced flash might appear to be the same as main flash, the difference is:

- Use main flash when the major light is the primary light source and the ambient minor light source are both illuminating the entire subject.
- Use balanced flash when the different light sources *illuminate different parts of the image.*

Opportunities for balanced flash abound, and you should aim to use it regularly. Sometimes you will encounter a nearby foreground subject that is illuminated mainly by your flash. Always position the off-camera flash considerably to either one side or the other and a bit higher than the camera, irrespective of using either balanced flash or main flash. The objective is to avoid the straight-on and flat, shadowless lighting that makes a subject appear two-dimensional. It is better to deliberately introduce some shadowing to bring out texture and contribute shape to the subject.

A single flash is providing most of the illumination of a nearby subject while being held to the side, thereby sometimes creating too much contrast when there is inadequate fill from the ambient light. In such cases, it's often helpful to diffuse some of the light from the flash. Many flash units include a plastic snap-on diffuser, which may help somewhat. The often-maligned theory that if a little is good, more is better, is valid here. I use an aftermarket diffuser to provide a softer light than the "stock" diffuser. Aftermarket diffusers, sometimes called "mini-softboxes," are available from several vendors, including HONLPHOTO, Lumiquest, and others. Any diffuser will attenuate light, some by two

or more stops, but most flash units will have adequate power for nearby subjects.

Now look at the flash mode that Nikon dubs "Balanced Fill-Flash." I interpret Nikon's mode only as an attempt to achieve *identical or at least very similar* exposures of the background and foreground subject. Thus, Nikon's Balanced Fill-Flash is not Fill-flash nor balanced flash, as defined here. I consider it a "special case," where balanced flash as defined here is the "general case." With balanced flash, we don't try to rigidly equalize foreground and background exposures. Instead, the balanced flash photographer can effect any reasonable relationship between background and foreground exposures that their artistry might suggest.

THE NORTHERN FLICKER

I am not referring to an erratic perturbation of the Aurora Borealis, but rather a northern flicker which is a beautifully colored member of the woodpecker family. Recently,

a) Northern flicker chicks beg loudly for food when they are old enough to poke their heads out of the nest cavity. The nest was in deep shade during the afternoon, but the meadow behind them was sunlit. The contrast between the flickers and the meadow was too great to capture in a single ambient light only exposure. Nikon D3, 400mm, ISO 3200, f/11, 1/250 with Shutter Priority, Cloudy WB, no flash.

b) Contrast is easily managed with flash. Set the ambient light exposure for the meadow, but still favor the maximum sync speed for flash to reduce the chance of ambient light ghosting from moving baby flickers. Then use flash to light the baby birds—a perfect situation for balanced flash. Nikon D3, 400mm, ISO 800, f/18, 1/250, EV −1 with Shutter Priority, Cloudy WB, SB-800 Speedlight fired at +1.3 FEC.

a lovely pair were found nesting in a dead aspen tree not far from our home. When drinking from the bird bath or hunting tasty insects in our yard, they often see us. Thus, they soon became used to us and accepted our close approach. We yearned for young flickers poking their multiplicity of chirping heads from the nest cavity and clamoring to be fed an appetizing aphid, juicy giant mayfly or savory caterpillar. In only a few days, we saw baby flickers poking out of the nest cavity. Now was the perfect time to get terrific images!

Because the chicks would soon fledge meant time was short. We quickly set up sturdy construction scaffolding at eye level approximately 20 feet from the chick's nest. Using a tripod on top of the scaffolding and a long lens 13 feet above the ground, I got comfortable and relaxed in my small camp stool and waited. Indeed, the wild-life photographer must be a patient person. Late in the afternoon, the nest was shaded by overhead green leaves while the distant background was a brightly lit mountain meadow. The difference between the shaded nest and the bright background indicated a whopping six-stop difference in light— an ideal situation for balanced flash. The bright light of the flash allowed me to stop down enough to bring the flicker and tree into sharp focus. Additionally, the daylight-colored flash overcame some of the nasty blue light of the shade and the green light reflected from the nearby foliage.

The strategy would correctly light the background to my taste with only the prevailing ambient light while allowing the nesting birds to be exposed from a single flash. I used a flash unit set to its remote (slave) mode which allowed wireless control. I set the communications group to (A) and channel to (1) to ensure the camera would properly communicate with the flash, and I set the flash zoom to its longest setting of 200mm.

I set my camera to Manual exposure and pointed my lens to see the background only. The camera ISO set to 200 and aperture at f/16 gave plenty of depth of field. Next, I adjusted the shutter speed until the index mark on the metering scale was set to zero compensation. I took a quick test shot to see the background exposure, and the histogram was a bit shy of a good ETTR exposure. I slowed the shutter speed by two clicks (two-thirds stop because the camera setting was set to 1/3 stop increments) and then fired another test shot. This time, I had a good histogram and no blinkies—a perfect exposure for the background—although the tree with the flicker nest was

woefully underexposed as expected. Incidentally, while you are reading of the recounting of my flicker experience and using thoughtful time of yours, the actual doing on my part consumed only a few fleeting seconds. Next, I set the flash unit to properly expose both the tree and the nest. I used the tree as a guide because there was no need to await the arrival of a flicker. I composed the shot, set the FEC to +1/3 stop (+0.3) and fired a test shot. The tree was a mite underexposed, so I increased the FEC to +2/3 stop (+0.7) and fired again. This shot had the tree nicely exposed, and the background was already correctly exposed, so now I only had to await a flicker. Because I was able to prepare in advance, I was able to enjoy a couple of hours of exhilarating photography while both the male and female flickers alternated in bringing in food for the demanding and noisy chicks. In order to allow me to revel in my standing as a part-time flash maven and full-time heckler, please remember in such cases to expose backgrounds with ambient light only, and then use flash to expose the foreground subject!

I must confess that I got terribly excited when I saw the flicker chicks bouncing and jouncing wildly this way and that! I got so adrenalized that a few times I failed to await full recycling of my flash before firing the next shot, and ended up with a few woefully underexposed flicker images of the nest tree! Indeed, adequate battery recycling time is only one more of the million things to remember, and a hint to always start with fully-charged high-quality batteries and never shoot faster than the time it takes for the batteries to recharge the capacitor.

Finally, I continually monitored the ambient light exposure for the background. While the sun descended to the western horizon, the ambient light gradually diminished. Slowing down the shutter speed as needed kept the background exposure optimal.

REVIEWING THE FLASH MODES

FILL FLASH

Fill flash depends primarily on ambient light to illuminate the subject. Use flash as a secondary light source, close to the camera and pointed directly at the subject anytime harsh shadows are created. Thus, the objectionable shadows are mitigated. Use both ambient light and flash light to illuminate the subject.

MAIN FLASH

Main flash uses flash as the main or primary light source. The ambient light is secondary. The flash unit is commonly positioned a little above and somewhat to the side of the camera to create the contrast in order to reveal shape and texture. Sometimes the flash is used as a backlight. When main flash is used, ambient light serves as a fill light.

BALANCED FLASH

Here, the flash illuminates one portion of the image, and the ambient light illuminates the other portion. Neither light source significantly illuminates both parts of the image. Think back to the butterfly example. The flash was the main source of light on the butterfly and the ambient light lit the background. Yes, the ambient light was detectable on the butterfly, but of so little strength that its contribution to the exposure was minimal.

The term "balanced flash" does *not* mean that the areas illuminated by flash and ambient are exposed to the same brightness. On the contrary, more than often, a definite difference in the exposure is the desired result. The great power of balanced flash lies in allowing you to choose the lighting ratio of those two parts of the image. When the ratio is something other than 1:1, it should be named "Unbalanced flash," but I refuse to use that term!

It is quite often useful to emphasize a foreground subject and minimize the background in an image by subduing its exposure. Recall the technique discussed in the butterfly example. Many images are improved by using balanced flash. Any subject illuminated solely by ambient light tends to have some merging of subject and background, whereas unbalancing the exposures of background and foreground can provide the coveted "pop"—the visual impact—to a subject. Indeed, I find I am more likely to darken the background while brightening the foreground, especially in close-up and landscape photography, than to actually equalize the brightness of both. Perhaps "Unbalanced flash" really is the proper term?

Balanced flash works well for landscapes as well as butterflies, flowers, close-up and macro as well as other subjects.

 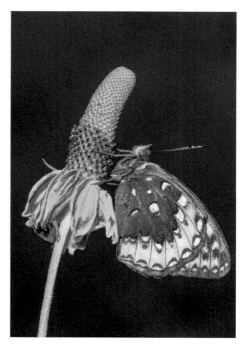

a) John found this female great-spangled fritillary sleeping on a cool morning. Knowing the butterfly could not go anywhere until the temperature warmed up, John used flash along with the shutter speed to change the brightness of the background relative to the butterfly. Canon 5D Mark III, 180mm macro, ISO 200, f/14, 1/3, Cloudy WB, one Canon 600EX-RT Speedlite set to +.7 FEC. Ambient exposure set manually.

b) Notice the background darkens as the shutter speed changes from 1/3 second to 1/8 second, a change of minus 1.3 stops of light. Now the dark butterfly more closely matches the brightness of the background in real life. The flash exposure on the butterfly is balanced with the ambient exposure for the background.

c) Increasing the shutter speed to 1/50 second eliminates virtually all ambient light. In all cases, the flash exposure is unaffected by changing the shutter speed, but the ambient light changes significantly. We never seek to make a background black for a diurnal subject. Notice how the dark edges of the butterfly merge with the black background. Those who prefer a black background should use flash to light the subject while increasing the shutter speed to remove ambient light.

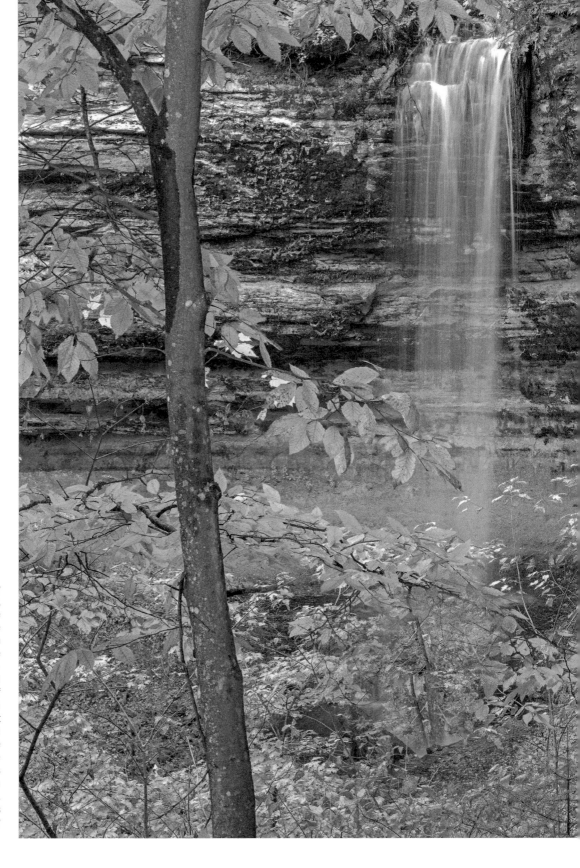

Munising Falls pours over a rocky outcrop a few miles east of Munising, Michigan. The tree to the left of the waterfall is in deep shade and some distance from the waterfall. John used a Canon 600EX-RT Speedlite mounted on a flash stand to balance the light between the tree and the waterfall. With the intention of focus stacking the entire scene, John took eight shots at slightly different focus distances for maximum overall sharpness. For each image, he made sure the Speedlite was ready to fire a full burst of light. The eight images were used to create one image with Helicon Focus stacking software. Canon 5D Mark III, 24–105mm lens at 70mm, ISO 200, f/8, 1/3, Cloudy WB, ETTL flash set to +2 FEC.

Balanced flash is especially useful for landscapes. Place the flash close to the foreground, and the Inverse Square Law prevents flash illumination of distant backgrounds. Take note that I said the flash must be close to the foreground. I didn't say the camera must be close. The insinuation (or hint) is that the flash and camera need not be in the same place. Simply put the camera as desired and then place the flash closer to the foreground region to be lit. I cannot stress enough that flash exposure is a function of the distance from flash-to-subject, not camera-to-subject. Any means of camera-flash communication is okay. When you use a radio or optical remote trigger, you can walk into the foreground (and into the image, if you like!) and illuminate the foreground region with one hand holding the flash and the other hand firing the camera with a wireless release. If using an optically coupled flash, don't stand between the flash and the camera. Otherwise, you risk blocking the signal. Be sure the flash's sensor can "see" the camera!

I live not more than 45 minutes from Old Faithful in Yellowstone National Park, and I often photograph the park's intriguing thermal features. I prefer the sunshine and blue sky illumination to clearly see the steam, but I'm not always lucky. Occasionally the weather is a dull overcast. How am I able to make attractive images in such loathsome lusterless light? Balanced flash, of course! The cloudy sky is considerably brighter than the geyser runoff that I want to shoot, and would be an important visual distraction in a straight photo. First, I establish an ETTR exposure of the background clouds, and by selection of shutter speed, drop it to taste, perhaps about two stops, to get a darker more dramatic background. Then I use my flash's FEC control to light up the geyser runoff area to the level I prefer. The resultant shot of a splendidly exposed geyser area against a dark and ominous sky can be very impressive indeed! Since I deliberately darkened the background with increased shutter speed to make the brightly illuminated foreground stand out, perhaps Unbalanced flash is the best term?

A caveat in landscape flash is to be wary of too much middle ground. If the foreground is extensive, it might be impossible to light all of it without resorting to heroically engineered lighting schemes. Therefore, this technique is best used when the foreground is close, there is little middle ground, and the background is distant. There are several methods to enhance the effectiveness of a flash.

Many subjects are much improved by a somewhat underexposed background and a brighter foreground sub-

ject. However, there is no guarantee that all images are enhanced that way. Indeed, some scenes benefit from the opposite treatment. Waterfalls are often a favorite subject of many an outdoor photographer. Many waterfalls are too large to treat this way, but some waterfalls and small water cascades flow over a background of dark rocks or even a dark cave. An image illuminated only by ambient light, where the water is correctly exposed, will often have the dark background as woefully underexposed shadow areas showing little or no detail. Once again, balanced flash saves the day. Set the ambient exposure for the water in the usual way, using shutter speed to control the "silkiness" of the flow. A good starting point might be ISO 400 at 1/2 second at f/11. Using your remote flash, walk over to the side of the waterfall and, with flash set to +2 FEC for lots of light, illuminate the rocks or background while firing the camera. Don't fire the flash through the water unless you want that particular effect. A mix of long shutter speed and flash produces a combination of silky appearing water and frozen drops, an effect we like a lot, but not all of the time!

Also, to have the camera in one place and the flash in another, you need a means of remote camera triggering. A friend at the camera or the flash will work, but even more helpful are various remote accessories for triggering the flash and the camera. Dedicated accessories made by your camera manufacturer are best. However, budget defensive accessories can be found on Internet auction sites. Before you buy any of them, make sure you fully understand their capabilities because many do not perform as reliably as the camera manufacturer's dedicated devices. Be especially wary of flash triggering devices that do indeed fire the flash, but do not enable TTL metering. When you buy twice, you exceed the cost of the camera maker's dedicated accessory! Please explain how buying two plus times saves money?

A TREE IN THE SUNRISE

Everybody loves to shoot a sunrise or sunset! Here's a great use for balanced flash. You have heard me mention that one student always hassles me and, in this case, he declares that sunrise and sunset shots should seldom be of sky alone or water alone, but must have something interesting in the foreground. Do you agree or disagree? Should you agree, the way to nicely light the foreground is to do what we have done before. Expose the sky to your own taste without using flash, and then use flash FEC to

a) Pete's Lake in Alger County, Michigan is a popular place for sunrise photography in October because the sun rises directly across the small lake. The image shows a fine silhouette of the maple tree in the foreground and the distant shoreline. Nikon D300, 18mm, ISO 200, f/16, 1/13, manual ambient exposure, 10,000K WB.

b) An SB-800 Speedlight is fired to light up the maple leaves in the foreground using −.3 FEC.

control the brightness of the foreground subject. In this situation, I use manual flash to make certain the flash emits all of its possible light. Should the light output need to be adjusted, use the power ratio, zoom setting on the flash head, and/or the flash-to-subject distance to reduce the light output. Using a red or orange filter (CTO) over the flash maintains the color of the flashed subject and keeps it consistent with the sunrise while giving it a nice touch. CTOs are inexpensive gelatin filters that require no optical refinement because they are covering the flash unit and are not in the optical path. Incidentally, don't overlook the opportunities to shoot a nicely flashed foreground against a dark starry sky, or shoot the Milky Way, using the same methods!

CHAPTER WRAP-UP

The past three chapters have covered fill flash, main flash, and balanced flash. Surely fill flash is the most widely recognized flash mode, but after a photographer takes command of the additional modes, Fill flash will likely not be used nearly as much. The capability of today's cameras and current photo editing computer software, shadow/highlight control or HDR techniques diminish the need for fill flash. Additionally, the abilities and flexibilities of main flash and balanced flash to significantly improve macro, landscape and other image subjects make them very powerful tools. Chapter 10 reveals the way to use flash in landscape photography in an entirely new way.

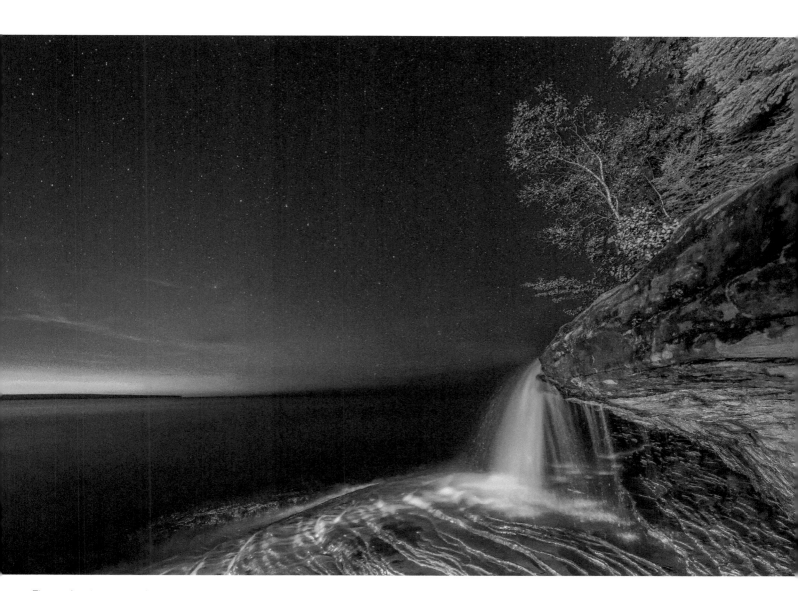

The evening sky makes a nice background for Elliot Falls. Nikon D3, 14mm, ISO 400, f/13, one second, manual ambient exposure, Cloudy WB. A Nikon SB-800 illuminates the waterfalls using auto flash with +1.3 FEC.

Flash in the landscape

Waves pound the beach as the evening sky turns a bright crimson color. The dark and gnarly tree standing ten meters in front of the camera is prominent in the viewfinder and nicely silhouetted against the flaming sky. Photographer Phil studies the scene carefully and sets 20mm on his wide-angle zoom, f/22 and 1/4 second, at the camera's native ISO 100. He routinely attaches and rotates his polarizer, this time to reduce some glare from the shiny water in the lake. Wishing to record texture and color in the now silhouetted tree, he attaches his flash. Phil's initial test shot is accompanied by a bright burst of light from the flash, but his LCD inspection reveals an irritating dark still silhouetted tree. The flash failed to add any detectable light to the tree. Phil's flash fired at full power. Do you know what went wrong?

THE MISERY OF MEAGER FLASH

Most dilettante flash users are bedeviled by the above occurrence. Nearly all photographers so afflicted quickly abandon outdoor and landscape flash, convinced that their dedicated flash just can't generate enough light to cover landscapes. But that's not true. The flash failed to light the tree not because it was lacking luminous power but because the flash was essentially "murdered." Lawyers among you will gag at the word misuse, but it does express the essence of the problem. Phil's setup parameters of ISO 100, f/22, the use of his polarizer and a wide-angle lens all combined to minimize the effect of the flash's light that hit this tree. Phil's flash was perfectly adequate to light the tree. It just needed a helping hand—which we are going to give him!

I encountered this identical problem with my first digital camera in 2003. Due to the instant feedback of those new-fangled cameras, I was able to experiment with different camera settings as I sought to light my own tree, or subject at that time, my landscape shot involved. Over many years, I've come up with a long list of ways—in fact, an ever-growing list—to aid the ordinary dedicated flash in lighting larger and more distant subjects. Let's explore my list and in so doing, you'll

Standing prominently against the night sky is this huge rock in Arches National Park. Two Canon 600EX-RT Speedlites were fired simultaneously to light this distant (50 yards) and towering rocky peak. You will be amazed at the distance a flash can light when you use ISO 6400 and f/2.8 at night! Canon 5D Mark III, 16–35mm at 16mm, ISO 6400, f/2.8, 15 seconds, 3200K WB.

The King of Wings is remote, difficult to find, somewhat dangerous to reach, and awesome to behold! This incredible hoodoo, capped with a gigantic wing, is perched on a ridge south of New Mexico's Bisti badlands. To be able to illuminate such a large hoodoo, John used several tactics using his Canon 600EX-RT Speedlites to illuminate the entire hoodoo. Tactics include a higher ISO, two Speedlites fired simultaneously for both images of a double exposure, reducing the flash to subject distance, zooming the flash head to 200mm, using manual flash, and choosing a more open f/8 aperture. Canon 5D Mark III, 24–105mm at 32mm, ISO 400, f/8, 1/200, Cloudy WB, two Speedlites fired twice during a double exposure.

discover that your own dedicated flash offers numerous ways to effectively light a landscape.

Returning to flash-frustrated Phil, let's evaluate his camera setup. First, we will explore the flash using the guide number method, and then march resolutely into new territory to supercharge your flash and your flash skills.

Do you recall the guide number formula from Chapter 1? It offered that:

Guide Number = Distance × Aperture
GN = D × A

GN is the flash's guide number and D is the *flash-to-subject distance* and A is the aperture. Look again at "D." Don't incorrectly use camera-to-subject distance unless the flash really is at the same distance as the camera. And if you need to look at the formula from a different direction, the same formula rewritten also means that: D = GN ÷ A and A = GN ÷ D.

The guide number of one popular dedicated flash (Canon 600EX-RT Speedlite) is 196.9 feet (60 meters) at ISO 100 when the flash head is zoomed all the way out to 200mm. Nonetheless, the dedicated flash automatically self-zooms to the focal length of the lens in use. When self-zoomed for Phil's 20mm lens, the flash's guide number had dropped to 26 meters. Remember that flash guide numbers act like stops which translates to approximately two stops of light loss! Next, consider the polarizer. A typical polarizer attenuates nearly two stops of light, effectively reducing the flash guide number from 26 meters to a paltry 13 meters.

So how effective is a GN of 13 meters, you ask? Recall that Phil's hypothetical tree was ten meters away. With Phil's "murdered" flash having an effective guide number of 13 meters, the maximum distance that his flash at full power would properly expose the tree with f/22 and ISO 100 is: D = GN ÷ A = 13 meters ÷ 22 = about 0.59 meters or less than a couple of feet!

Wow! No wonder that tree was so grossly underexposed! And no wonder so many frustrated novice flash users abandon outdoor flash. Wait! Wait! There is more to

The South Fork Indian Pictographs near Coral Pink Sands Dune State Park in Utah are protected with a fence forcing one to shoot from 30 feet away. To reach that distance with flash, John did not use a polarizer, zoomed the flash head to 200mm, used a more open f/13 aperture, and ISO 400. Canon 5D Mark III, 70–200mm lens at 200mm, f/13, 1/20, Flash WB, and one Canon 600EX-RT.

Change made in setup	Increase in light transmission or camera sensitivity	Effective guide number after change (feet)	Effective guide number after change (meters)
Remove polarizer	+ two stops	85.3	26
Re-zoom the flash head	+ two stops	170.6	52
Change from f/22 to f/11	+ two stops	341	104
ISO 100 to ISO 1600	+ four stops	1364.8	416

Finally, let us review the tree's illumination:

$$D = GN \div A = 416 \text{ meters} \div 11 = 37.8 \text{ meters!}$$

Initially, I marveled at how a guide number had been "murdered" down to 13 meters by only four inappropriate choices of setup parameters. Now look at the enormous rehabilitation of the guide number when the same four choices were wisely corrected. Can Photographer Phil now light a tree that's ten meters away? Absolutely!

TACTICS FOR LIGHTING THE LANDSCAPE WITH FLASH

I continue to urge workshop students to experience the splendid landscape images obtainable by using flash, and not surprisingly, I've seen that the more logically I can explain the techniques, the more enthusiastic the students are. For several years I have been progressively accumulating a list of methods for making your flash more and more effective at lighting landscape images. Now I am going to list 20 of those methods here. Yes, some may seem obvious, and they often are, but never forget that fundamental law of photography: nothing in photography is complex, only that you must remember a million simple things! A good idea forgotten is useless! I will keep repeating, while your job is to remember as many as you can.

1 PURCHASE A POWERFUL FLASH

Comprehend? I told you some methods would be obvious. My pal, a former race-car driver had a saying: "No matter how fast you go, somebody out there goes faster!" It probably follows that somebody out there can sell you a more

tell! Assume we raise the ISO to 1600. From ISO 100 to ISO 1600 is a four stop increase in light sensitivity. Next remove the polarizer in order to gain another two stops. Then manually zoom out the flash head to its highest position at 200mm. Lastly, one more refinement; change the aperture f/22 to f/11. Tabulating our changes from the impoverished GN = 13 meters, and remembering that a two-stop increase change is a doubling of the guide number, we can understand that:

powerful flash. Yet when it's time to buy a new flash, and you can't buy the most powerful of all, be sure to remember that the higher the guide number, the better the flash works for landscape work. The GN of a new flash acquisition should be one of your top priorities. My strategy: I buy the most powerful flash made by my camera maker.

2 INCREASE ISO

An ISO increase has absolutely no effect on how much of your flash's reflected light reaches your camera's sensor. Even so, an increased ISO allows your camera to make more effective use of whatever light does indeed arrive at the camera. As usual, there are factors to balance, and

in this case, it is image noise. Does the image noise at higher ISOs become objectionable? If not, continue on. If so, don't forget that modern image editing software can work magic in improving images. Occasionally, even a noisy image is far better than no image. A noisy image of infamous skyjacker D. B. Cooper, flashed in the middle of a gloomy forest in the dark of a moonless night, would make you very famous indeed!

3 AUGMENT APERTURE

One of the best ways to increase the "reach" of your flash is to open up the aperture. If you use f/8 instead of Phil's selection of f/22, the benefit would be an additional three

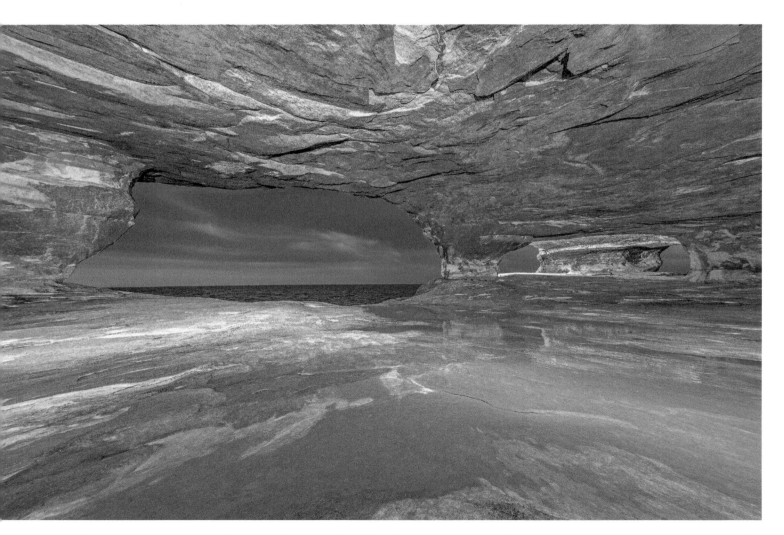

Sea caves are fascinating places that offer many creative opportunities. This particular cave grows ever so slowly when gigantic Lake Superior waves smash into it. When using three Canon 600EX-RT Speedlites mounted on flash stands simultaneously, and stopped down to f/16, John still could not cover the depth and optimally light the cave. Instead, John used f/4, a four stop gain of light from the Speedlites striking the sensor, and this was plenty to fully light the cave. He shot eight images while focus stacking his way through the cave to achieve excellent overall sharpness. Focusing stacking and flash is a powerful combination. Shoot wide open to enable the flash to light more, and focus stack to achieve the sharpness! Canon 5D Mark III, 16–35mm at 18mm, ISO 500, f/4, 1/80, Cloudy WB.

stops of light. When a lot of extra light is needed, use the maximum aperture of the lens, perhaps f/4 or even f/2.8. Balance the factors encountered. This time it is depth-of-field. The larger our aperture in the pursuit of light, the shallower the depth-of-field. When an important part of our composition is out of focus, the shot is lost. How is it possible to benefit having considerable light improvement of the larger aperture and still keep the desired subject matter in focus? Read on!

4 FOCUS STACKING

Focus stacking is an absolutely fascinating technique that allows use of any preferred aperture, even the largest our lens offers, while at the same time still having everything in the frame in crispy sharp focus! Magic, you ask? No, simply focus stacking. I won't explore the technique in depth here, but do be cognizant of the fact that focus stacking allows any desired depth-of-field, at any aperture you select. You might opt for the widest aperture available to maximize receptivity to light, or perhaps choose the lens's "sweet spot," the aperture of greatest sharpness, usually one or two stops down from the maximum aperture. The main thing to remember is to start the stacking series with fully charged flash batteries. If you hanker for yet one more thing to remember, be sure to let the flash unit fully recharge between shots. Both of these components are essential in order to give your software frames similarly exposed images, be it Photoshop, Helicon Focus, or Zerene Stacker. Excessive exposure range will surely give your software a digital headache, but the large aperture and focus stacking combine to rehabilitate the deplorable result from f/22.

5 LARGER APERTURE LENSES

Focus stacking enables capturing extreme depths of field even when using the maximum aperture offered by the lens. If using a 24mm f/4 lens, the amount of light from the flash emitted through the lens is four stops more at f/4 than f/16. Focus stack using f/4 to obtain even more depth of field than offered at f/16. To add another stop of light from the flash, use a faster 24mm f/2.8 lens wide open at f/2.8. Though expensive and heavy, an f/2.0 lens gets you another stop of light! Combining the maximum apertures of fast lenses with focus stacking becomes a highly effective way to increase the range of your flash. I regularly employ focus stacking to maximize the lighting capability of my Canon 600EX-RT Speedlites.

6 TACKLE THE TILT LENS

Can you pronounce "Scheimpflug"? I can't, but I know that in 1904, the esteemed Austrian Army captain showed how tilting a lens in a certain way can substantially increase image sharpness at wide apertures. The Scheimpflug Principle again needs more space than presently available for a full explanation, but the bottom line is this: by adjusting the tilt lens in a proper manner, a shooter can bring a foreground and a background both into sharp focus at wide apertures. The tilt lens does not change the depth of field. It does, though, change the so-called "plane of focus" from the usual parallel-to-the-sensor plane into a new plane determined by the subject matter.

Summarizing, a tilt lens offers an additional way to maintain landscape sharpness foreground-to-background, while still using the wide aperture so helpful in optimizing a flash's output. Tilt lenses, however, are expensive, and focus stacking will produce at least equivalent if not better results.

7 PROHIBIT THE POLARIZER!

All basic photography books that I've read, and even the ones I have written, point to the polarizer as the one indispensable filter for outdoor shooting. A polarizer is enormously helpful in reducing glare, increasing color intensity, darkening blue skies, and much more. Most of the time the polarizer is highly beneficial. Despite that, choices must be made. The time a polarizer should not be used is when the priority is on maximizing flash effectiveness. Removing the polarizer from the front of the lens removes about two stops of light attenuation. The result gives the same effect as a two-stop increase in the Guide Number. When the flash-to-subject distance remains constant, removing the polarizer gains up to two stops of aperture light. A properly prodigious perk that deserves a prominent place on your "Remember This" list!

Think of any other filter you may be using. Because most filters absorb light, they reduce flash effectiveness. All filters should always be removed when not absolutely essential for the shot.

8 DUMP THE FLASH DIFFUSER

Most dedicated flashes come with some form of diffuser. Most often, a translucent white plastic "dome" snaps in place over the flash's head, or perhaps a white translucent panel deployed by pulling it out of a storage slot in the

flash unit head. Some flashes provide both. Landscape photographers are counseled to avoid any diffusion, whether it be a component of a dedicated flash system or some third-party device. Agreed, a single light source can emit very harsh light indeed, but in nearly all landscape shooting, power has priority! Besides, in landscape photography with flash, contrast is more likely controlled by using multiple flashes, firing one flash more than once, or most commonly mixing flash with ambient light.

9 TABLE THE TELECONVERTER

As you undoubtedly know, teleconverters serve to magnify the optical power of a lens. The laws of optics show that teleconverters must attenuate light, and so they do. The 1.4x and 2x teleconverters absorb one and two stops of light respectively. It follows then, that when light intensity is important in outdoor flash photography, it is prudent not to use a teleconverter. Instead, either use your longer lens or use your "ten-toed magnifier" and walk closer to your subject.

10 ESCHEW THE EXTENSION TUBE

Extension tubes are more commonly used to increase magnification in macro work, but are sometimes used to reduce the minimum focus distance (MFD) of longer lenses. Neither usage has much application to landscape shooting, and all uses attenuate light. The degree of attenuation depends on the tube length and on the lens focal length in use, so I can't state it specifically. Enough light is lost to warrant extremely skeptical attention in your landscape flash work, where you need all of the light you can muster!

11 FORGET THE FLASH FILTER

It would be wrong to say forget the flash filter entirely, but definitely some of the time is realistic. The reason is that the flash itself has a color temperature approximating that of the sun. It is a neutral color that generally works best for most outdoor images, but not always. A good example where neutral flash color doesn't work is flash illumination of a foreground in the red light of the rising or setting sun. A neutrally-colored beach against a red background definitely appears unnatural. A good fix is to use gel filters over the flash head, causing the flash illuminated image areas to look more like the reddish ambient light. I like to use a set of CTO (Color Temperature Orange) filters

from *Honl Photo* for this purpose. From my testing, I find the various CTO's absorb differing amounts of light. The densest CTO (1) absorbs 1.3 stops of light. The other CTO densities: 3/4, 1/2, 1/4, and 1/8 absorb 1, 2/3, 1/3, and 1/3 stop respectively.

The point to be remembered is that CTO filters don't attenuate lots of light but, like most filters, they do attenuate some. The careful shooter always considers light brilliance as the top priority and uses filters only when necessary. However, during the time when I was working with the final edits on this book, I found myself increasingly using CTO filters to balance or sometimes unbalance the flash's light with the ambient, and to selectively color the subject illuminated by the flash. Since CTO filters don't absorb a lot of light, often it is best to use them to solve color problems.

12 COMPLEMENT THE COMPENSATION

Flash Exposure Compensation (FEC) is another way to force the flash to emit more light. One can often enter some positive value for the FEC and thus increase the output from the flash. That is true, obviously, only if the flash is not already outputting full power and has nothing more to give. If not already at full power, there is additional light power easily obtainable for your landscape flash images.

13 DIMINISH THE DISTANCE

Not particularly wishing to harass you, the important distance in flash exposure is the distance between flash and subject. It is *not* the distance between camera and subject. That sometimes inconvenient incontrovertible law of physics implies a means of operating a flash unit that's not mounted on the camera. You can use a cable connection of adequate length. You can use a light pulse optical system, albeit limited to line-of-sight applications. Better yet, you can use a versatile radio based system like the one now integral to the Canon 600EX-RT or the 430 EX-RT Speedlites, or a third-party offering, the gold-standard being the PocketWizard systems.

The buddy system is effective too. By the way, the buddy system is quite flexible. Either the buddy stays with the tripod-mounted camera and releases the shutter when so ordered, or the buddy carries the flash to the desired position and properly aims it. Here's a bonus: any remote system can be used within its limitations to attractively sidelight or backlight the subject.

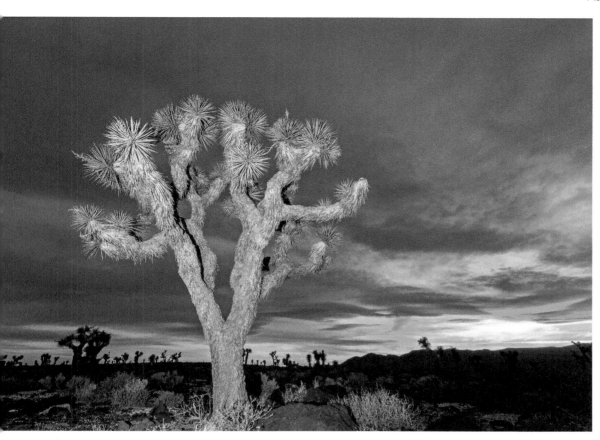

a) Remember that an unfiltered flash emits a light similar in color to midday sun. Often it is better to filter the flash to more closely match the prevailing ambient light. Notice how the relatively white light from the Canon 600EX-RT Speedlite looks unnatural in color with the warm colors of the setting sun. Canon 5D Mark III, 16–35mm at 16mm, ISO 400, f/11, 1/40, 10,000K WB, FEC +1.

b) Placing a 3/4 CTO gel filter on the flash head makes the light emitted by the Speedlite more yellow to approximate the warms color at sunset. The Honl Velcro Speedstrap wraps around the flash head making it easy to attach Honl CTO (color temperature orange) gels to the flash.

Backlighting and sidelighting have their own virtues, but frontal lighting can sometimes be adequate without a remote flash. If more light is necessary, any of the remote flash systems permit reducing the flash-subject distance to a degree that dramatically increases the effect of the flash unit. It's not difficult to get an additional two stops by holding the flash half of the distance from the subject as the camera—a benefit I enjoy whenever the subject permits. Since I typically photograph landscapes alone, I always have four flash stands in my vehicle which can be used to support one or more flashes considerably closer to the subject than the camera. Obviously, I make sure neither the stand nor the flash appear in the image.

14 THE DREAM BEAM

Nearly all flash units sold today allow adjustment of the area covered by the flash beam. One popular unit (Canon 600EX-RT) allows the beam to be automatically adjusted to suit the coverage of the lens in use, from 20mm to 200mm. Nevertheless, it is not our dream beam! While still adequate for most indoor work, we outdoor flash shooters of either close-ups or landscapes generally use flash for lighting only a portion of the overall scene. So irrespective of the lens focal length on the camera, it is best to generally zoom the flash to some narrower than default beam in order to most effectively light that special part of the whole image.

Once you've reduced the flash beam width to the narrowest appropriate for the subject, then simply use the FEC control as usual to set the exposure. The data for one popular top-of-the-line flash in the table below emphasizes the tremendous benefit of a narrow beam. Incidentally, when you prefer GN to be in meters, divide the "feet GN" by three to get the approximate number.

Flash zoom position (mm)	Approx. GN at full output (feet)	Flash zoom position (mm)	Approx. GN at full output (feet)
14	49.2	70	164
20	85.3	80	173.9
24	91.9	105	190.3
28	98.4	135	193.6
35	118.1	200	196.9
50	137.8		

Notice that the change in light output from a zoom position of 200mm and a zoom position of 135mm is not great, but to go from a 28mm zoom or 35mm zoom to a 200mm zoom approximately doubles the GN, a whopping two stops more light! So, to obtain your "dream beam"—the beam that covers your subject yet still provides maximum light—be sure to zoom your flash to the highest zoom number your subject allows.

15 POINT PRECISELY

Most likely, it is condescending to persist in promoting precise flash pointing, but you would be surprised at how forgetful some shooters can be and equally surprised at how important it can be. Think of this: in the last section we discussed the merits of "tight zooming" which of course narrows the beam of the flash. And the narrower the beam, the more important accurate aiming becomes. At a 200mm zoom setting, it takes only a few degrees of error to miss the target completely and even fewer degrees of error to unevenly light the subject or target. Compounding those unhappy results is the difficulty in aiming the flash when no light is being emitted. A small narrow beam LED flashlight taped to the flash can help. Yes, it's one more thing to remember. I have not yet resorted to the flashlight trick, but a minimum of 40% of my flash students are pointing-challenged, and those should seriously consider using the LED flashlight trick!

16 THE MULTIPLE MERITS OF MANUAL FLASH

Automatic flash metering is a complex optical and electronic process that attempts to determine how much light the flash should emit. Even a stray high tonality spot in the foreground or background can easily cause the flash to fire at less than full power. Moreover, the modern flash unit fires preflashes to measure the subject tonality. Irrespective of the power level commanded by the preflash measurement, the preflash itself consumes power. The main flash burst occurs "immediately" after the preflash so the energy storage capacitor in the flash unit has inadequate time to regain the energy consumed by the preflash. Engineering minded readers will please forgive my somewhat liberal use of the word "immediately" but

(opposite) Mission San Xavier Del Bac near Tucson, AZ is fascinating to photograph, especially in the evening hours. A large historical building, Barb zoomed her Nikon SB-800 Speedlight to the longest focal length and carefully pointed the flash straight at the mission to light it. Nikon D4, 38mm, ISO 1600, f/3.2, eight seconds, 2500K, manual ambient and flash exposure.

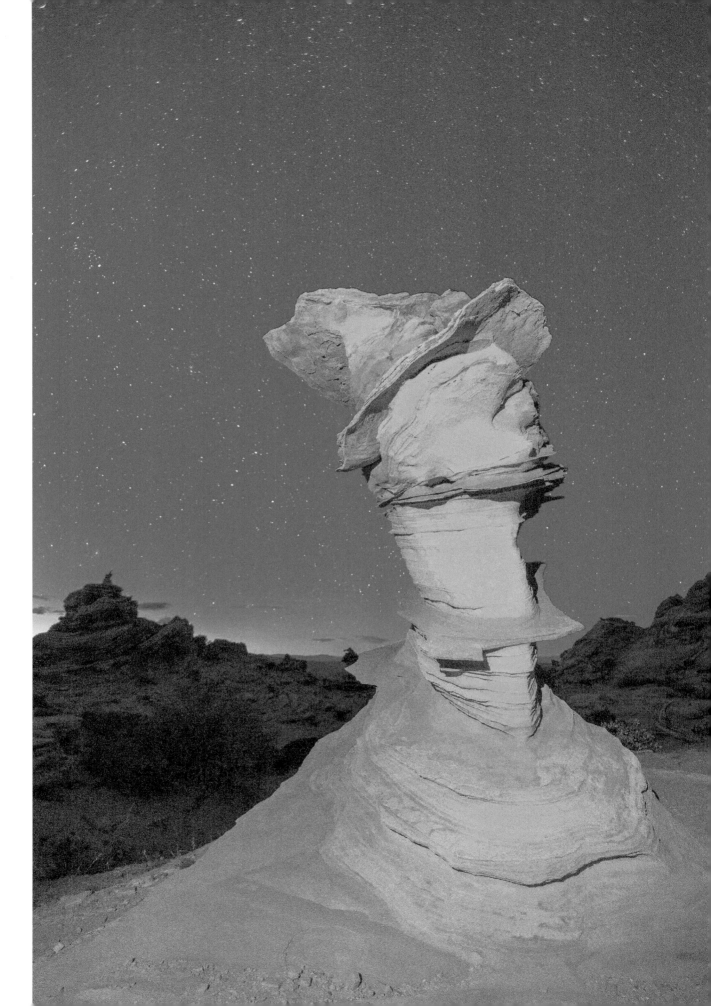

(opposite) Weird rock in South Coyote Buttes is an unbelievable creation of erosion over time. Using a 1/2 CTO filtered Canon 600EX-RT Speedlite, John first focused on (and exposed the rock) with flash using f/13 at 1/160 second to prevent the night sky from appearing in the image. The Flash WB was used. John tried several attempts until he got the image he wanted of the rock. After that he used the multiple exposure mode on his Canon 5D Mark III to select the best image of the rock and make it the first of a double exposure. John next manually focused on the stars using a magnified live view image, changed the exposure to f/2.8 for 20 seconds and set 3000K WB to make the starry night sky look enchanting. Note that for the second shot of the double exposure, he did not use flash.

it does illustrate the issue, i.e. that the power of the main flash burst has been diminished about 1/3 stop by the event of the preflash. Kindly note that the 1/3-stop loss is only an issue when the flash has been commanded to fire at full power, whereas at a commanded power lower than full power minus 1/3 stop, no problem exists.

I see two potential problems with ETTL flash which are the error of scene tonality irregularities and the possible error of loss of full power caused by preflashes. Is there a way to solve both problems? Of course! Thank you for asking. Simply set your flash unit to manual mode, set the power level to whatever is necessary, including "Full," and voila! No power is wasted by metering irregularity and none by preflash energy loss since no preflash is emitted when the flash is used in its manual mode.

How do I know at what level to set my manual flash? One method is the flash exposure meter. I have a couple of these expensive gizmos, but with modern cameras, I no longer need or use them. I take a guess at a power level, shoot the image, and immediately check the histogram and highlight alert for flashing highlights or "blinkies." If I need to raise power, I do. If I need to lower power, I do. I manipulate effortlessly the flash power. Read on.

Hopefully having convinced you to be receptive to your manual flash mode, let us re-visit the many methods available to adjust the amount of light output, and refine our exposures. Assume your first test shot was too bright and you need to reduce the flash output. You have these means available, each within their limits:

- Reduce the aperture.
- Lower the flash power level.
- Widen the flash zoom setting.
- Increase the flash-to-subject distance.
- Use a hard-plastic dome diffuser that may have come with your flash.
- Use a pull-out diffuser that may be a component of your flash.
- Use a third-party diffuser.

- Milady's white silk handkerchief can work fine, and if she demurs, a layer or two of scrap paper towel is guaranteed to work just as well.

Suppose now that a wee bit of over enthusiasm in applying one or more of the above corrective devices resulted in an underexposed test shot, and you have to add some light. Another list? No way. Quickly use the above list, review your changes, and remove or reduce them appropriately.

17 USE A FLASH EXTENDER

Wildlife photographers, and especially bird photographers, often use a "flash extender" to concentrate the light output of a flash. A flash extender is one way to enhance your flash output and versatility. The flash extender is sort of a "super zoom" comprised of a Fresnel lens and a mounting means to attach it to the flash head. The Fresnel (say: fray-NEL or FREZ-nel) lens that concentrates the light from your flash is a photography specific form of lens used in many optical tasks. Large, heavy, and very expensive, glass Fresnel lenses have been used in lighthouses for about 200 years, but they can take the form of an inexpensive thin plastic sheet like those commonly used as magnifying lenses, and yes, the ones used in flash extenders. Most photographers use the "Better Beamer" variety of flash extender. While it does not increase the flash output, it can concentrate light where you most need it.

18 FIRE ONE FLASH MULTIPLE TIMES DURING A LONG EXPOSURE

When a flash has been fired at full power, essentially all of the electrical energy stored in the flash's capacitor has been used. One must now wait—perhaps three to five seconds—while the capacitor is re-charged and before the flash can again fire at full power. Yet, sometimes, a nighttime exposure goes on and on. Many exposures last for 20 seconds, or even much more, especially when one is doing the increasingly popular night sky photography. During those extended periods when the shutter is open, one can manually fire a flash every time the "flash-ready" indicator shows the flash has fully recharged. To my knowledge, all high-end flash units have a push-button to manually fire them. During a long exposure, several flash bursts can be fired. An enterprising shooter has the option of firing multiple bursts at a single area or subject, thus considerably brightening it, or perhaps even use the multiple bursts to light multiple areas or multiple subjects.

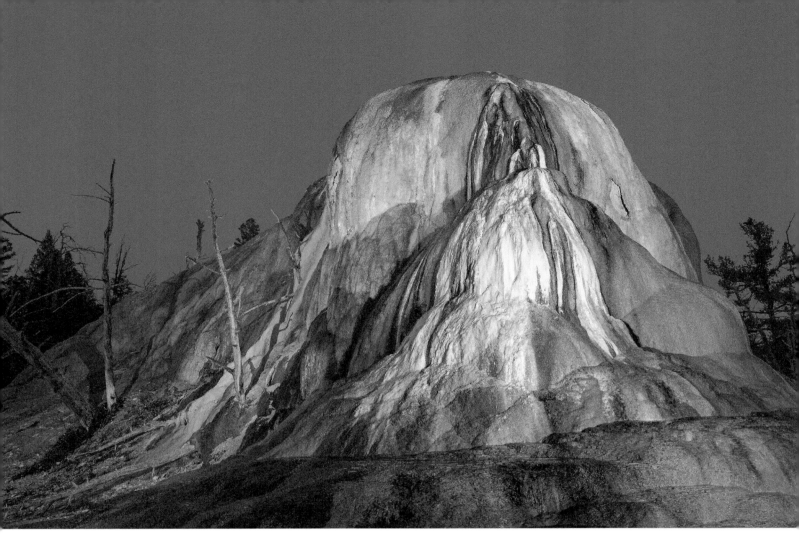

John used a 1/2 CTO filtered Canon 600EX-RT Speedlite to expose Yellowstone's Orange Spring Mound at twilight. John used a four-shot multiple exposure to fire the flash manually at full power, four times, to illuminate the large mound. He handheld the Speedlite to fire two flash bursts on the right side, and then two on the left side to fully light the mound. Canon 5D Mark III, 24–105mm at 32mm, ISO 500, f/14, 1/15, Flash WB.

19 USE MULTIPLE FLASH

When it comes to multiple flash, the old saying might be true, 'If a little is good, more is better.' Most outdoor flash users would enthusiastically crave for more flash units. The fabled "Two-gun Wild Bill Hickok" could probably have fired two flashes alternatively and doubled the number of flashes during a long exposure. So can you. Adding a second flash of equal power provides another full stop to the exposure. The second flash allows a second area or subject to be illuminated. Yes, the more the merrier, but remember that the third flash will not add one more stop. But the fourth one will. If you have four flashes, how many more do you need to gain another stop of light? The number of flashes must double, so the answer is eight! You can always find use for as many flashes as you can afford or carry, and don't forget that you can borrow a flash or two from a cooperative nearby photographer. It is only

required that the wired, optical, or radio triggering system will fire them all. While keeping in mind the practical limits as well, I truly can't light up a mountain one mile away no matter how many flashes I have (at least not yet), no matter how much I wish I could.

In the field, I routinely use four Canon 600EX-RT Speedlites simultaneously. Three are mounted on light stands and the fourth one I hold and point where its light is most needed. I am usually some distance away from my tripod-mounted camera and fire the camera with my carefully pointed handheld flash by pushing the release (REL) button on the Speedlite. Even I can do two simple things—point and fire—at the same time! So can you!

20 MULTIPLE EXPOSURE

I've already mentioned that I've long endeavored to discover new ways to illuminate landscape subjects at greater

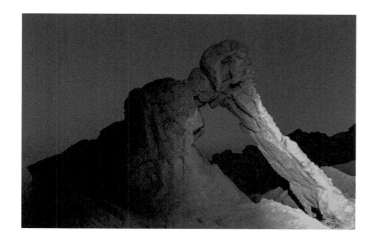
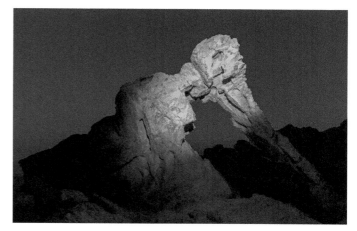

Elephant Rock is one of the big attractions at Valley of Fire State Park near Las Vegas, NV. John fired a single 1/2 CTO filtered Canon 600EX-RT Speedlite during each exposure of a four shot multiple exposure to produce the final fully illuminated image. John calls it light painting with flash as he lights different portions of Elephant Rock. Could you light paint this with a flashlight? No way! The sky was much brighter than it looks. Notice the 1/200 second shutter speed that is used to darken the bright sky. The fast shutter speed makes it impossible to light paint with a flashlight because there would not be enough time. Canon 5D Mark III, 16–35mm at 16mm, ISO 500, f/13, 1/200, Daylight WB.

and greater distances. It is often uttered that teachers learn from their students through teaching, and my workshop students are certainly no exception. Additionally, I've been fortunate enough to have some really sharp students who have become good friends over the years. One of them is Al Hart, who has been instrumental in editing several of my photography books and who regularly attends my Michigan summer workshops. At one workshop session, when I asked if anybody could think of one more way to increase long distance flash effectiveness, Al immediately offered: "Multiple exposure." Multiple exposure! Of course! How did I overlook such a powerful technique?

Many, if not most, modern "serious" cameras offer a multiple exposure mode, and it is a splendid feature for the outdoor shooter. One can fire the flash at the same target a number of times, or can light multiple targets too.

As an aside, I've thought long, practiced a great deal, and tremendously enjoyed figuring out and sharing all of these ways to make flash so exceptionally more effective than usually thought. Neither the current literature nor the Internet present comprehensive information on the subject and certainly nothing like we've explored here. Yet, if I ever assumed that the list was complete, I'm sure I would quickly be corrected. So, if you can show me and/or my students an additional method to improve outdoor flash, please tell me about it by sending an email to me at: info@ gerlachnaturephoto.com.

MULTIPLE EXPOSURE ALLOWS GREATLY INCREASED FLASH OUTPUT

When a single flash burst fails to adequately light a target, perhaps adding a second burst will fill the void. While it is possible to manually fire a flash two or more times during a long exposure—eight seconds, for example—it doesn't work when the shutter speed in use is two seconds or faster. The exposure must be long enough for the flash unit

A 1/2 CTO filtered Canon 600EX-RT Speedlite is fired three times during a triple exposure to add light to the silhouetted Wilson Arch at dawn south of Moab, Utah. Canon 5D Mark III, 16–35mm at 17mm, ISO 800, f/11, 1/80, 10,000K WB, manual ambient and flash exposure.

to fully re-cycle. The flash re-cycle time is battery condition dependent, a complicating factor. In addition, the long eight-second shutter speed is not so often appropriate for the ambient lighting. Invoking long exposure noise reducing procedures, i.e. NR, adds yet another complicating factor. So what is the poor light deprived photographer able to do?

Using multiple exposure methods turns out to be the least complicated answer. Most current cameras will allow multiple exposure. How is the overexposure from ambient light handled? The easy answer is, for a double exposure, just reduce the metered exposure by one stop, using ISO, aperture or the shutter adjustment. Some modern cameras will do the exposure adjustment automatically. Use the Average option with Canon and the Auto Gain with Nikon. Moreover, cameras which allow double exposure generally allow multiple exposures but only up to a certain limit. As but three examples, the Canon 5D Mark III can process up to nine exposures and Nikon's D810 and D4 can handle up to ten. Think of that! You are able to fire a flash at full power nine or ten times to produce a single exposure! Woo-hoo! The excitement begins. Do you want yet another thrill? Use a second flash unit to get 18 or 20 full power bursts per exposure! To paraphrase the late Senator Everett Dirkson, "A few flashes here and a few flashes there and pretty soon you're talking real light"!

I truly love the flexibility and bright lighting opportunities of the multiple exposure technique. Let me recount a specific case in point. I was photographing the man-made stone formation called False Kiva in Canyonlands National Park. The Kiva needed two flash bursts to adequately light both the front and the rear of the rock formation. Naturally, I have more than one flash unit, although it is a

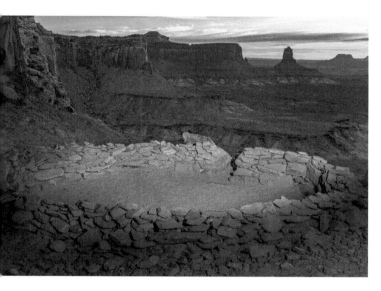

a) Using the double exposure tactic, John used a Canon 600EX-RT Speedlite zoomed to 200mm to light the back of the round structure.

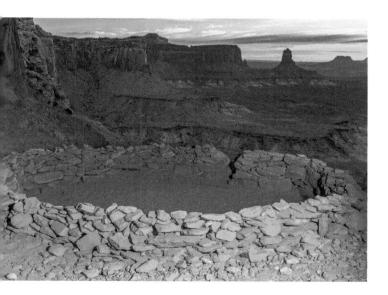

b) Then he zoomed the flash head to 24mm to light the front.

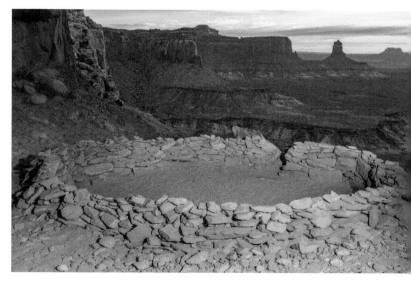

c) The camera combines both exposures to produce the final result. Canon 5D Mark III, 24–105mm at 35mm, ISO 800, f/16, 1/160, Cloudy WB, both ambient and flash exposure set to manual.

False Kiva in Canyonlands National Park has a terrific view that ancient inhabitants surely enjoyed. The foreground is under a large rock overhanging so it is pitch black. A single flash cannot evenly light up the round rock structure in the foreground.

hassle to point two flash unit's handheld at different areas simultaneously. So I followed this sequence:

- Determine the optimum ambient light exposure for the background, keeping in mind that sometimes it is desirable to make the background darker (usually) or lighter than it really appears. The dark foreground will be illuminated later by the flash.
- Compensate the ambient light background exposure for the upcoming double exposure.
- Set exposure manually by reducing the proper ETTR exposure by one stop.
- Set your camera, if possible, to do it automatically.
- Set the flash unit to manual exposure and full power.
- Zoom the flash head to 50mm, illuminating the foreground object only a few feet from the flash.
- Make the first exposure.
- Zoom the flash to 200mm to properly reach the rock formation farther from the flash unit. Carefully aim the now narrowed beam of the flash and shoot.

The camera combines the two images into a single image in which the ambient light properly exposed the background, and the two flash bursts combined to light the circular rock formation in the foreground. Certainly that is a lot to read and follow but it is truly feasible once you decide to think it through. You must not only think *about* it, but in the field you must think *of* it.

Overcast or cloudy days are no impediment to terrific images. The ambient exposure can be lowered to produce ominous appearing stormy skies while the foregrounds are properly lit by multiple flashes. However, an oft-encountered problem is often excessive ambient light. Assume a dark cloudy day at noon. The ambient light is about four stops darker than bright sun conditions. For bright sun, the oft-quoted Sunny Sixteen rule would say ISO 800, 1/800 second, and f/16. Just the same, my present four stops down sky condition, a good ETTR exposure could be ISO 800, 1/800 second, and f/4. Even so, I want the clouds to be underexposed two stops from normal for that dark and menacing appearance, so I raise my shutter speed two stops to 1/3200 second and take the shot. Now is the time to add the flash. My camera was set at ISO 800, f/4 and 1/3200 second. To lower the shutter speed to the flash sync speed of 1/200 second—a light increase of four stops—and maintain the exposure, I must reduce the aperture by four stops. Now my f/4 aperture must go to f/16. Whoa! The f/16 aperture grievously wounds my flash. I have long searched for an answer to the problem of how to avoid small apertures on bright days. Hi-speed

sync is not the answer because of the much-reduced effectiveness of the flash when used in this mode. There is one solution, requiring considerable patience, and that is to shoot only in the dimmer ambient light of dawn or dusk or on seriously dark cloudy days. At some lowered level of ambient light, it is possible to render the background as you like it, at a large aperture, and at or below the sync speed. If you know of a viable technique for conquering the "too much ambient light" predicament, when you share it with me, you will be awarded the coveted "Flasher of the Year" certificate!

If only camera makers would do away with mechanical shutters, and make cameras with electronic shutters with sensors that can be instantly activated and then deactivated to perform the job of the shutter like those found on some point and shoot cameras. This would be an enormous game-changing camera allowing for far more control over the ambient light and permit a full-powered burst of light from the flash at any shutter speed! How about it camera makers? While I am dreaming, let me add a wish for cameras having ISO 12,500 with the ISO 400 quality of today. Now that would be one more game-changing event for all photographers worldwide.

USE COMBINATIONS TO GET THE LIGHT YOU NEED!

I always use several of the 20 ways to help the flash simultaneously light objects in the landscape. Using a higher ISO, zooming my Speedlite to 200mm, and using a larger aperture are nearly always three of my choices. It doesn't end there. Think about the possibilities when you use four flashes simultaneously and shoot an eight-shot multiple exposure to make the image at night with ISO 3200 and focus stack a large foreground object at f/2.8! Combining these techniques allows lighting larger and more distant objects with flash than you ever thought possible!

I have confidence this information has energized you to open your landscape photography to using the wonderful benefits of flash. I have put a significant amount of thought into how to use flash profitably in landscape work and developed these tips. The journey from how one can possibly use flash in the great outdoors to the destination of skilled user is fun and rewarding. Get started! Begin by conquering uncomplicated, elementary lighting first but continue to grow.

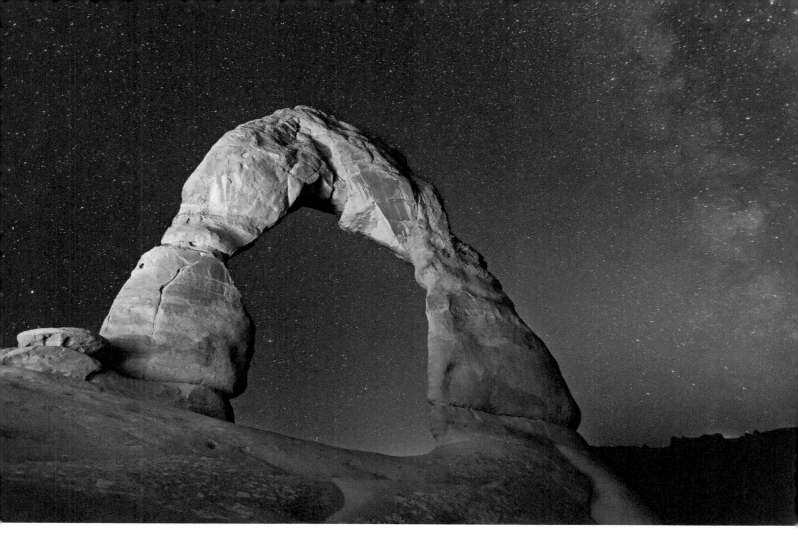

When using ISO 3200 to capture the stars, a single flash can illuminate Delicate Arch in Arches National Park. Canon 5D Mark III, 16–35mm at 16mm, ISO 3200, f/2.8, 20 seconds, 3200K WB, manual flash and ambient exposure.

The first clear night available, try this. Locate any nearby attractive subject—a tree, wooden wagon wheel, flower, large rock—that can be positioned against the night sky. When the sky becomes dark, two hours or so after sunset, use a strong flashlight so you can manually focus the subject. Set your exposure to ISO 3200, 20 seconds, and at your widest aperture—f/4 or if you have it, f/2.8. That exposure will expose the stars nicely. During the 20 seconds that the shutter is open, fire the flash in its manual mode. Take test shots to adjust the power ratio, zoom control, or flash-to-subject distance until the foreground subject is properly illuminated. If using automatic flash exposure, then adjust the FEC. You will be surprised by how quickly your reward will be a beautifully exposed foreground subject against a starry sky. Just get out there and try it!

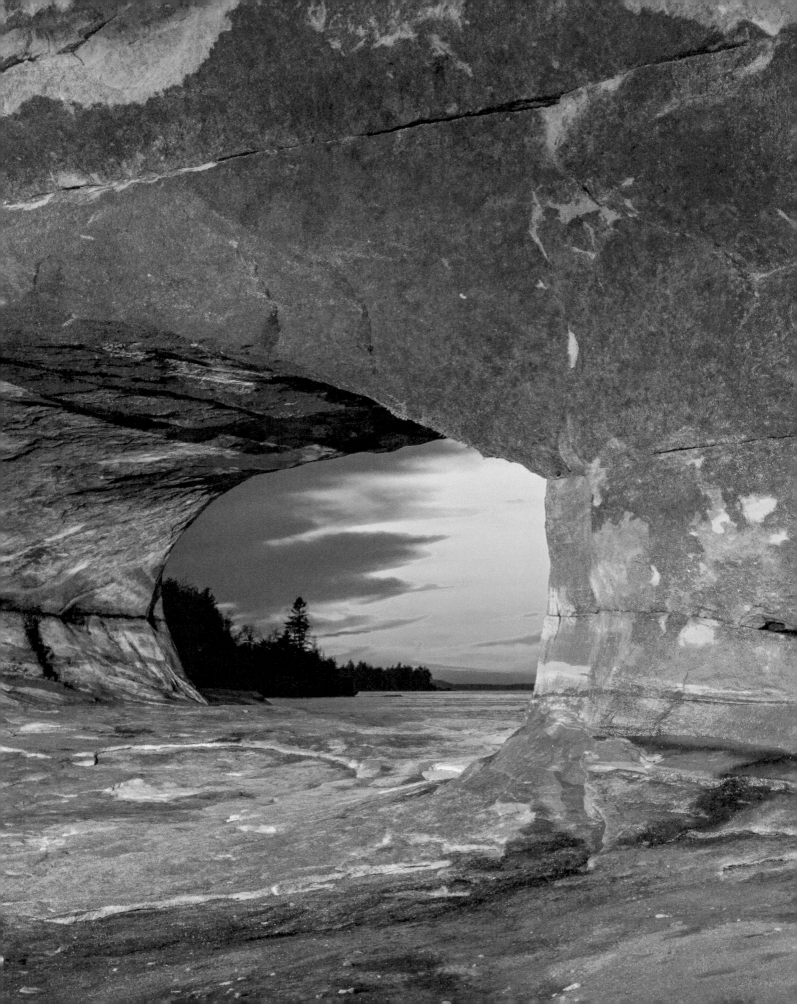

Multiple flash

A single flash as the only light source typically produces unattractive images. If the flash is mounted on the camera so that the subject has purely frontal lighting, the subject is rendered somewhat featureless because straight on lighting lacks shadows. All the shadows fall directly behind the subject and consequently are invisible. When the flash is too near the retina, the reflection may cause red-eye in both human and animal subjects. Yet when the flash is removed from the camera and held to one side and there are indeed feature revealing shadows, the side opposite the flash can be dark and lack detail. The contrast again can be offensively high, actually higher than sunlight produces, because sunlight may be reflected by a myriad of objects within the frame and to some degree illuminate the shadowed side. A single flash may severely underexpose a distant background as a result of the Inverse Square Law.

Two or more flashes used simultaneously give the user far more precise control over subject lighting, and depending on the situation, perhaps over background lighting as well. Using two flash units to light a subject will allow a nearly endless variety of helpful lighting schemes and control of subject contrast. Newbies to the flash scene are often hesitant to use more than one flash, even though it is not very difficult. Skillfully mixing ambient light with multiple flash is quite straightforward once you are familiar with the techniques and do it successfully a few times.

Below, follow our thoughts on using multiple flash:

CREATE AND CONTROL SHADOWS

A pop-up flash or a single flash mounted on the camera produces few visible shadows because most of the shadowing falls directly behind that which caused them. An off-camera flash is an entirely different matter. Hold or mount a flash on the right side of the camera so that the flash-to-subject line is approximately 45 degrees from the camera-to-subject line. Now the flash illuminates the right side of the subject, creating shadows on the left side. If the shadows are unpleasantly

The Lake Superior Sea Cave was almost pitch black inside at sunset. John set up three Canon 600EX-RT Speedlites each with 1/2 CTO gels on them and determined the exposure for the inside of the cave. Using automatic flash metering, he decided on using FEC +2 for the cave. Then he slowed down the shutter speed until the evening sky looked pleasing. As the western sky darkened, he slowed the shutter speed. Here, setting the flash exposure first makes sense because the ambient light exposure steadily diminishes. Canon 5D Mark III, 24–105mm at 35mm, ISO 640, f/16, 1/3, Cloudy WB, +2 FEC.

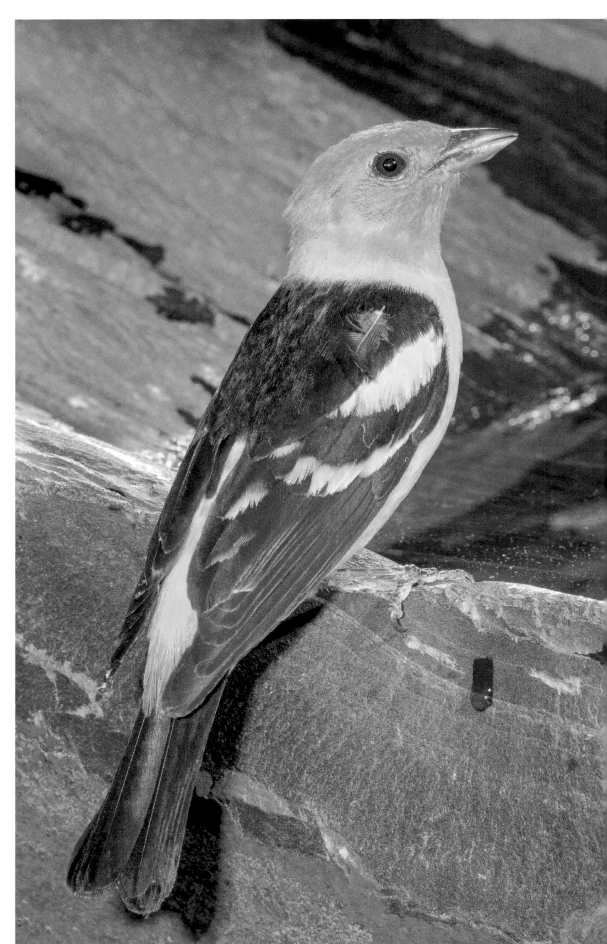

A western tanager won't come to a seed feeder, but dripping water into a small pond readily drew it in. Notice the highlights at the top of its head and beak. These highlights better separate the tanager from the background. The highlights are produced from a Canon 600EX-RT Speedlite placed above and behind where the bird will be to rim-light the subject. Canon 7D Mark II, 200–400mm lens at 200mm, ISO 200, f/16, 1/250, Flash WB. Three Canon 600EX-RT Speedlites using +1 FEC and fired with an on-camera ST-E3-RT radio controller.

harsh, add a second flash to the left of the camera which will fill in or open up those shadows to any degree desired.

BACKLIGHT THE SUBJECT OR LIGHT THE BACKGROUND

Add a third flash to the above setup. Now you *genuinely* have multiple flashes, but you are rewarded by multiple opportunities! One is that you can backlight the subject, and the resultant rim light is able to generate a splendid glow behind nearly any subject, especially hairy or fuzzy ones. The portrait photographer uses this technique often, but what we call a "backlight," they call a "hair light." Even if subject backlighting is not one of your artistic yearnings right now, why not use that third flash to brighten up a background? Consider perhaps placing a gel on the flash to colorcast the background.

LIGHT OBJECTS OVER GREATER DISTANCES

Two identical flashes fired simultaneously double the light output and enable you to light more distant objects. I commonly use four Canon 600EX-RT Speedlites to gain two stops of additional light to illuminate objects in my landscape photography.

FREEZE ACTION

The short duration of a flash can be quite effective for freezing fast action. The hummingbird photographer uses flashes at 1/16 power or even 1/64 power to obtain

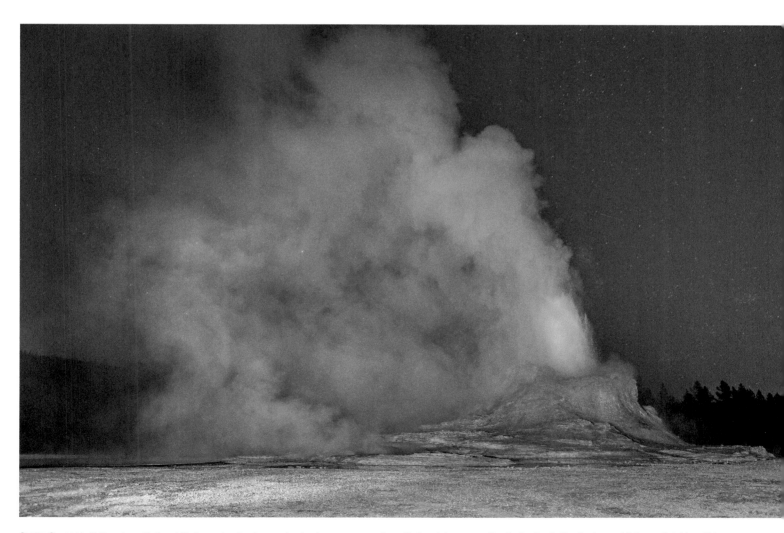

Castle Geyser in Yellowstone National Park erupts about every twelve hours, more or less. Fortunately, an eruption lasts about 40 minutes and it is predictable within plus and minus two hours. John focused on the cone ahead of time by lighting it with a strong flashlight while manually focusing the lens using a magnified live view image. Three Canon 600EX-RT Speedlites lit the erupting geyser while the long shutter speed exposed the stars. Canon 5D Mark III, 16–35mm at 32mm, ISO 1600, f/4, 20 seconds, 4000K WB. Auto flash with FEC at +.7.

incredibly brief exposures of 1/10,000 second or 1/20,000 second. These short flash durations are necessary to freeze the ultra-high-speed wings of the little avian speedsters.

Some insect photographers use flash the same way in order to freeze the motion of, say, a fast-flitting fleeing fruit fly. Years ago, I was dazzled by black and white photos of boxers (two-legged) who were just on the ouch-end of a right cross and were flinging drops of sweat into the air. Those drops were proudly frozen (photographically) by a press camera featuring a focal-plane shutter capable of 1/1000 second. Think of that! Nowadays, with a modern flash unit, you can enjoy motion freezing flash durations 20 times that fast!

METHODS FOR FIRING MULTIPLE FLASH SETUPS

I am sure you have noticed the plethora of TV ads in which a phone number is repeated three or more times. Advertising experts claim that repetition is the key to the learning process. Let's go along with them and review and expand on hardware considerations when using multiple flashes.

ELECTRONIC SLAVE TRIGGERS

A "slave trigger" is an electro-optical device that triggers a remote flash when the slave is activated by a burst of light from a master flash. Often a small (perhaps the size of a walnut) and, usually, inexpensive accessory device, the trigger can be physically mounted on the remote flash. The electrical connection between the slave and the remote flash can be via connections within the flash's shoe mount or maybe via a PC cable. Note, however, that cables and connectors are a common source of electrical unreliability and downright failure. Sometimes, the photographer can enjoy the convenience of a flash unit with a built-in slave function. A built-in slave allows the flash unit to be triggered by the light burst of a "master" flash that is generally mounted on or near the camera. Did you notice my having used the term "burst" a couple of times? Using the term "burst" was no accident. Let me stress that the slave doesn't react to the brightness of the master flash, but rather to the "suddenness" of the master flash's occurrence. Please note that the slave will ignore any particular level of brightness and react only to the *sudden increase in the level* of the master flash. Alas, not all is lighting bliss. The tiny accessory slave trigger is unable to differentiate

your master flash from mine or that other guys', or even hers. In any photographer rich environment (think photo workshop or wedding), an accessory slave trigger is practically guaranteed to flash and flash and flash from everybody else's camera as well as your own!

Over four decades ago, I photographed nesting birds with the nature photographer's "gold standard" of slide film (known as Kodachrome 25). A film of many merits indeed, but its ISO of 25 failed to make the list, and I needed flash to illuminate the nesting birds. Not unlike today's hummingbird shooter, I used several inexpensive manual flashes in my setup. In one setup, I used three flashes:

Flash #1 Flash one is the main flash. I placed it to one side of the camera about three feet from the nest and slightly higher than the camera.

Flash #2 The second flash is the fill flash used to open up the shadows created by the main flash. I put it on the opposite side of the camera, close to the camera and at about the same height. The distance from the nest was about six feet. The doubled distance provided a fill light that was two stops down (weaker) from the main light. Two stops? Or should twice the distance be one stop? After all, if I double my ISO, I make a one-stop change. The Inverse Square Law, however, dictates two stops. This is such an important concept for flash photographers, I will not explain it here. Please look it up one more time. My theory is that when you have to look it up, you are more likely to remember it.

Flash #3 The third flash lights the background. It illuminated an artificial background about eight feet behind the nest.

To actuate these three flashes, I had the #2 fill flash wired directly to the camera with an ordinary PC cord, and the other two flashes actuated by slave triggers. When the camera fired the wired #2 flash, the other two fired in response. Being a photographer, I can say the other two flashes fired instantaneously even though the engineer who overheard me say that points out that things may happen fast, but nothing happens instantaneously. Do note that I selected the #2 fill flash to be the wired flash for two key reasons. First, the fill flash is closest to the camera and needs the shortest PC cord. The second reason is more important—slaved flashes must "see" the burst from a flash. The fill flash is pointing at the main and background flash, both of which are in front of it, so the chances of their attached slaves seeing the light are greatly improved. Remember that flashes operated by the

electronic slave triggers were used in manual mode, because optical slave triggers offer only triggering, with no other control of the flash.

WIRED CONNECTIONS

Triggering a group of flashes by direct wiring is conceptually simple, electrically simple, and physically simple, although often creating a proverbial rat's nest of wiring. Because cords are easily entangled in people's feet which may lead to grievous personal injury it is a bad thing. And photo gear might get damaged! Cameras and flashes that are connected together with cables use "PC connectors" and "PC cables." In our world of photography, the term "PC" does not denote "personal computer" but is a holdover from an antique camera-shutter design of yesteryear called "Prontor/Compur." This is one piece of trivia that you are allowed to forget.

Do not forget about sex! I have been told that all successful authors should always include some sex, so here we go. PC connectors on cables, cameras, flashes, slave devices and other flash accessories are defined as male or female, a designation predictable by their configuration. Looking closely into a PC connector (at my age one needs a magnifier), you will see either a small pin or a small receptacle hole into which such a pin fits. I leave to the reader the responsibility of assigning the correct nomenclature.

Now, to use a wired-flash system one must connect the camera to each of the flash units. Consider a three-flash setup for bird nests, hummingbirds, or perhaps portrait shooting. Here is an example of the thought process for a wired-flash setup:

Every Nikon and Canon camera and all flashes I have used have been equipped with a single female PC connector terminal, though some inexpensive equipment may omit the PC terminal. Does each of your three flashes have a PC connector? If not, then one needs an inexpensive hot shoe-to-PC adaptor for each flash not so equipped.

Now, with four items to interconnect a camera and three flashes, one needs a three-way Flash Sync Adapter, like those made by Kaiser, Kalt, Medalight or Samigon. These small devices typically have one male PC connector and three female PC connectors. The adapter's male connector attaches to the camera's female connector by a female-to-male PC cable of suitable length. Each of the three female connectors of the adapter is connected to the female connector of a flash by a male-to-male PC cable of suitable type and length.

I have vaguely referred to cables "of suitable type and length," weasel words well-worthy of a writer who cannot possibly know the details of your system. The cables must be long enough to get from point A to point B. Longer cables are more versatile, but also offer that greater likelihood of tangling in somebody's feet and pulling over the camera or the flashes, or tripping an individual and causing personal injury. Shorter cables offer ease of use and storage. The male-to-female cable must reach from the camera to the adapter and the male-to-male cables must reach from the 3-way flash adapter to each of the three flashes. Thus, the placement of the adapter will affect the choice of cable lengths. I often use gaffer tape or duct tape to attach cables to tripods as a means of strain relief.

There are two common types of PC cables—the straight cables and the coiled "curly cord" extensible cables. Flexible curly cords are convenient to use, but remember that when extended, they are already applying springy forces to flashes and cameras. Those forces keep the cables off the floor and up in the air, ripe for somebody to snag one with a wayward arm and possibly pulling over the flashes or camera.

My own kit consists of three eight-foot male-to-male cables, one eight-foot female-to-male cable, and a Medalight Flash Sync Adapter.

Caution #1 Your own setup might need different cable lengths and different connectors than mine. Remember to measure thrice and cut once.

Caution #2 My electrical engineer pal tells me that connectors are among the most failure-prone components of any electronic system, due, he advises, largely to the frequent handling they endure. If you should experience a cabling failure, be sure the connectors are properly inserted by gently twisting them while applying firm pressure to the insertion. Moreover, the connectors can become loose because of mechanical deformation. I routinely use electrical tape to keep all connections snug. An inexpensive "PC Conditioner" tool can sometimes rectify loose connections. PC cables, adapters, and accessories, are available from paramount cords, and many other vendors. By the way, I just found out that www.paramountcords.com will make custom PC cords where three or more leads run off it that does away with the three-way flash connector that so commonly fails.

Reviewing the PC wired flash system, we find the good:

- It is an inexpensive system.
- It doesn't require line-of-sight between components.

- Another photographer's flash does not interfere with yours.
- Cameras and flashes of different makes and models are fully compatible as long as they are equipped with PC connectors and one pays attention to connector sex.

The bad:

- The cables, and especially the connectors, can be unreliable or can fail completely after mishandling, being trod upon or for no apparent reason, and then magically begin to work some time later.
- No automatic flash operation is supported. Flashes operate in the manual mode only.
- The camera is unaware that a flash is in use, so the shooter can accidentally set a shutter speed above the maximum sync speed and ruin the shot.
- It takes longer to wire everything together than to use a wireless system.

And the ugly:

- A "rat's nest" of cables going hither and yon can endanger people and property. It can endanger the images when the system has been trashed by being trampled upon or entangled by any oblivious passersby who strolls through your set.

WIRING FOUR OR FIVE FLASH UNITS TOGETHER

Or six or seven, if you wish. One can extend the 3-flash system to enough flashes to bankrupt the most enthusiastic flash shooter by merely adding additional Flash Sync Adapters (FSA) and appropriate cables. For example, here is a 5-flash system:

- Connect the camera to the male port of FSA #1.
- Connect two of the female ports of FSA #1 to Flashes #1 and #2.
- Connect the third female port of FSA #1 to the male port of FSA #2.
- Connect the three female ports of FSA #2 to Flashes #3, #4, and #5.

The above 5-flash system requires six cables (one cable to the camera and five to the five flashes) and 13 connections, and expanding it to more than five flashes involves even more. If you are confused, make a simple sketch on paper and it should become quite clear. But, to help you visualize where all of the connections are found, here is a list:

- Attaching two flash sync adapters together is one connection.
- Attaching the camera to the paired flash sync connectors is two connections.
- Attaching five flashes to the paired flash sync connectors is ten connections.
- And this totals 13 separate connections.

With all of those cables, something that should work well often does not. Check all of the connections by gentle pushing and twisting, and when you are satisfied that all connections are solid, apply some strain relief by taping or other means.

WIRELESS CONNECTIONS

We have covered ganging flash units by optical slaves and by cabling to give you both a complete viewpoint as well as to present inexpensive options. Yet if budgeting is not a barrier, you should stuff the ballot box in favor of a wireless system, either optical or, preferably, radio. Modern camera systems have built-in optical capabilities. The radio systems, superior in many ways, can be acquired as accessories. Canon recently pioneered radio flash control, and you can be sure other camera systems will follow their lead and Nikon has done just that with the recent introduction of the Nikon SB-5000 AF Speedlight.

More updated pop-up flashes, especially Nikon and Canon, have built in ability to serve as master flashes. Nikon refers to a *commander* mode that enables the pop-up to control as many remote flashes as can "see" the commander by line-of-sight. Canon is relatively new in that feature, but as always when in doubt, use that all-important but too rarely used photo accessory, the camera manual, to check things out. Pop-up units can generally be configured to contribute a programmable amount of light to the exposure.

Optical systems, as mentioned, require line-of-sight placement of flash units. They allow the user to select one of

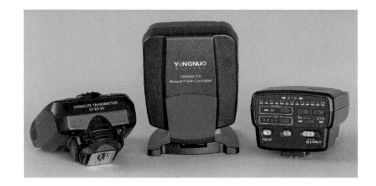

Perhaps the best way to fire one or more off-camera flash units is with optical or radio wireless controls. Photographers today enjoy numerous options. When choosing what is best for you, always consider what your camera maker offers first. Canon's optical only flash controller on the right is the ST-E2. John has used it for years, but it does require line-of-sight and the distance is somewhat limited. Canon's ST-E3-RT on the left is a radio only wireless control and the far less expensive Yongnuo manual flash controller in the middle is radio.

the several communications "channels" for the inter-flash optical communications that are weak flash bursts of either infra-red or visible light. The multiple channel system is a boon to those in multi-photographer shooting locations. If you select, for example, Channel 1 for your system, I can use Channels 2, 3, or 4, for mine, and our systems will not "cross-fire." That helps us avoid inter-photographer open warfare! However, if you are working with 4-channel flash systems, make sure any fifth shooter is *persona non grata* until an unused channel becomes available.

ANNOYING OPTICAL SYSTEM NUISANCES

Lest you think that optical systems are akin to peaches and cream, please let me introduce you to a little flash reality. Aside from the obvious, here are two more insidious issues one may encounter in maintaining the essential line-of-sight placement of flashes. I often photograph wildlife from a hide. A what? Okay, that's British talk, and we colonialists call it a "blind." While it is bad enough when one must carry a heavy blind a long way to the suitable site, then the blind must be set up while it flaps wildly to and fro in the omnipresent blustery winds. You then have to hunker in the cramped interior on a sunny day while the internal temperature little by little approaches that of Venus. Additionally, one must consider the flash system. With only the tip of the lens extending from the blind, a camera-mounted flash does a good job of lighting the interior of the blind, but the fabric prevents the subject from being illuminated. Bad news. The pop-up suffers the same failing to say nothing of inadequate power. Consequently, I duct-taped a flash unit to the lens cap so that the entire flash unit was outside the blind, and connected it to the camera hot shoe by a short dedicated cable. At last my master flash can wirelessly fire the slaved flashes because the fabric of the blind no longer blocks the optical signal. Mission accomplished!

Yet one more problem raises its head when you're shooting verticals. Why, you ask, should a flash system care about camera orientation? One reason. Suppose you're focused on (no pun intended!) a bird's nest, and have two remote flashes, one camera right, and one camera left, and each about the same distance from the camera. The triggering flash, mounted on the camera, is either a hot-shoe mounted unit or is a pop-up. It may or may not be contributing to the exposure. In such a symmetrical system, there is no line-of-sight problem. Each of the remote

flashes see the preflash configuring signals from the camera flash (in dedicated systems). Great! Next, shoot a vertical by rotating the camera a quarter-turn to the left counter-clockwise. Oops! The left remote is a happy flash, but the right remote is flash deprived because the lens is now between the camera flash and the remote flash, interrupting the line-of-sight. Obviously, if you were to turn the camera clockwise instead, then the left remote is trigger-challenged and the right remote becomes trigger-happy. As it happens, I shoot using my right eye, so turning the camera counter-clockwise prevents my nose from being mashed into the camera back.

One easy fix may be as simple as merely removing an interfering lens hood. Another may be "remoting" the master flash by a short cord as we did in the blind problem. A little thinking often generates several solutions, and the best solution of all is a radio system that doesn't give a hoot about the line-of-sight.

FLASH STANDS

Do you have the malleable body of comic book superhero Plastic Man? If not, you cannot yourself hold and point two or three flashes separated by ten feet and 15 feet each from the camera as well as properly point and operate the camera. Most shooters mount their flashes on light stands designed for that purpose. Light stands come in a myriad of sizes, shapes, prices, and perhaps irrelevantly, colors. Some are more suited for the studio, some for the outdoors, and some work fine for both. Macro work excepted, flash stands are practically essential for multiple flash work. Those with wider bases are better for use outdoors where uneven ground and rocky terrain (along with logs and other impedimenta) conspire with high winds to upend your expensive flash gear. I've often had to battle the winds by staking the flash stand to the ground. I pound a metal fence post into the ground and affix the flash stand to it with duct tape. FYI, duct tape or still better, gaffer tape, is more useful and workable and a valuable addition to your equipment kit.

FLASH STAND OPTIONS

An Internet search will reveal a zillion or more different flash stands on the market. I own flash stands of many configurations that have long been discontinued but continue to serve me well. The major suppliers like B&H Photovideo and Roberts Camera are good sources, as is

Flash stands come in all sizes and prices. Most work just fine for outdoor use. Most flash stands come with a generic 5/8″ stud on top of the light stand. Attach a female receptacle and locking knob adapter to hold the mini-ball and the attached flash. The adapter is attached directly to the top of the stand, then a mini-ball attaches to that, and the flash to that so the flash can be pointed in any direction.

www.impactstudiolighting.com. One stand that I like is their model LS-96HAB. It extends to 9.5 feet, has suitable flash-mounting fittings on top, and the wide base necessary for good stability in windy conditions and on uneven ground. Flash stands that allow independent movements of the three legs are particularly good on uneven ground and hillsides.

MINI BALL HEADS

Not only must a flash be somehow attached to its stand, it must be adjustable horizontally and vertically so it can be pointed at the subject area. For your information, some flash units are equipped only with hot shoe attachments and require an adaptor to attach to the flash stand. Incidentally, those adaptors are so small that Murphy's Law, which states that if anything can go wrong, it will, always prevails. It practically guarantees that when the adapter is needed, it will have either been forgotten or lost. Keep it on the flash stand at all times except when it must be removed, and promptly replace it afterward. A mini ball head is an excellent way to mount a flash to a stand. Numerous good ones are available, and the Phottix BH-Mini is an excellent choice as is the Giottos MH-1004. The Giottos, like several others, comes with a camera attachment screw that's 3/8″-16 and in most applications will need a reducer bushing (often included with the product) for the more common 1/4″-20 threads. To attach everything together, make sure both you and your salesperson know all of the thread sizes and sexes necessary to mate all of the parts.

FLASH GROUPS AND LIGHTING RATIOS

FLASH GROUPS

When using wireless multiple flash, it is possible to assign flashes to various groups. If using three flashes, all of the flash units could be assigned to the same group, perhaps Group A or All. Perhaps you want the main flash and the background flash to emit the same amount of light, but you want the fill flash to be two stops weaker. This can be accomplished by assigning the main and background flash to Group A by selecting Group A on each flash. To make the fill flash two stops weaker, assign it to Group B and then choose the appropriate ratio. Many wireless flash systems allow three or more groups to be selected.

FLASH RATIOS

To be perfectly honest, nearly everything about flash photography is quite easy, except flash ratios that can be described in extremely complex ways. Explaining these systems can numb minds much sharper than mine, so I prefer to keep things simple, and I really don't think the most complex ways to explain flash ratios is really necessary for outdoor photography.

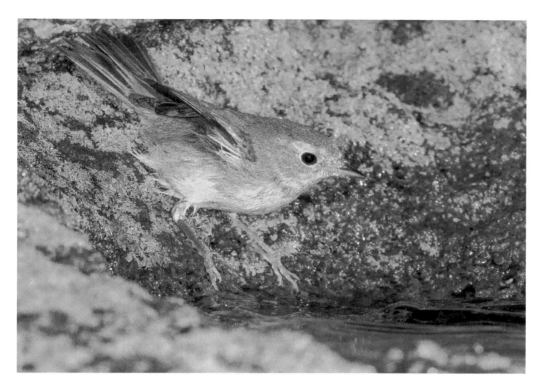

a) A female Wilson's warbler is attracted to the sound of dripping water during its September migration. John set a 4:1 flash ratio. The main flash is on camera left. Notice the slight shadow on the rock to the right of the warbler and the darker tail feathers on the right side. The other fill flash is right of a line that would connect the camera to the warbler. It fills in most of the shadow the main flash creates. Canon 5D Mark III, Canon 200–400mm with built-in 1.4x teleconverter at 560mm, ISO 500, f/13, 1/200, Flash WB, three Canon 600EX-RT Speedlites using auto flash.

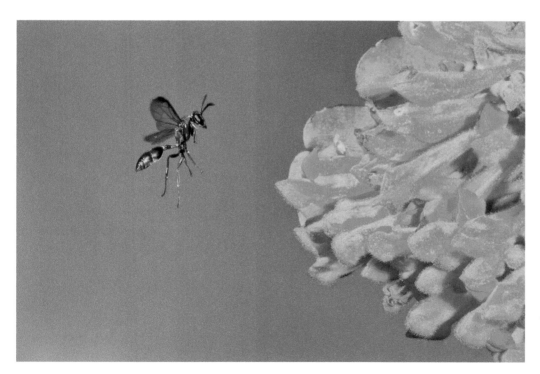

b) Multiple flash can even freeze a flying wasp. Barb accidently shot this one while photographing hummingbirds with John's Canon 1D Mark III, 300mm, ISO 200, f/18, 1/250, Flash WB.

Forty years ago, I noticed that photographing most subjects in bright sunshine created harsh objectionable shadows. Using a light meter to take exposure readings, I discovered the shadows were three to four stops darker than the sunlit side. I generally don't want the shadows to be three or more stops darker than the bright areas, but I do want some shape-revealing shadows. Conversely, I find that if I set the flashes to give equal light to all portions of the subject, the light is too flat, like that on an overcast day, so I don't want a 1:1 light ratio. As a guideline, I think setting the flashes to make one side of the subject one to two stops darker than the other side provides the shape

revealing light I seek without generating dense detail hiding shadows. If the light on the subject is one stop brighter on one side than the other, then consider this to be a 2:1 ratio. If two stops brighter, it is a 4:1 ratio and three stops brighter is an 8:1 ratio.

SETTING FLASH RATIOS WITH GUIDE NUMBERS

For a great amount of my 40 years in photography, I have used the guide number system to set flash lighting ratios to control image contrast when using multiple flashes. It's regrettable that so few shooters employ it, often asserting that the guide number system is way too complicated and involves the terrifying topic of math equations. Yet the truth is that there are no equations to master, and mere grade school arithmetic will enable you to usefully and creatively employ the system.

Assuming all three flashes are the same model, set all three to their automatic through-the-lens metering modes which are called E-TTL for Canon systems and i-TTL for Nikon systems. In those modes, all three flashes will fire at the same power, thus emitting the same light levels. If the three flashes are not the same model, then this process becomes more difficult, but you could make it work using trial and error. I always use identical flash units to avoid the problem of varying maximum output levels.

Procedure for a simple 1:1 flash ratio:

- Attach each of the three flashes to the mini ball head on its own light stand.
- Place flash #1 slightly above the subject, about 45 degrees to the subject on camera left and about four feet from the subject.
- Place flash #2 about four feet from the subject on camera right and closer to the camera.
- Place flash #3 above the subject and about four feet behind to provide rimmed backlighting or hair-lighting.
- Now shoot the image and evaluate the exposure with attention to any contrasts caused by the multiple flash units.

Remember that the effect of a flash on the subject is related, among other things, to the distance between flash and subject. Remember that the relationship is controlled by the Inverse Square Law. It is now easy to use guide numbers to re-position one or more of the flashes.

Assume for this discussion, you wish to create shadows two stops darker than the right side of the subject. You need to weaken Flash #1 on camera left. Pick it up and move it back from its present four-foot distance to a new distance of eight feet, and re-aim it at the subject. Why

eight feet? By doubling the flash-subject distance, the light from that flash spreads out over an area four times as large as it formerly did, and the light intensity is one-quarter of what it was. The left side of the subject is around two stops darker than the right side. The shadow reveals shape and the subject depth while allowing for plenty of color and detail.

Okay, I admit that flash appears so complicated, but trust me, it becomes second nature rather quickly. My need for changes to light ratios exceeding three stops is rare, so I need to only remember the 1.4, 2, and 2.8 numbers so very commonly used in various aspects of photography. The 1.4, 2, and 2.8 distance multiples produce one, two, and three stops of light change, and that is honestly all there is to it! I don't measure the distances, eyeballing it (that means guesstimating) works just fine.

WIRELESS FLASH RATIO CONTROL

Dedicated flash systems using wireless controls typically allow flash ratios to be modified without moving the flashes merely by pushing a few buttons on the flashes or using a menu selection. Both systems work well, but there are some considerations for using the guide number system to adjust ratios because the flashes must be moved to different distances.

Is there enough unobstructed space into which to move a flash when it is too bright on the subject? Sometimes the photo blind is in the way. The Inverse Square Law requires that as the need for light reduction increases, the flash-subject distance increases much faster. As an example, if the fill flash is eight feet from the subject, and you wish to reduce the fill flash by two more stops, it must be moved back to 16 feet. Is there space to do this? If using a cabled system, is there enough cable to move the flash for a three-stop light reduction? If using a cabled system, can I lay cable where it is protected from dangers? If using an optical system, can we increase the distance and maintain line-of-sight? Can I re-position and re-aim moved flashes and still keep my shadow direction under control without additional test exposures?

I have mentioned both methods, and for most of my photo career I determined that the guide number controlled the movement of flashes quicker and easier. However, now that I nearly always use my radio-controlled Canon 600EX-RT Speedlites, I currently use a master controller to adjust the ratios about half of the time.

WORKING WITH LIGHTING RATIOS

Nothing confuses flash newbies as much as flash groups and ratios. For simplicity sake, consider only two flash units being used at once, but in practice, it could be several. One flash is assigned to Group A and the second flash to Group B. Note that a group can be one or several flash units. By assigning them to a group, one can wirelessly change the amount of emitted light between the two. For example, one can make the Group A flash emit four times the light (a 4:1 ratio that represents two stops) than the Group B flash. If you want the Group B flash to be two stops brighter than the Group A flash, set 1:4 on the right side of the scale. This difference in light output between the Group A flash and the Group B flash is a light ratio. Canon would say the A:B light ratio is 4:1 when Group A emits two stops more light than Group B. Look at the following image of the Canon ST-E2 Speedlite controller.

Notice the ratio series on the rear of the ST-E2 Speedlite controller at the top of the unit. The Group A flash is assigned to the left and the Group B flash is indicated on the right. This configuration *does not* mean the A flash must be on the left side of the subject and the B flash on the right side. The flash can be anywhere. What do these ratios mean? Make certain you understand the ratios on this scale in the image.

Flash ratios allow you to determine the density of shadows that highlight the shape of an object. They aren't that difficult to work with once you get used to them. Notice the scale at the top of the Canon ST-E2 optical flash controller. A 4:1 ratio means the A group of flashes will emit two stops more light than the B group. Should one set a 1:8 ratio, the B flash group emits three stops more light than the A group. Keep in mind a group could be one flash or many flashes all assigned to the same group.

Starting on the left and working to the right, the ratio series is:

8:1, 4:1, 2:1, 1:1, 1:2, 1:4, 1:8

This is precisely what the ratio series means in stops, which I find is more intuitive to understand. Remember the ratio series on the left represent Group A, whereas, the ratios to the right represent Group B. It isn't that difficult, so bear with me while scrutinizing the table below.

Relationship between the ratios and stops

Ratio	Group	Significance
8:1	A	Group A is three stops brighter than Group B
4:1	A	Group A is two stops brighter than Group B
2:1	A	Group A is one stop brighter than Group B
1:1	A & B	Both Group A and B emit the same amount of light
1:2	B	Group B is one stop brighter than Group A
1:4	B	Group B is two stops brighter than Group A
1:8	B	Group B is three stops brighter than Group A

To use wireless flash ratio control, set the A flash four feet from the subject left of camera. Set the B flash exactly the same distance —four feet—to the right of the camera. Point each at the subject. To equally light the subject on both sides, set the A:B ratio to 1:1. To make the right side of the subject two stops darker than the left side, what ratio must be set? The A:B ratio should be 4:1. Conversely, to make the left side of the subject three stops darker than the right side, set an A:B ratio of 1:8. After you do this a few times, it becomes quite straightforward. Remember these ratios are accurate only if the two flashes are identical in all respects. Each flash must be the same distance from the subject to account for the Inverse Square Law, and the same flash head zoom setting.

LIGHTING SCHEMES

TWO FLASHES

Make a portrait of an animal or human without letting the background go black. The two flashes will light the front of the subject. How do you light the background that is 20 yards or more behind the subject? Since you only have two flash units, a flash cannot be used to do it. Multiple flash does not preclude the use of ambient light. Attract your

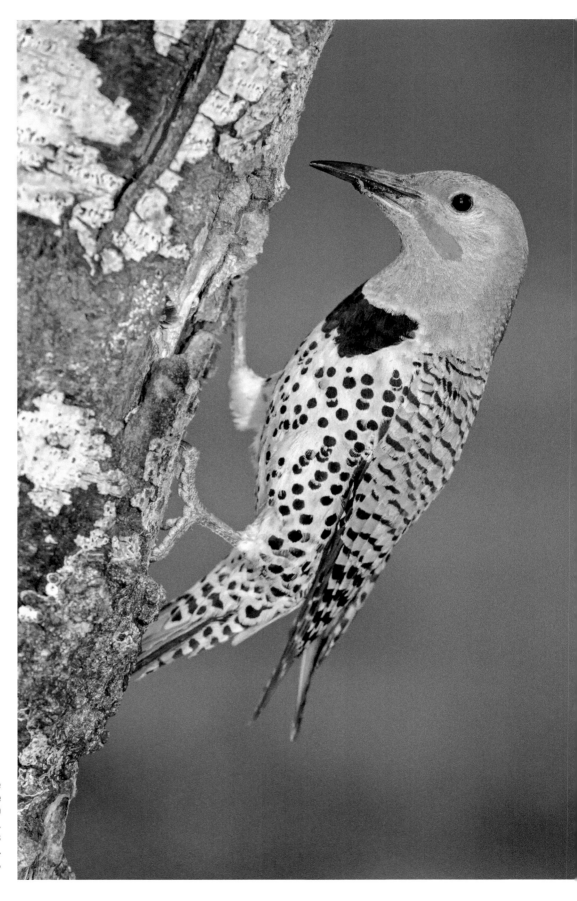

Barb used ISO 2000 to allow the ambient illuminated background to be optimally exposed. Two Nikon SB-800 Speedlights lit the Northern flicker. This is a case where multiple flash is used to make a balanced flash image. Nikon D3, 400mm, ISO 2000, f/9, 1/200, Cloudy WB.

wildlife subject or ask the person you will photograph to sit in a shaded area where the background is brightly illuminated with ambient light.

Start with ISO 200, f/16 for depth of field, and determine the exposure for the background with the shutter speed control. Perhaps ISO 200, f/16, and 1/30 second nicely exposes the bright background. Set the camera to the manual exposure mode to lock in the exposure. If you use any autoexposure mode when you compose the subject, the meter will "see" a lot of dark subject and when it runs its exposure calculations, the camera will automatically change the exposure. Will the background be too dark or too bright? If the automatic exposure using Aperture Priority is ISO 200, f/16, and 1/30 second for the bright ambient light on the background, and you then fill the image with a dark subject in the shade, the camera will automatically adjust the exposure to lighten the image. Since most photographers favor Aperture Priority (we rarely use it), the camera does precisely that and gives priority to the aperture and the shutter speed drops causing an overexposed background. You could use Aperture Priority and the exposure compensation control to optimally expose the background, but if you then compose the shaded subject a little looser or tighter, once again the background isn't optimally exposed. Manual exposure locks in the background exposure which works excellently as long as the ambient light doesn't change on the background and you don't introduce any devices that absorb light in the optical path—such as a polarizer. Naturally, any subject in the shade is significantly underexposed, but no worries, since the two flashes will take care of that.

Place the main flash about four feet from the left or right side of the subject. Now set the fill flash close to the camera-subject line but on the opposite side of the main flash and also four feet from the subject. The fill flash adds light to the shadows created by the main flash. Adjust the flash ratio by using the guide number trick or setting one flash to group A and the other to Group B. If you want the shadows to be prominent, but not too dark, having the shadowed side two stops darker than the side lit by the main flash works well. If the main flash is Group A and the fill flash is Group B, set the flash ratio to 4:1 and make sure both flash units are the same distance from the subject—remember the Inverse Square Law is at work. If using guide numbers and the main flash is four feet from the subject, grab the light stand that supports the

B flash and double the flash-to-subject distance to eight feet. If you want less contrast—one stop perhaps—then multiply four feet by 1.4 = 5.6 feet and put the fill flash at that distance. If you want more contrast—perhaps three stops—multiply four feet by 2.8 which equals 11.2 feet. You can measure this distance with a tape measure, but I don't anymore. Eyeballing the distance works just fine! Obviously, there are an unlimited number of ways to use two flashes in a lighting setup.

Another effective way to light a portrait is to use bright sun as a backlight to rim the subject's hair while using the main and fill flash in the normal way to light the shaded face.

THREE FLASHES

Use one flash as the main light, a second flash as the fill light, and a third flash to either backlight the subject or light a natural or artificial background behind the subject.

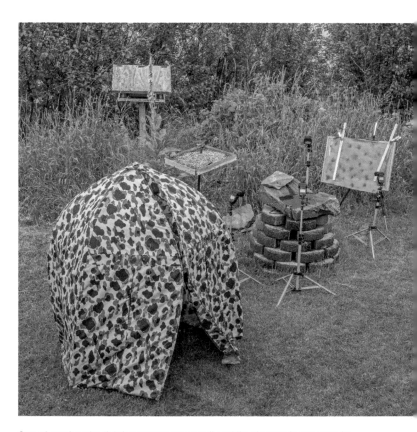

One of our favorite lighting setups at a small puddle of water in the yard for photographing birds and small mammals. Four flashes are used. One flash lights the artificial background that is supported with a painter's easel to avoid a black background. A second flash backlights the subject. The other two flashes light the front of the subject, but one flash is set to contribute two less stops of light than the other to provide soft shadows to reveal the shape of the subject.

FOUR FLASHES

Advanced portrait lighting ideally uses four flashes. Four flashes allow for a dedicated main, fill, hair light and background light. Some wireless flash systems allow the use of three or more flash groups—A, B, C, and so on. If your system only offers three flash groups, assign the main and fill flash to group A, the hair light to group B and the background flash to group C. Adjust the FEC and flash ratios to obtain desirable light output from each group of flashes. Remember, we are using the word "group" loosely since it can be only one flash. If the main and fill flash are both assigned to group A, how do you make the fill flash emit less light on the subject? You know the answer! Just pull the fill flash back the appropriate distance and the Inverse Square Law makes sure the fill flash lights the subject less than the main flash. Perhaps there isn't enough room to move the fill flash back as a tree, rock, photo blind or another obstacle is in the way. Often when photographing nesting birds, everything is erected on top of some construction scaffolding and the platform is not large enough to accommodate much forward and backward movement. In such cases, I often keep the main flash and fill flash at identical distances to the subject, but set the zoom on the flash head much wider than the main flash to dissipate the light over a larger area and effectively reduce the illumination on the subject from the fill flash. Flash zoom is sometimes a crucial point! Sometimes it is best to use the zoom control on the flash to adjust

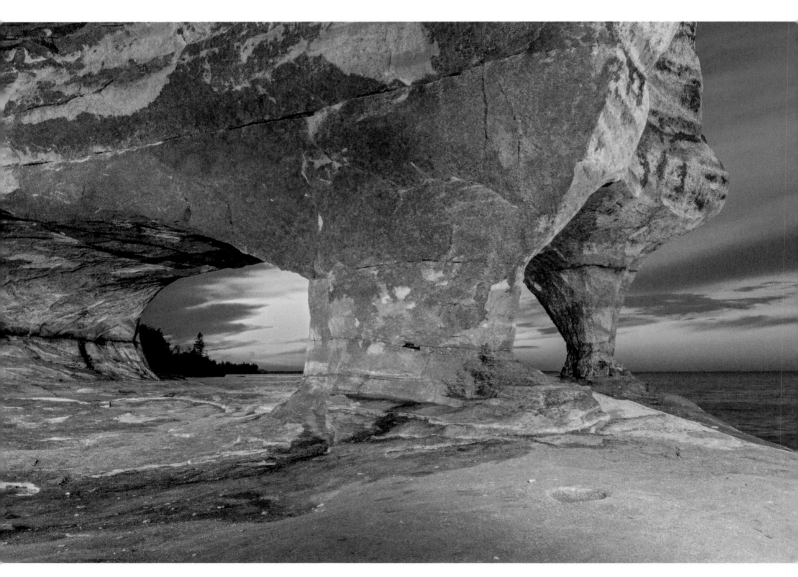

Another version of the Lake Superior sea cave with a 24mm wide-angle lens. Canon 5D Mark III, 24mm, ISO 640, f/16, 1/3 Cloudy WB, three Canon 600EX-RT Speedlites on flash stands controlled with the on-camera ST-E3-RT Master set to +1.3 FEC.

the flash ratio. If you desire a denser shadow, zoom the flash head wider to spread the light over a large area. Of course, if you desire more fill light, then increase the zoom setting.

MORE FLASH UNITS

Optical wireless controls will fire every flash that is set to receive the signal. Keep that in mind. It is possible to fire 20 or more flashes simultaneously. It isn't likely you will ever own 20 flash units or even ten, but for some lighting schemes, using more than four flashes is advantageous. The maximum number of flashes I have used at one time is seven, to light a hummingbird!

LIGHT MODIFICATION

The accessory market teems with gizmos and widgets for modifying the light emitted by flash units. There are soft boxes—round, square, rectangular, long, short—enormous enough to require a sizeable studio for their setup, small enough to hang directly on your camera-mounted flash, and everything in between. You can purchase gadgets in white and silver interiors for different contrast renditions. Some are single and some double diffusion. They come in expensive models endorsed by widely-known photographers, and they come in inexpensive models widely endorsed by nobody. All of the same descriptive potpourris applies to the even more widely used umbrellas, but they go a step further and offer the option of translucent light modification. There, the light source is not reflected by the umbrella, but the umbrella is used in a "shoot-through" mode between light and subject, as a large diffuser.

The usefulness of light modification is generally greater in indoor use where the ambient light is dim and one relies more on flash illumination. In my own photography, I prefer to manage contrast by controlling flash ratios as discussed above, and mixing flash with ambient light.

Contrast and shadow management are functions of the subject. In my long-ago youth, I did some portrait photography. Aside from the mood controls of shadowing, the subject texture was very important. A portrait of a young woman needed to be shot with soft light. The soft light appreciably reduced the shadowing that reveals undesired skin texture. The soft wrap-around light from a larger and close-in softbox or umbrella thus showed a softer smoother skin and reduced the visibility of blemishes. The ruddy he-man portrait, on the other hand, showing every facial pore and whisker, was enhanced by the harsher crosslighting of a more distant and smaller light source.

A couple of caveats about light modification:

In outdoor work, the larger the diffuser or reflector in use, the larger the target area for even a small gust of air. Reflectors and wind get exceptionally frustrating even when you have helpers. I have been trained in physics, but I've yet to understand how the mere erection of a large softbox or umbrella immediately increases the wind speed to hurricane proportions. Sometimes I effectively defeat the wind by using small flash-mounted softboxes and diffusers like those available at www.honlphoto.com.

You think the wind is frustrating? I once had the studio task of flash photographing a group of four two-year-olds and their five puppies all in one shot. The toddlers thought I was a doctor approaching with multiple vaccination needles and the puppies thought I was a wholesale food distribution agent. Chaos prevailed in the foreground, in the background, and everywhere else. I quickly resorted to taking whatever shadowing and lighting contrast I could get, and quit trying to manage anything, except my temper. Such episodes led me to abandon portrait photography in favor of landscape, wildlife, and macro subjects.

Perhaps puppies aside, shooting with multiple flash is tons of fun and opens a whole new creative world for those who enjoy doing something different. The lighting is easily controlled by any of the methods we've discussed, and the results can be very gratifying indeed.

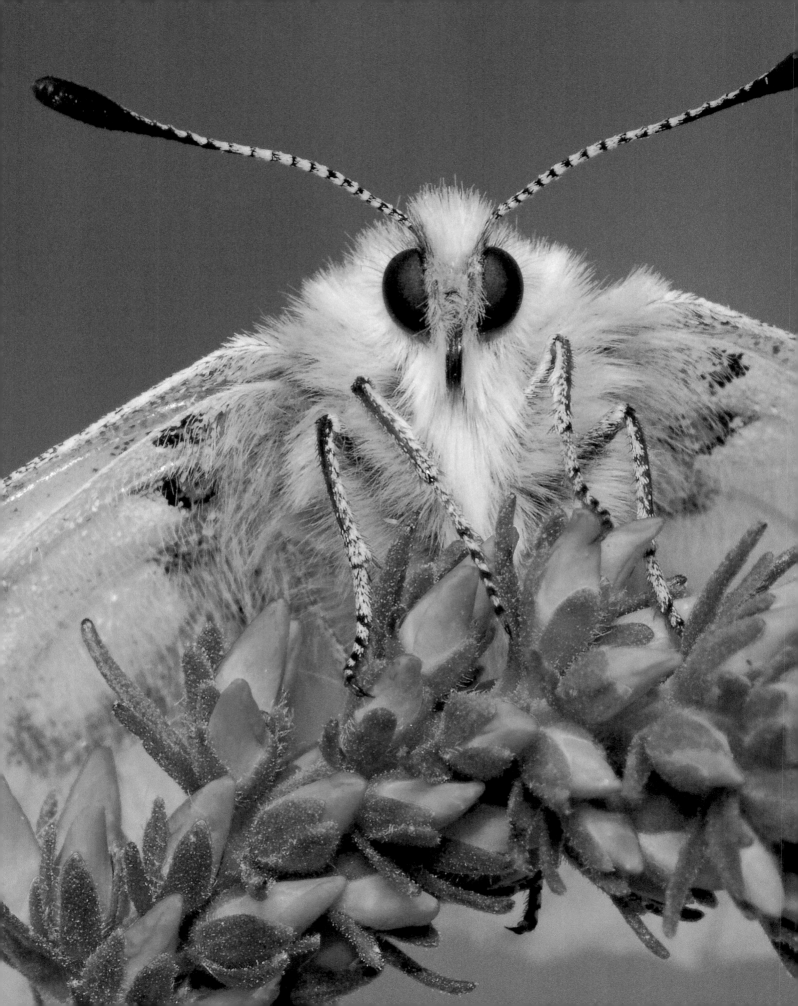

Close-up flash

Electronic flash is certainly the most flexible and convenient means of lighting macro subjects. Modern flash units, even small ones, produce more than enough light to properly expose small subjects. Small flash units light objects at the small f/16 to f/22 apertures most shooters like to use for greater depths of field. Many close-up photography problems are solved by using flash.

Flash will remove undesired colorcasts. Small subjects are often plagued with colorcasts caused by the ambient illumination. For example, a white mushroom growing in a green forest likely to have a green cast. Light-colored subjects photographed in the blue light of an overcast day will take on that blue cast. The subjects either appear the color of the ambient light or have their actual color modified by the addition of the color of the ambient light.

The light from a flash has no material colorcast. The color of that light is near 5500 Kelvins, which approximates the color of mid-day sunlight and tends to mask offensive colorcasts like the types mentioned. RAW file shooters have the ability to correct colorcasts in post-capture editing. I suggest (as do most photography writers) that it is always best to make the captured image the best possible in order to reduce the workloads in the digital darkroom.

The light from a flash can be precisely directed for the desired effect. With or without portable light modifiers like snoots and grids that attach to the flash, you can direct the light as needed. Perhaps the macro shooter might prefer to point the flash through a leaf from the rear, showing off a pretty arrangement of veins with the backlighting. Maybe it is helpful to put some light underneath the overhanging and shadowing cap of an Amanita mushroom, or possibly down the long throat of a nice pitcher plant.

Flash is a reliable source (keep spare batteries readily available!). We sometimes use reflectors to bounce light into an inadequately lighted and shadowed part of a subject, but sometimes the ambient light is too dim. A close-in flash will certainly solve that problem.

Fill flash adds light to the shadows on the Rocky Mountain parnassian butterfly. Nikon D4, 200mm macro lens, ISO 200, f/22, 1/5, Cloudy WB, Aperture Priority, manual focus, and one Nikon SB-800 Speedlight set to FEC −.3.

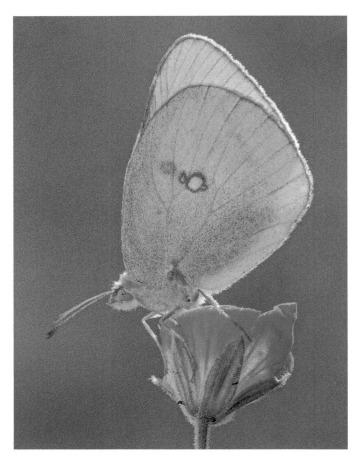
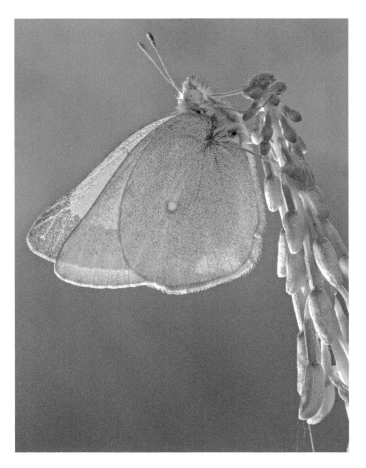

Backlight produced from a Nikon SB-800 Speedlight rims these sulfur butterflies with highlights, making the wings glow like a light source, which emphasizes the veins in the wings. Nikon D4, 200mm macro, ISO 200, f/22, 1/5, Cloudy WB, Aperture Priority, auto flash set to −.3 FEC.

Short flash durations freeze minute subject and/or camera motion to produce sharper images. Even when a little ambient light is permitted to record in the image, the razor-sharp image from the flash exposure tends to mask a slightly soft ambient exposure.

The flash shooter has plenty of convenient options for controlling the light from their flash. Here are a few:

- Raise the FEC to add light.
- Lower the FEC to reduce light.
- Set the flash to manual zoom. Zoom to longest focal length to increase light or to the widest focal length to reduce light.
- Move the flash closer to the subject to increase light or farther from the subject to reduce light if using manual flash. Don't forget the Inverse Square Law!
- Use the power ratio options to adjust flash output when the flash is being used manually.
- Place a white handkerchief or two over the flash to reduce output.
- Sharp images are practically assured if the focus is correct and the exposure is by the short duration of the flash without any material contribution of ambient light.

- Cover the flash with colored gels to alter the color of the light. I routinely use 1/2 Color Temperature Orange (CTO) gels to add a yellowish colorcast to the subject.

A LITTLE HISTORY

In the Acknowledgments section of this book, I recognized the excellent start into nature photography I received from my teachers and mentors, John Shaw and the late Larry West. Among the myriad of things those experts taught me was to use only Kodachrome 25 (K25), the "must use" film of the day for any photographer aiming to have their work published and light small subjects with flash.

John and Larry were keenly interested in butterfly photography, as was I. In warmer temperatures the evasive little critters were flittering and fluttering to and fro across the meadows at speeds impossible for us to match. We learned that when working at the higher mid-day temperatures, even when we could locate a resting butterfly, they were too wary to approach with a bulky tripod setup.

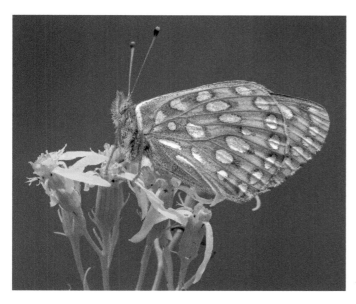

Use gel filters to change the color of the light emitted by the flash.

a) A full CTO Honl gel filter adds a pleasing golden color to the fritillary and flower, but not to the background. Unlike a warming filter on the lens, a gel filter on the flash provides a way of selectively coloring only what is lit by the flash.

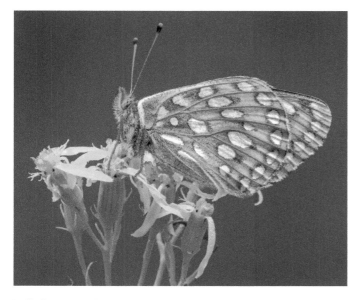

b) No filter on the flash is used so the warm tones of the flower and the butterfly are subdued. In our opinion, a set of Honl CTO (color temperature orange) gel filters, the Speedstrap for attaching the filters to the flash, and a roll-up gel filter case are absolutely essential for flash use the majority of the time (www. honlphoto.com). Canon 5D Mark III, 180mm, ISO 250, f/16, 1/5, Daylight WB, FEC for both images is +.3

We had to work hand-held. Even in bright sunshine using fast lenses, the ISO 25 of the Kodachrome film didn't allow fast enough shutter speeds to ensure sharp images. Image stabilization had yet to be invented, but, undeterred, Larry and John turned to the use of flash.

Shaw and West devised a simple "flash bracket" for attaching the small and undedicated flash to the camera, held near the front of the lens and above it. This position held the flash free of shadowing by the lens hood, close to the subject and in a position providing pleasant lighting. Just as they couldn't effectively use on-camera flash, neither can today's macro shooters. Moreover, users of current pop-up flashes are even more constrained when trying to light a subject that is close to the lens because of the lower height of the pop-up flash. Therefore, in macro work, we must get the flash off the camera as pioneered by Shaw and West way back in the early seventies.

With the flash brackets, photographers exclusively used manual exposure modes with the camera and manual control of the flash. We had to "stay on top" of the exposure because the frequent movements of camera and lens to achieve different magnifications for different shots caused changes in the flash lighting. Furthermore, we had severely limited post-capture cropping abilities, so we had to compose properly in the field since personal computers with powerful software were not yet part of our lives.

If we always shot at a fixed camera-subject distance, we soon learned the proper f/stop to use with our ISO 25 film. After all, with the shutter at max sync speed and a close-in flash, the ambient light was not generally a factor. We were often favoring black backgrounds. And as we gained even a little bit of experience, our ability to change distances and f/stops without thinking much about it definitely increased. That was because our distance changes were generally only a fraction of our usual working distance.

SINGLE FLASH BRACKET

Macro shooters today enjoy a tremendous improvement in ease of shooting because of the sophisticated automatic TTL exposure systems. Handheld flash photography of small and macro subjects, made easier by a small flash mounted on a flash bracket, allows chasing after the subjects without the inconvenience of a tripod. The short duration of the flash allows effective high shutter speeds which avoids sharpness problems because of camera shake. While contemplating handholding, remember that the tripod is not merely to steady a camera during exposure. A tripod allows you time to contemplate composition considerations. This means I only shoot handheld when using a tripod isn't feasible.

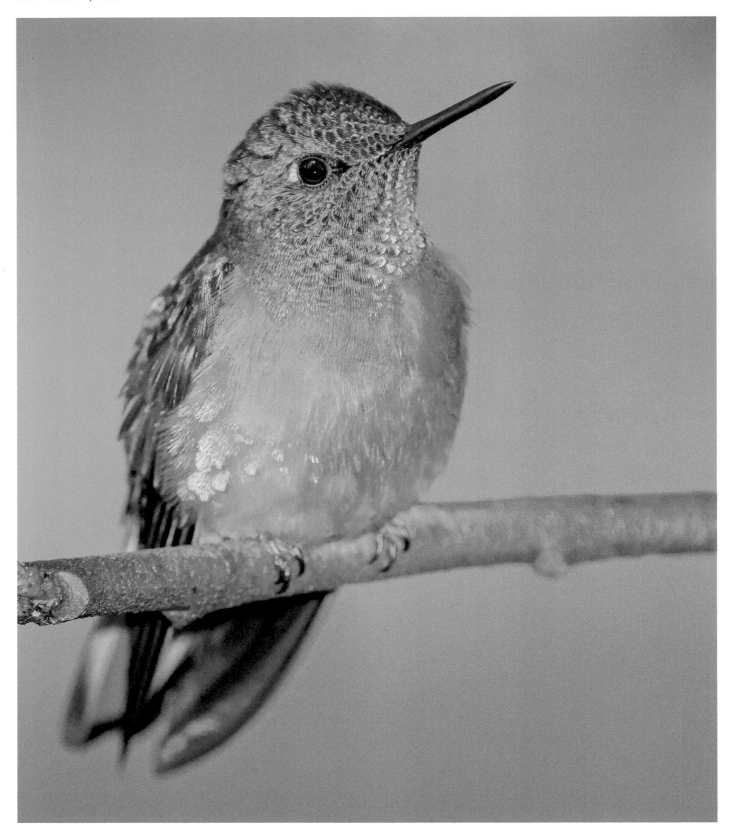

Barb used a Nikon SB-800 Speedlight as the main light for the chestnut-breasted coronet hummingbird at Guango Lodge in Ecuador. Main flash let her easily darken the background a small amount by increasing the shutter speed thus reducing the ambient exposure. Due to the dim ambient light, Barb was forced to use f/5 to prevent a black background. Nikon D300, 200–400mm at 400mm, ISO 1250, f/5.0, 1/250, +1.0 FEC.

Optical triggering can be troublesome in macro work. The relative positions of camera and flash during experimentation with lighting direction, and as we change between vertical and horizontal shots, may interfere with line-of-sight needs.

Radio systems, in general, do away with line-of-sight issues. However, one of my workshop students with some radio engineering experience cautions that before buying a third-party non-manufacturer radio system for macro work, you test it to ensure proper operation at very close camera-flash distances. He noted that sometimes a too close radio transmitter can overload a nearby receiver and prevent its proper operation. The receiver is said to be blocked.

Eventually, we conclude that for macro work with a flash bracket, a cable connection is a good idea. Always learning from my students, I noted that one of them, adept with a soldering iron, shortened his overly long standard cable to make it less unwieldy when using his flash bracket. It's a good idea if you're okay with your flash remaining on the bracket. If that kind of work is out of your jurisdiction, perhaps you can find a friend, neighbor, or relative, who can do the half hour job for you. Come to think if it, there are commercial entities who might take on one odd job.

We generally use only one flash for macro work. The image contrast is usually not too objectionable because the flash, being very close to the tiny subject, appears as a "large light source" and generates soft shadows. Single flashes used with today's capable TTL exposure systems and multi-positioning flash brackets are a very viable means of good macro photography.

In very bright ambient light, we often improve our handheld shots by subduing the detail into an otherwise chaotic background. As always, we set the background exposure first, generally ensuring we are under the maximum sync speed. We adjust the background exposure to achieve our artistic desires for the background, often a desirable stop or two darker than normal. Next we adjust the flash to optimally expose the subject. The ambient light moderates the shadows of the subject, subduing the contrast. Moderate image softness caused by subject motion or camera motion is often masked by the flash controlled sharpness of the subject itself.

EQUIPMENT IDEAS

Included are some thoughts on the common current equipment that Nikon and Canon users favor for single flash handheld shooting. If you are not using Canons or Nikons, take heart. I am not familiar enough with the enormous quantity of gear available to recommend it here, but I do know that many photo suppliers can outfit you with appropriate equipment. Be insistent on your functional needs.

CANON EQUIPMENT FOR HANDHELD CLOSE-UP AND MACRO WORK

Canon 430 EX II (optical only) or 430 EX III-RT (optical or radio)

Either the 430 EX II or the 430 EX III-RT is a small and light flash that makes the bracket's job easier. It is less expensive than its cousin, the Canon 600 EX-RT, and nearly one stop less powerful, but still provides more than adequate light for close-up and macro shooting. The 430 EX III-RT is the flash John uses to shoot close-ups, and he controls it using radio with the Canon ST-E3-RT Speedlite controller mounted in the camera's hot shoe.

Canon off-camera shoe cord (OC-E3)

The OC-E3 is a Canon dedicated flash cord which permits E-TTL automatic flash exposure. Electrically and functionally, it's just as if you had the flash mounted on the hot shoe of the camera. Two great advantages are the elimination of any reliance on line-of-sight to fire it, and the flexible cord allows better flash placement.

NIKON EQUIPMENT FOR HANDHELD CLOSE-UP AND MACRO WORK

Nikon SB-700

This Nikon flash is smaller and lighter than Nikon's top-of-the-line SB-910 but provides plenty of light for close-up and macro photography. If you already have the larger flashes and don't mind the size and weight, then either the SB-900 or SB-910 will do a fine job.

Nikon SB-28 coiled remote cord

This Nikon dedicated flash cord permits iTTL (intelligent through-the-lens) automatic flash exposure. Electrically and functionally, it is just as if you had the flash mounted on the hot shoe of the camera. Elimination of any reliance on line-of-sight and greater ability to adjust flash angles are major benefits. And being a "curly cord," it is more or less out of the way on a flash bracket.

FLASH BRACKETS

There are so many flash brackets available that I couldn't even begin to give you a count. As usual, you can get gear of different prices from Robert's or B&H, and you can buy some directly from the camera manufacturers. Look at Kirk Enterprises of Angola, Indiana (www.kirkphoto.com), Really Right Stuff of San Luis Obispo, California (www.reallyrightstuff.com) and Wimberley, Inc., of Charlottesville, Virginia (www.tripodhead.com).

If your macro lens has a tripod collar, it's appropriate to affix your flash bracket to that collar, thus preserving the flash's ability to remain on top when you rotate the camera for verticals. Ensure that your bracket has an articulating arm so that the flash can be mounted near the front of the lens, above the lens, and moved around to permit sidelighting from both sides. Again, make sure that all the gizmos and gadgets used for attaching the bracket to cameras and attaching the flashes to brackets are compatible with the cameras and flashes to be used. The three flash bracket makers mentioned in the previous paragraph are competent to advise you with your purchase to make certain everything is totally compatible.

DUAL FLASH BRACKETS

Handheld flash shooters in close-up and macro work often prefer using two flashes for better control of lighting ratios. The appropriate bracket or bracket system has two articulating arms, one for each flash. A word of caution: one of my students, being of a mechanical mind, set out to design and build his own dual flash bracket. It was to be the flash bracket better than all flash brackets—the mother of all flash brackets—that would bring down shame and disgrace on all other flash brackets. He seemed to have succeeded with its functionality, and it was indeed a thing of beauty to behold. However, the contraption was so large, so unwieldy, and so heavy, that when loaded with his big Nikon camera and his two large and heavy Nikon SB-910 flashes, it was essentially impossible to use. More than a little embarrassed, he ended up happily using a very ordinary commercial bracket.

CANON MR-14 EX II MACRO RING LITE

A ring light flash typically has its light-emitting parts arranged around the lens so that the subject can be illuminated from this side or that and sometimes from top or bottom. This one attaches to the filter threads of my Canon macro lenses. It has adequate light output for close-ups but no ability to control the angle of lighting. Like many ring lights, it produces no shadows, thus reducing its desirability for our kind of shooting. It is coveted where shadows are undesired such as in scientific and forensic photography, and I understand that this one is widely used by dentists. For outdoor photography, I much prefer the next one. However, there is a general caveat for ring lights. *Most close-up and macro shooters dislike shadowless results, so if intending to use a ring light, demand a system with independently adjustable power.*

CANON MT-24EX MACRO TWIN LITE

This Canon ring light features dual flash tubes that can be fired together or independently to add some shadowing. A ring light is right at home for taking handheld shots or residing on a sturdy tripod. The light also attaches to the filter threads of Canon macro lenses.

The two flash heads cannot only be independently adjusted as to lighting angle, they can be independently adjusted in flash power, allowing a wide range of lighting angles. The controller part of the system mounts on the camera hot shoe and connects to the flash heads with short cables. The physical reach of the flashes is readily extended with extension arms sold by Wimberley, Inc. (www.tripodhead.com).

The bottom line: If you are a Canon shooter, and if you want a ring light, and if you intend chasing your subjects

Main flash is incredibly useful to expose the dragonfly optimally while, at the same time, underexposing the background minimally which emphasizes the subject. Nikon D4, 200mm macro, ISO 200, f/22, 1/1.3, Cloudy WB, manual ambient exposure and auto flash using +.7 FEC.

around the field and shoot handheld, this is the ring light to get.

NIKON R1C1 WIRELESS CLOSE-UP SPEEDLIGHT SYSTEMS

This sophisticated system includes an SU-800 Wireless Speedlight commander and two SB-R200 wireless remote Speedlights. The commander attaches to the camera hot shoe and communicates optically with the flashes. The two flash units can rotate around the lens attachment and allow wide variations of lighting direction and contrast.

NIKON R1 WIRELESS CLOSE-UP SPEEDLIGHT SYSTEMS

Notice that the "C1" nomenclature has been removed from the model number. This means that no commander is included. The two flash units are controlled either by the camera's pop-up flash in its commander mode, or by a Nikon dedicated flash mounted in the hot shoe. The latter is helpful if one wants to use and control additional remote flashes.

USING MACRO FLASH SETUPS AND BLACK BACKGROUNDS

A dedicated multi-flash setup, or even a single flash, are fully capable of producing attractive images in appropriate situations. Generally, we make the role of ambient light minimal when shooting handheld, but we have more exposure leeway when on a tripod. Sometimes I use one of my ring light flashes to shoot a shaded subject when I have slowed the shutter speed to allow the ambient light to expose the background while the ring light is illuminating the subject.

Returning to the subject of black backgrounds, I tend to advise against them, but what you personally prefer or dislike in your photograph remains largely subjective. One caveat, though, is that you should consider that the black portions of your subject do not merge into the black background and become invisible. The black markings on a butterfly's wings or a bee's antennae or a hummingbird's black or very dark beak are examples needing attention. Your feelings regarding black backgrounds are neither right nor wrong—they are your feelings and you are entitled to them. But watch out! Your feelings may be irrelevant at your local camera club image competition. There, your image may be critiqued by judges with opposite tastes.

Ways to effectively illuminate the background:

1 Shaded subject and a sunlit background

We are taking an early morning walk through a shaded chilly 45-degree meadow, and we soon discover a pretty butterfly roosting on a nice coneflower. The meadow is shaded by tall trees to the east. After creating a good composition, we discover that the background is bright blue sky. We set the exposure for the background, but the butterfly is in the shade and probably, we guess, at least three stops below the brightness of the sky. Without our trusty flash, we would have produced one very dark butterfly. Instead, we used balanced flash, shot handheld, and achieved a nice sharp image with butterfly and background both well exposed.

2 Subjects against close backgrounds

Consider the remarkable tiger beetle. Many species are native to this continent and all are ferocious predators. Several of the species live in sandy areas. These beetles prey largely on other insects, preferring fleas, flies, bees and numerous others. If a tiger beetle weighed around hundred pounds, we would need a well-armed bodyguard to venture out of our homes without becoming a tasty beetle breakfast.

Twelve-spot dragonflies are active when warm, but completely motionless when asleep on a cool dewy morning. Barbara used some fill flash from behind the dragonfly to slightly rim light the shape. Nikon D4, 200mm macro, ISO 200, f/19, 1/3, ambient exposure with Aperture Priority, auto fill flash using a Nikon SB-800 with −1.3 FEC.

John used main flash and hardly any ambient light fill to make a sharp image of an alpine spring beauty under steady winds on Mount Evans at 14,000 feet. Because the wildflower was growing so close to the ground, the flash was able to light both the flower and the background. Canon 5D Mark III, 180mm macro, ISO 200, f/16, 1/10, Cloudy WB, Canon 600EX-RT Speedlite set to +.7 FEC.

When photographing the basking beetle, one generally finds them on sandy earth or on small objects close to the ground. The background is close enough to the subject that they each get similar light from one flash and no black background is produced.

A different but similar case involves a slumbering moth quietly roosting on the bark of a beech tree. The mottled gray color of the moth blends into the tree bark. With so little depth to the image, one flash burst easily lights both moth and tree.

3 Add an artificial background

One way to achieve a pleasing background for your macro shooting is to make your own. To satisfy my own tastes, I have often made backgrounds by doing the following:

I made several very soft and de-focused images of some kind of foliage or groups of pink, red, or yellow flowers. I preferred darker tones to avoid obtrusive backgrounds and to reduce shadows of the subject appearing on the background. I printed them 11″ × 14″ on matte paper to reduce unwanted reflections. I mounted each background print on foamcore using a spray adhesive, although stiff cardboard would work as well. The job is best done outdoors or in the garage. The migratory powers of spray glue are astonishing and just gluing a small 11x14 inch print can generate enough glue overspray to cover everything in your house.

I took great care in the mounting to remove any air bubbles because tiny air bubbles can cause image-ruining shadows on a sunny day or when using flash. Lastly, make certain that the angle of the background placement and the placement of the flash(es) don't produce shadows on the background or reflections from ambient light or flash.

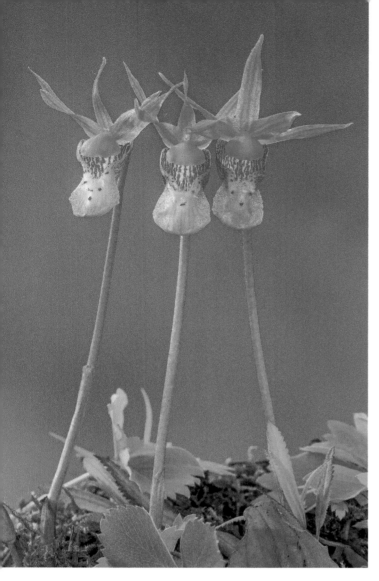

Gorgeous calypso orchids thrive on the damp mountain slopes near Yellowstone National Park. The orchid only grows six to eight inches tall and in dense vegetation. John used an artificial photo background to eliminate all background clutter. John had to shoot six images to achieve the depth of field in the image and then processed the focus stack with Helicon Focus. A single Canon 600EX-RT Speedlite backlights the orchids. John made certain the flash fired during every exposure in the focus stack. Canon 5D Mark III, 180mm macro, ISO 100, f/8, 1/13, Cloudy WB, manual ambient exposure and ETTL flash using –.3 FEC.

FINAL THOUGHTS

Many photographers shooting close-ups and macro, and especially those shooting the speedy little jumping, bouncing and bounding, leaping and hopping, flitting and flying insects, will certainly appreciate owning a flash bracket with one or two flashes.

I own both the Canon and Nikon multi-flash setups and thoroughly like using them when following active targets standing on any appealing object that instantly becomes the background.

While having discussed the one flash handheld mode of close-up and macro shooting, I still prefer to use the single flash with the camera tripod-mounted for several reasons. One reason is because I can easily use a wireless flash off-camera. Holding the flash in my hand, it is simple to place the flash to either side, to the top, bottom, or in my favorite mode—backlighting my subject. Yes, to some lesser degree, bracket-mounted flash allows some flash direction control but nowhere near the freedom of creativity you get with the camera on a tripod and the in-hand flash connected by a cable or used wirelessly. I realize most of you don't have this option yet, but the Canon 600EX-RT, when paired with the radio remote controller ST-E3-RT, allows the camera to be tripped by pushing a button on the Speedlite. This is an incredibly convenient feature!

Using flash to backlight or sidelight a macro subject with some carefully used ambient lighting of the background can produce absolutely splendid macro photos. When you seriously want to understand all the nuances of it, be sure to read our *Close-up Photography in Nature* book in which close-up flash techniques are described thoroughly and in detail.

John and Barbara own a Nikon and a Canon twin-light flash setup that supports two small flashes near the front of the lens. They also have a number of flash brackets that support a single flash near the front of the lens. We planned to include a photo of us using them, but did not have an image and for good reason. Neither one of us likes to be locked into a bracket-supported flash. Most flash bracket users chase the subject and shoot handheld, but we are underwhelmed by the results. All too often the focus isn't where it should be due to camera shake and the resulting background is black. Instead, we prefer to photograph on a tripod and handhold the flash which allows for adjusting the lighting angle rapidly and frequently using side light or back lighting the subject. John is holding the flash and trips the camera by pushing the REL button on the Canon 600EX-RT Speedlite.

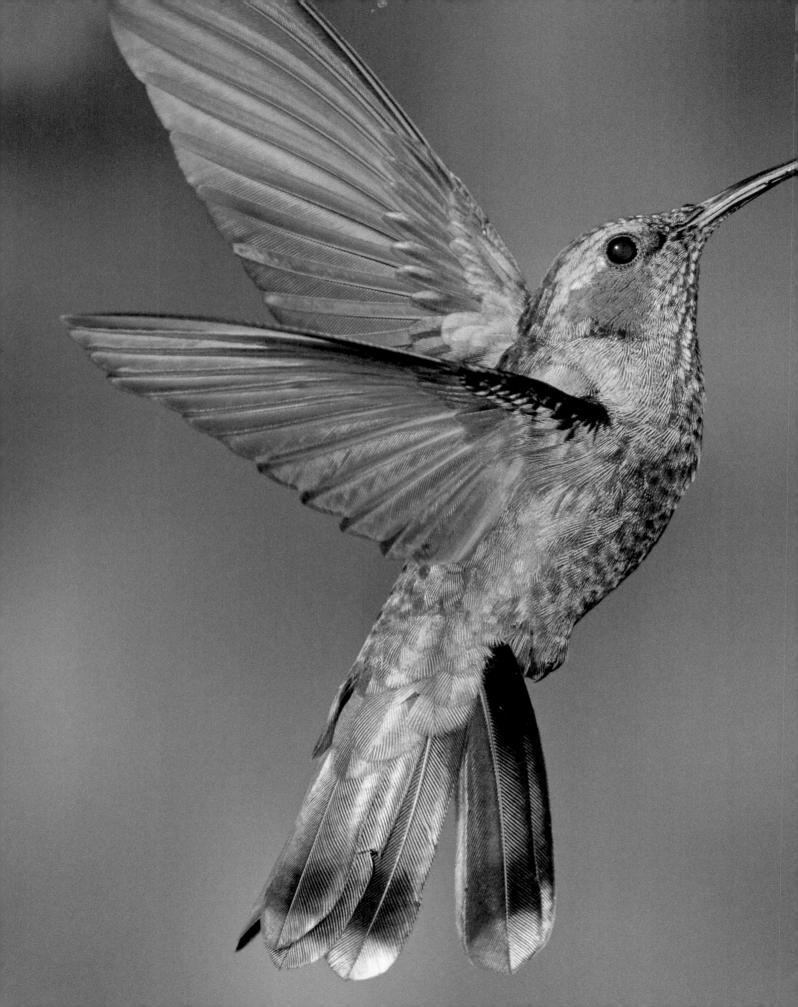

Hummingbirds with high-speed flash

WHAT SHUTTER SPEED FREEZES HUMMINGBIRD WINGS?

The delicate and graceful little creature we know as the hummingbird lives only in the Americas. We recognize about 330 species with the greatest diversity of species living near the equator. Ecuador, for example, has approximately 150 species, while our hummingbird deprived United States claims only about eighteen species. Anna's, black-chinned, rufous, and calliope hummingbirds inhabit portions of western Canada, and the ruby-throated hummingbird breeds in central and eastern Canada and the United States. Most species migrate to the southern climes during the cold of winter, though Anna's hummingbirds winter along the west coast as far north as Seattle, Washington.

The teeny hummingbirds arrive back at my Idaho home from their winter digs in early June. Broad-tailed, calliope, rufous, and infrequently a black-chinned are all species I get to enjoy and photograph near home. Since the year 2000, hummingbirds have been a prime target of my cameras and I photograph them most often with multiple flash.

I use the flash in manual mode dialed down to very low power—usually 1/32 power. The low power setting is required to achieve the short flash duration needed to freeze the super-speedy wings of the hummingbird. I have read that hummingbird wings beat as fast as 60 to 80 complete cycles per second, which makes the audible hum from which the name derives!

The low power provides the needed short flash duration to arrest the motion of the wings, but it provides woefully little light. I need at a minimum three to four low-power flashes to get enough light to optimally expose the bird and the background. Over the years many lighting arrangements have been used to help make attractive hummingbird images, many of them appearing in the Gerlach series of instructional photo books and in digital slide programs. They are also on the Gerlach Nature Photography instructional Facebook page and a Flickr page called Bull River Hummingbird Photo Workshops. I have

Four Nikon SB-800 Speedlights on manual at 1/32 power freeze the wings of the green violetear hummingbird at the Tandayapa Lodge in Ecuador. Nikon D3, 200–400mm at 300mm, ISO 200, f/20, 1/250, Flash WB.

often thought that even if no one else ever saw one of my hummingbird images, I would continue to make them because it's just tons of fun. That is the reason I am going to devote enough time and space at this time to encourage all readers to try it!

If you look diligently enough, perhaps you might find a nature photography enthusiast who doesn't want to photograph hummingbirds. It would be a tough search.

The newcomer to this aspect of the nature photography endeavor is often inclined to look at a fine hummingbird image and wonder what unearthly shutter speed is required to photographically freeze those hyper-speed little wings.

The 60–80 cycles per second wing speed I mentioned allows the hummingbird to fly upside down, to hover in place, and even to back up! To freeze those wings would

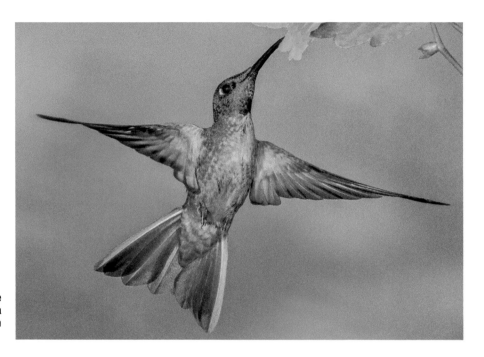

a) The short flash duration at 1/32 power freezes the lovely fawn-breasted brilliant hummingbird. Barb used a Canon 1D Mark III, 500mm, ISO 200, f/18, 1/250, Flash WB, and four Canon 580 Speedlites.

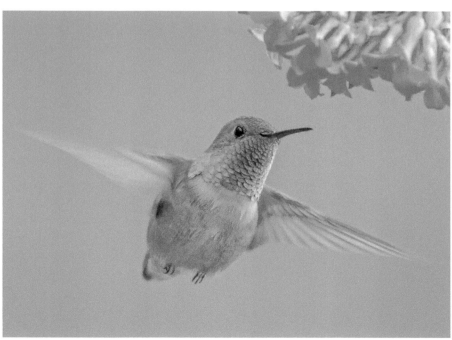

b) Blurry wings are more natural since that is the way we see hovering hummingbirds. Blurry wings can be achieved in many ways. Photographing the rufous hummingbird with all ambient light blurs the wings. So does mixing ambient and flash together and using all flash with the long flash durations found at full, 1/2, and 1/4 power. Nikon D3, Nikon 200–400mm at 400mm, ISO 1000, f/13, 1/400, Cloudy WB and no flash.

need a shutter speed of about 1/10,000 second or even faster. It is probable that even the most super-duper modern topnotch extremely expensive DSLR will only get to 1/8000 second, which is still not quite fast enough. So, clever folks that we are, we will just abandon thoughts of mechanical shutters. We will actually slow the camera down to its maximum sync speed of 1/200 second or perhaps 1/250 second, depending on the camera model, and use our quickie flashes to make the needed very short exposures. It is not all about camera shutter speed, but is all about using flash(es).

The manual mode of most flashes offers selectable fractions of the full power. Typical power fractions are 1, 1/2, 1/4, 1/8, 1/16, 1/32, 1/64, and 1/128 of full power. Each of those listed changes in power settings produces a one-stop exposure change. For example, moving from 1/8 power to 1/16 power is a one-stop reduction in light. And 1/16 power is two stops (four times) brighter than 1/64 power. At 1/16 power, a typical flash has a duration of about 1/10,000 second. Think of that! In your mind, divide a second into ten thousand parts. *Only one* of them is the *slowest* speed we use to freeze a hummingbird's wing motion! If we drop the power a stop more to 1/32 power, a typical flash duration nears the 1/13,000 point that does a fine job at wing freezing. Although some flash instruction manuals actually list flash duration as a function of power level, some do not, and therefore the above numbers given here are experience derived approximations. Speaking of which, because I so often use 1/16 power on my own Canon flashes, I know that it does a good job of wing freezing.

I may have implied that the entire exposure of the hummingbird's wings will be by the multiple short duration flashes, but I now need to clarify that a bit. The large apertures and high ISOs suggested by the power anemic flashes makes the setup prone to fuzzy wings. It is a "ghosting" caused by bright ambient light and controlled by the mechanical shutter. The image is actually a sharp rendition of the wings caused by the flashes combined with a blurred rendition caused by ambient light. So first, even though the flash exposure is unconcerned whether your shutter speed is 1/200 second or two seconds, you must keep it as high as possible, that being the maximum sync speed. Don't widen your aperture or raise your ISO and thereby "murder" your flash setup by failing to exclude ambient light! Next, you must keep the ambient light as low as possible. Shooting on overcast days is

helpful, as is shooting in the shade of trees, tents or porch roofs. I most often use dark open porches for most of my hummingbird photography, or I simply photograph them in the yard during the last two hours of the day when the ambient light is quite dim, so this light isn't captured by the sensor and the hummingbirds are most actively feeding. Don't miss that pertinent point. I find hummingbird photography to be the best during the last two hours of the day because more hummingbirds visit the feeder setup just before dusk!

I have noted that with my own Canon 5D Mark III, a five-stop underexposure will reliably produce a nearly black background. The porches and tents that are set up for our popular annual British Columbia hummingbird workshops are nearly six stops darker than the unshaded sunlight. A good exposure for the multi flash-illuminated hummingbirds turn out to be ISO 200, f/16, at the maximum sync speed, typically 1/200 second. Moreover, it is coincidentally a correct Sunny Sixteen exposure. The Sunny Sixteen exposure is f/16 at a shutter speed that is the reciprocal of the ISO, and that is what we have here. So, if we were to get a good exposure out in the sun, and if the ambient light under our porches and tents are six stops darker, we will certainly not suffer any unwanted grossly grievous ghosting caused by the ambient light.

ATTRACTING HUMMINGBIRDS

Hummingbirds feed largely on flower nectar, but being efficient little beasts, they munch on tiny insects, too. Hummingbirds eat while expertly hovering. They are particularly fond of the nectar because its high sugar content nourishes the extremely high metabolism needed to maintain the hummingbird's high-speed flitting about. Most species of hummingbirds are readily attracted to the desired photography location by careful placement of sugar-water feeders. Hummingbirds are especially attracted to large red feeders with perches. We photographers will quickly replace the large feeders with small feeders having very tiny dispensing tubes easily concealed in the image.

Finding it easier to hide the smaller dispensing tubes with leaves and flower petals is a boon for us. We find that a good scheme is to affix a leaf to the dispensing port with double-sided tape, leaving the very end of the port visible and accessible to the hummingbird. The birds must get some sugar water at each visit or they will quickly move on when disappointed, so it is important never to let the

Use the taller feeder when not photographing to attract hummingbirds to your photo station. They are readily attracted to the plastic yellow flower. When photographing, remove the other feeder and use the much smaller hum-button (available commercially) that is so easy to hide behind a real flower. The hum-button is supported with a stiff wire that is bent into shape. It is incredibly effective!

feeder go dry. When the hummingbirds are acclimated to the setup, move a flower blossom into place to just barely cover the end of the tube. The idea is to keep the feeding tube visible to the hummingbirds, but invisible to the camera, so that your image shows as much of the bird's beak as possible but not the tube. Precise thought about camera placement is extremely helpful. Camera movements of only an inch or so left or right may markedly improve the image. The goal is to hide the feeding tube or tiny Hum-Button with a leaf and flower blossom completely, but still be able to see most of the hummingbird's beak while feeding.

PREPARING SUGAR WATER

Be certain to use regular cane sugar. Never use artificial sweeteners, as the poor tricked birds will believe they have fed but will starve of the energy they need. Unlike some people I know (I will not mention any names, of course), the hummingbirds never need to diet. A 4:1 mix of water to sugar is considered "standard," although I have come to believe that a somewhat sweeter 3:1 mix works better

for attracting the hummingbirds and encouraging them to return. So I mix three cups of water with one cup of sugar and stir until all of the sugar is dissolved. Some folks like to boil the water a short time to kill mold and enhance the lifetime of the mix, especially in warmer climates. I don't because I live in Idaho's colder mountain climate. Note that I do, however, replace the solution every couple of days, not because of the mold but because the truth of the matter is that there are so many hummingbirds both near my home, as well as at the Canadian hummer workshops, that feeders need to be refilled sometimes twice a day. There is no time for mold to develop even if it were warm.

EQUIPMENT

LENSES

An ideal lens for hummingbird photography is a high-quality zoom lens capable of reaching 400mm. Zooms are particularly adapted for this form of shooting because the various species of hummingbirds are of different sizes. In

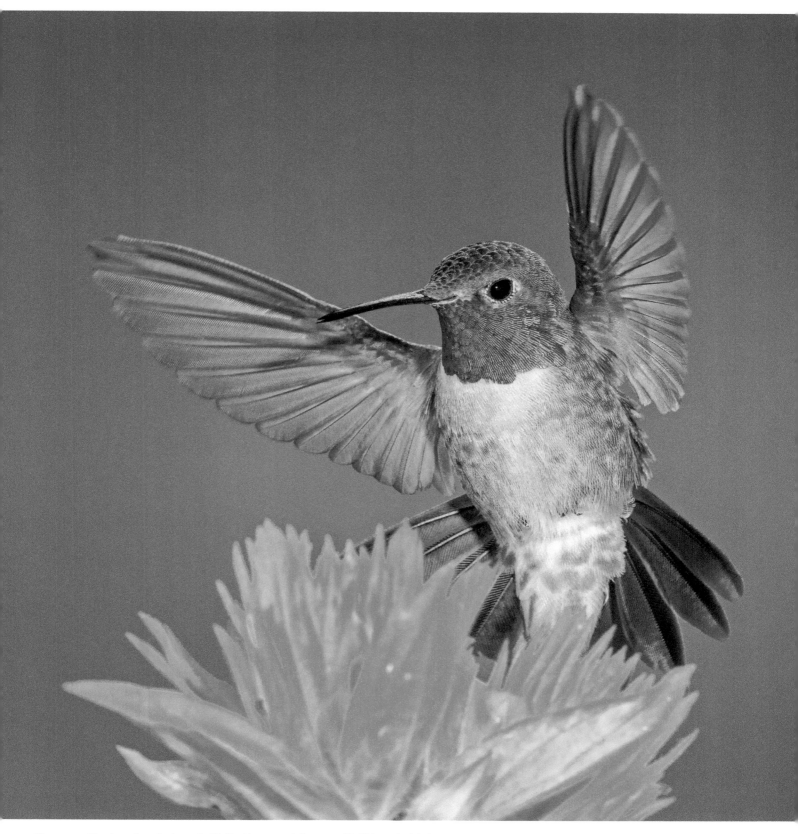

We once used feeders where the hummingbird had to approach from one side. This worked, but greatly reduced the angles you get and tended to make the hummingbird face away from you which reduces the chance for capturing iridescent colors. With the hum-button, hummingbirds approach from all sides and tend to face the camera creating far better poses and improved color. Canon 1DX Mark II, 560mm, ISO 400, f/18, 1/200, Flash WB, four Canon 430EX III-RTs set to 1/32 power.

addition, sometimes two birds are feeding simultaneously at which time a different framing is preferred. Walking to and fro to deal with compositional changes is tiring, and sometimes good composition takes second place to fevered footsie fatigue. Worse, it disturbs the birds. Expensive but awesome are the 200–400mm zooms made first by Nikon and then by Canon.

I once quite successfully used a Canon 300mm f/4 lens with a 25mm extension tube mounted between the lens and the camera to enable the lens to focus closer than its normal Minimum Focusing Distance (MFD). A closer focusing lens allows me to fill the frame with more of the hummingbird, and I can sit quietly about five feet away to

not scare the birds while being able to fill the image with a calliope hummingbird, the smallest bird in North America.

Summarizing, any lens of at least 300mm that can fill the viewfinder with a four-inch subject at the distance of about five feet will prove usable for hummingbird photography. The lens need not be fast. The multiple flashes even dialed down for the short duration bursts provide enough light to satisfy any 300mm f/5.6 lens, as long as it has operable autofocus under the prevailing light conditions.

TRIPOD AND HEAD

If low-power flash is the only source of light—no ambient—then sharp images are reliably obtained as long as

Would you believe a bat-hummer? Maybe not, but multiple flash using short flash durations work perfectly to freeze a pallid bat flying low over the water. Our good friend Bill Pohley allowed us to use his fine image. Bill photographed this bat at The Pond at Elephant Head near Amado, AZ (www.phototrap.com). Canon 5D Mark III, 500mm, f/22, eight seconds, four flashes fired when the bat broke a Phototrap beam. Why was the shutter speed eight seconds? There is too much lag time between tripping the camera and taking the image. Instead, on a dark night when a bat is detected drinking from the pond, the camera is tripped and hopefully during the next eight seconds the bat breaks the beam. If it doesn't, then fire another eight second exposure as long as the bat is present. Should the bat break the beam emitted by the Phototrap, there is no lag time since the shutter is already open so you have a good chance to sharply focus the bat.

you focus carefully on the hummingbird's face. This is true even when handholding the camera. Handholding can very quickly become exceedingly tiring, especially to those, like me, who lost their youth well before Velvia 50 slide film became hot stuff! Far more convenient is a tripod-mounted "gimbal head" that holds the camera where pointed, but allows the several degrees of freedom needed to optically pursue the ducking and diving speedy little birds.

We both always use what has been arguably the gold standard brand of tripods for the nature shooter, a Gitzo. When buying one now and then, we buy only the "legs" without any head, as we need to outfit the legs with specific heads according to what we are shooting. For hummingbird photography, we like to use a Kirk BH-1 ball head and then attach a Wimberley Sidekick. This combination has been gratifyingly helpful in our work. Wimberley also offers a "full size" gimbal head that I use with my heavier 800mm lens for photographing other types of wary wildlife, but not hummingbirds. The larger head has some functional advantages that are thoroughly discussed on www.tripodhead.com, but is larger and more expensive. Either way, a gimbal head is great news. When a hummingbird appears and it is bouncing and bounding this way and that as it backs off the feeder, the gimbal head allows a very smooth, virtually weightless, following of the bird. You will not wear yourself out handholding the camera and lens when you use a gimbal head! By the way, in the past few years, some Wimberley competitors have started offering various versions of gimbal heads, but we continue to favor Wimberley products. The originators of these heads are still the best in our opinion!

FOCUSING

A continuous autofocus mode is by far the most helpful. Be sure to use a single autofocus point and keep it on the hummingbird's face. Then, the camera and lens will attempt to maintain focus while the camera and/or subject are moving about, as long as the shooter holds the focus button down. Looking through the viewfinder and using a gimbal head, one can easily maintain or make in-flight changes in the composition. Although I normally use back-button focusing for most of my photography, I find activating the autofocus by pressing the shutter button down half-way works better for hovering hummers.

POSES

The novice hummingbird shooter very quickly learns that some of the most photogenic poses occur right after the hummingbird has fed. The bird backs away from the feeder, then turns and momentarily might face the camera as it turns again to head back to the feeder. In that face-on pose, the throat often displays the most remarkable iridescent colors.

CAMERAS

Practically any digital camera is effective for hummingbirds. Cameras having a full-frame sensor generally provide lower noise, capture higher dynamic range, and may produce noticeably better quality images than cameras with small sensors. Still, all cameras, no matter the sensor size, work fine for hummingbird photography. However, with a given focal length lens, the bird image in the full-frame sensor occupies a smaller percentage of the frame, giving two more benefits. One is that in the heat of battle, the shooter is less likely to inadvertently clip a wing or a tail, essentially ruining the image. The other is that the additional image real estate around the bird itself provides more opportunity for improving the composition by aesthetically-driven cropping.

Now, having extolled the virtues of the full-frame sensor, let me argue the opposite viewpoint that a "crop sensor" camera is perfectly acceptable for photographing hummingbirds. The crop factor, commonly 1.5X or 1.6X, causes the bird to be a larger percentage of the frame. That allows one to fill the frame without having to walk closer and without having occasional need for an extension tube to allow focusing at the closer distance. Additionally, the crop-sensor camera is generally smaller, lighter, easier to carry and less expensive.

DOES ONE NEED A BLIND?

Hummingbirds are generally unafraid of, and unconcerned with, the motionless photographer near the feeder. The operative word is "motionless." They are certainly wary of rapid movements. Rapid movements by a surprised photographer with the hummingbird's arrival at their setup should definitely be suppressed. So by being reasonably cautious, one would not need a blind. If you should detect that the hummingbirds are suspiciously skittish, a blind may be in order. An inexpensive hunting blind from the

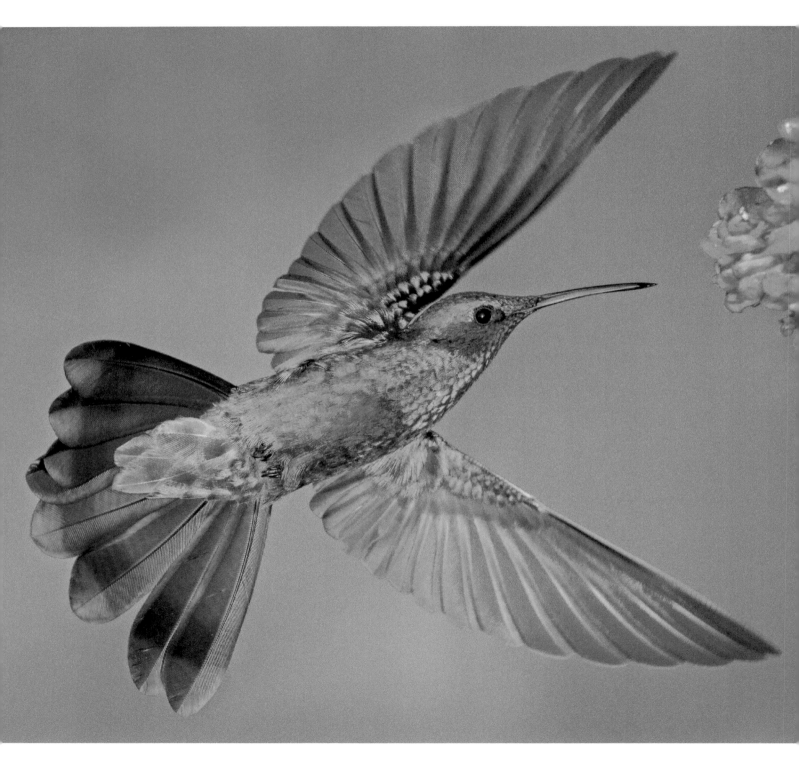

The sparkling violetear is attracted to a sugar water feeder hidden with a flower in Ecuador. We find the most attractive poses happen when the hummingbird is hovering in front of the disguised feeder and not actually feeding in it. We look for pleasing wing positions and flared tail feathers! Barb was shooting John's Canon 1D Mark III, 300mm, ISO 200, f/18, 1/250, Flash WB, and four Canon 580 Speedlites.

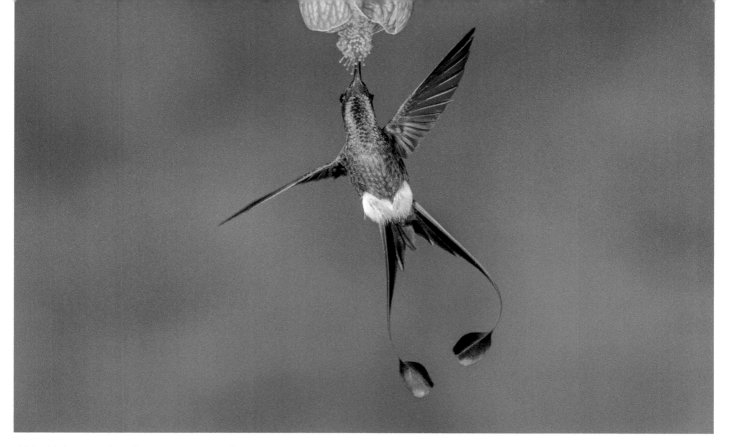

a) Adorable booted racket-tails are common at the Tandayapa Lodge in Ecuador. With the wings and especially long tail, it is helpful to compose the image somewhat loosely to avoid cutting off a wing tip or tail. Nikon D3, 200–400mm at 310mm, ISO 200, f/20, 1/250, Flash WB, four Nikon SB-800 Speedlites on manual at 1/32 power.

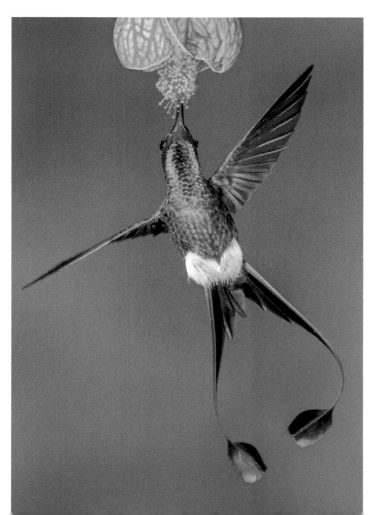

b) Cropping the image after shooting, on the computer, produces a more frame-filling and stronger composition. From years of experience, we know if you try to compose this tightly, most wonderful poses will be ruined because a portion of the bird is cut off.

corner sporting goods store can often work well doubling as a photo blind. If you do have a fabric blind, watch out for loose corners or other parts flopping, flapping, and flailing about in the wind. The resultant noises and erratic movements might do more to disturb the birds than did the blind deprived photographer.

SETTING UP THE FLASHES

Over the years, we have shot tens of thousands of hummingbird images, and the vast majority used flash illumination. Several flash makes and models will perform perfectly. Nonetheless, we cannot cover them all here, so we will continue to concentrate on the Canon and Nikon gear that shows up most of the time at our workshops. Do not panic! If you are shooting a different brand of camera, simply equip yourself with the camera manufacturer's offerings in dedicated flashes and all will be fine. We prefer to use three or four flashes in our personal hummingbird setups and in the setups for our British Columbia hummingbird workshops. We urge you to use a wireless control system, optical or radio, but avoid optical slaves and cabled systems. Why? Whenever I set up a cabled system, it nearly always fails on the first try even though I connect everything perfectly. Whenever I set up a wireless system, the entire setup always works fine the first attempt.

FLASH CHOICES

The ultimate Canon flash

My winner in the Canon flash (called a Speedlite by Canon) contest is the 600EX-RT. Four of these splendid units offer plenty of power and flash ratios down to 1/128 of full power. The flash zoom capability extends to 200mm. The long zoom allows placing the flash farther away from the hummingbird or background, making it easier to use without having the flash appear in the image. The ST-E3-RT radio controller can manage this flash with no line-of-sight issues between master and slave. For far less money, the less powerful but perfectly adequate Canon 430EX III-RT Speedlite is an excellent alternative.

The power requirements for this flash and controller setup are very convenient. They each take the common AA batteries. The Eveready Ultimate Lithium is a winner in the non-rechargeable category. If you, though, like me, prefer good rechargeable batteries, go for the Eneloop or Powerex 2700 models.

Nikon

The top-of-the-line dedicated Speedlight in the Nikon line is the highly praised SB-910. The SB-910 is perfect for the job, but Nikon helps you out a bit if you don't have enough of them. Nikon offers its model SB-700 that is considerably less expensive than the SB-910 but has more than adequate power for hummingbird photography. The SB-700 offers optical wireless control and can be used as a remote or as a commander. So if you are buying flashes solely for hummingbird photography, get the SB-700. If you are buying

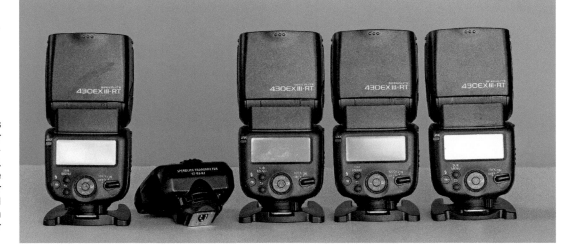

Four Canon 430EX III-RT Speedlites and the ST-E3-RT radio controller are all that you need for professional quality hummingbird images. While John is a huge Canon fan, he does reluctantly admit that four Yongnuo YN560 IV Speedlites and their YN560-TX manual radio flash controller work every bit as well for one-quarter of the price!

your first flashes and anticipate doing the outdoor flash photography you have been learning about in this book, the larger SB-910 is preferable. Note: Nikon recently introduced their first radio-controlled Speedlight—the Nikon SB-5000 AF that is controlled with the optional WR-A10—so now the wonderful radio-control option is available.

All of our comments regarding batteries for Canons are perfectly applicable for Nikons, so I will condense the battery choices here. The power requirements for this Nikon flash and controller setup are very convenient. They each take AA batteries. I prefer good rechargeable batteries. Eneloop (available at Costco) and Powerex 2700 batteries are highly regarded and are the ones I use. The MAHA C801D eight-cell battery charger individually charges each

battery to optimize its power reserves. Search the Internet to discover dealers with competitive prices.

FLASH STANDS AND MINI BALL HEADS

I have mentioned this before but it is well worth repeating when discussing hummingbird photography: be certain to use a separate light stand and ball head for each of your flashes. Some shooters try to mount two, or even more flashes on only one stand, but they soon learn that they cannot reliably get favorable lighting that way. The ability to individually place and point the flashes is critical. Let me expand a bit on appropriate placement of the flashes.

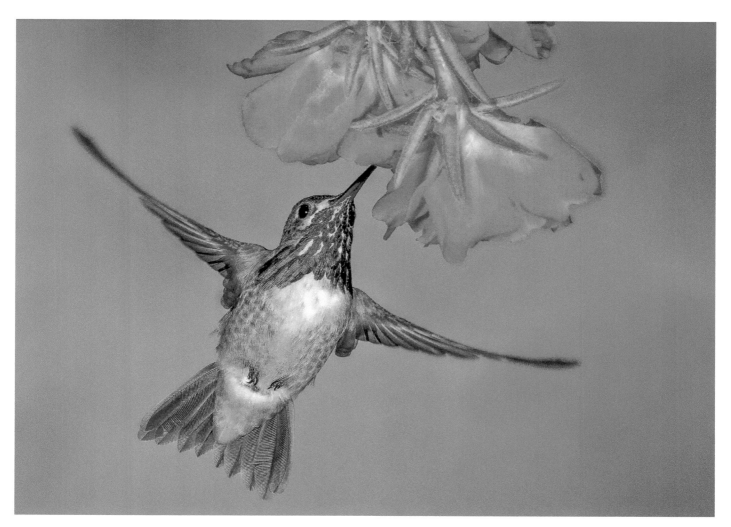

Male calliope hummingbirds display gorgeous violet colors in their gorget when the light strikes the feathers at the correct angle. There are two keys to capturing iridescent colors consistently. Place a flash above the hummingbird and another flash slightly below it. Even more important, the hummingbird must be somewhat angled toward the camera. A side view doesn't produce iridescent colors. In the next image, you see a setup where the hummingbird approaches from the side. The hummingbird must look at you once in a while for the camera to capture the gorget colors. Now that we use hum-buttons, most of the time the hummingbird is facing the camera making the colors in iridescent feathers easy to capture. Nikon D70, 200mm, ISO 200, f/22, 1/250, Flash WB, four Nikon SB-800 Speedlites at 1/32 power.

Flash #1 Main Gorget Light

The gorget is the area of iridescent brightly colored feathers on the throat of most male hummingbirds. It is not pronounced *gore-jay* as I first heard it, but properly as *gore-jet*, with the accent on the first syllable. It is pronounced similarly to *gorgeous,* and some say not without good reason.

By judicious placement of the feeder, you know where the hummingbirds will be when you press the shutter on your camera. To best show off the gorget, place the #1 flash in front of, and higher than the bird. You will do well if the flash is about 14 inches in front of the hummingbird, above, and tilted down to light the top of the bird. Coming from above, this light will cause the underside of the hummingbird to be in shadow, but it greatly improves the chances of capturing iridescent colors.

Flash #2 Bottom flash

This flash is to light the hummingbird's underside. Let me re-phrase placement of the second flash. This flash adds a little light to the overall frame, but particularly lights that portion of the hummingbird's anatomy that is shadowed by Flash #1. A good placement would be at approximately the same height as the lens or slightly lower, close to the camera-subject line, and again, around 14 inches, or perhaps a little more from the hummingbird.

Flash #3 Background flash

Flash #3 should be pointed at the background. Care should be taken to keep it centered. The background should be evenly illuminated to ascertain that there are no hot spots. Avoid making one side of the background brighter than the other. Keep the flash low enough so the flash unit itself does not appear in the image. Point the flash upward at the background to evenly illuminate it. A distance of two feet or thereabouts generally illuminates the background adequately. Adjust the flash to background distance as needed to achieve the desired brightness. Glossy photo prints used as a background typically require less flash to light, but reflections from the flash tend to cause hotspots unless the background is angled correctly. Painted backgrounds require more flash, but reflections are much less of a problem. I prefer photo backgrounds printed on matte paper to reduce the reflection problem.

Flash #4 Backlight flash

Flash #4, when used, is helpful to backlight the hummingbird. The backlighting does a nice job of separating the bird from the background, especially where the background and the bird are of similar tonalities and colors. Because the lack of contrast can cause unwanted visual merging of bird and background, the flash should be positioned above the hummingbird and to the side to prevent it from appearing in the image. Placement approximately 20 inches from the hummingbird is appropriate. Backlight flash does an incredible amount to improve overall lighting by rim-lighting the bird and reducing black shadows that may appear on the top side of the wings.

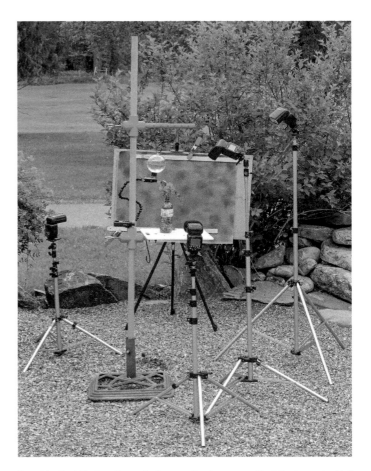

Four identical flash units on their own stands are excellent for hummingbird photography. It is important to be able to easily adjust the position and the angle of the flashes to allow for numerous variables such as type of flower, how the sugar water is being hid, how the birds work the setup and also lens choice. Notice the artificial painted background (photos work too) and the two adjustable homemade red devices on the closet rod that enable adjusting the plant and the feeder up and down in tiny increments.

SEVEN FLASH SETUPS

Seven flashes? Incredible! On first glance, this seems like a serious overkill. This overkill probably makes the departed soul of electronic flash inventor Harold Edgerton do a happy dance. Trust me, though, it has a good place in extra sophisticated hummingbird photography.

I use the first four flashes to illuminate the hummingbird, but not arranged exactly as above. Here is the setup:

Flashes #1 and #2 are placed as high gorget flashes, one on each side of the hummingbird. Flash #3 is the "underbelly" flash that cancels out the shadowing caused by the higher Flashes #1 and #2. Flash #4 is the backlight flash on the hummingbird. In this setup, I place the background about six feet behind the bird, three feet further than normal. By leaving that six-foot space, I now have room to place some real flowers between the bird and the background, making the hummingbird's environment even more realistic and more attractive. Now I need to light those flowers. One light on the flowers causes nasty shadows as any one leaf or petal will cast a shadow on other leaves or petals. No problem. I use Flashes #5 and #6 to evenly light the flowers and put small diffusers over the flash heads to soften the light still more. Flash #7 is used to evenly light the background. All of the flashes are triggered wirelessly. So there you have it—seven flashes on that little itty-bitty bird!

DO FLASHES HARM THE HUMMINGBIRDS?

Flash never harms the hummingbirds in the least. Initially, some birds might notice the flash (or the sound of the shutter) and back away from the feeder to review their situation. It takes them little time to accept the flashes, and some birds may even perch on them. (Bring a damp cloth!) The extremely short light bursts are at very weak energy levels. Even in the seven-flash setup above, the total energy output of the seven flashes is less than that of one flash at full power, so the radiated heat is minuscule. In hundreds of thousands of hummingbird exposures, each and every one using multiple flashes, no hummingbird has yet been seen to burst into flames, not even a wisp of smoke. Moreover, there is other good evidence that the flashes are quite harmless. We have had individual birds, easily recognized by uniquely unusual feather markings return to our setups year after year for several consecutive years. They have showed no accrued ill effects of being photographed at least 200,000 times.

THE BEAUTY OF WING MOTION

During our annual hummingbird workshops at the Bull River Guest Ranch in southeastern British Columbia, I have met hundreds of neophyte hummingbird shooters. All of them, virtually unanimously, believe that hummingbird photography is a very difficult art form. However, once they see how we do it, they are amazed at its inherent simplicity. So much so, that before the workshop ends, the new practitioners can begin to feel that it is all too easy and the frozen wing images begin to look alike. No problem! For that, we have a prescription.

Barbara and I worked hard to develop the setup and shooting schemes discussed above. We did so because of the impossibility of the human eye and brain to stop the very rapid wing movement of the hummingbirds. But there comes a time when the minds of all good students come to the aid of variety. They wonder whether it might even be fun to see some blurry wings. As practically always, though, when shooting live creatures, the eyes must be very sharp. We have devised two ways to accomplish these contradictory effects of blurry wings and sharp faces when using flash. Here they are:

METHOD #1 MAIN FLASH IN BRIGHT AMBIENT LIGHT

This method relies on what amounts to a simultaneous double exposure. Ambient light serves as the minor light at a shutter speed deliberately calculated to blur the wings. Actually, by using the mechanical shutter, we have no choice. The wings will be blurred; it is just a matter of how much. The flash used as the main light optimally exposes the hummingbird and the short duration effectively stops the wings and produces a sharp image of the hummingbird's body. The combined sharp exposure from the flash and blur from the ambient light produces an uncommonly nice feeling of motion in the image. Suppose the optimum exposure for the multiple flashes is ISO 200 and f/16 at 1/200 second. Under the bright overcast, the ISO 200 and f/16 exposure might be about 1/25 second. If we slow the shutter from the usual 1/200 second down to about 1/50 second, there will be an appropriate ambient exposure of the blurred wings while the flash does its normal job of wing freezing.

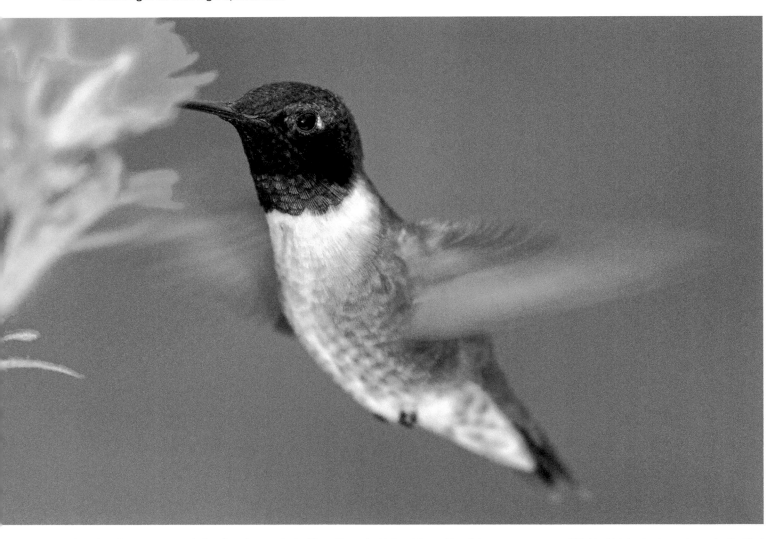

A single flash is used as the main light for this male black-chinned hummingbird and the ambient light serves as a strong fill light which is about one stop under the ideal ambient lighting exposure. Canon 7D Mark II, 200–400mm with 1.4x at 560mm, ISO 640, f/5.6, 1/500 with HSS, Cloudy WB, one Canon 600EX-RT Speedlite set to +1 FEC.

METHOD #2 FILL-FLASH IN BRIGHT AMBIENT LIGHT

This technique is easy and the essence of which we have already covered. When our bright ambient is common bright sunlight, we are back to that old favorite, the Sunny 16 Rule. If using ISO 400, the proper exposure is 1/400 second at f/16 or any equivalent. Equivalents include, without limitation, 1/800 at f/11, 1/1600 at f/8, and 1/3200 at f/5.6.

Assume the hummingbird feeder is in the open yard and in the early morning sunshine. The optimum exposure in this slightly less than full sunshine at ISO 400 might be 1/800 second at f/8. The ambient light is the main light, and the high shutter speed of 1/800 second easily freezes the barely moving body of the feeding hummingbird. However, at 1/800 second, the wings are totally blurred. Along comes the flash! The short duration of the manual mode flash set at a low power is being used as a fill light, one which will freeze the wings. We have created an image of composite sharp and blurred wings and a resultant feeling of motion.

Note, though, that the shutter speed of 1/800 second is far beyond the maximum sync speed, so the high-speed sync mode must be used. High-speed sync will supply several bursts to illuminate the entire image as the shutter curtain gap traverses the sensor. As noted, multiple bursts are powered by only one charge of the flash's storage capacitor and so each single burst is quite weak compared to a full burst. The reduced light is not critical in our hummingbird work because we are using it only for fill and because it will be very close to the subject.

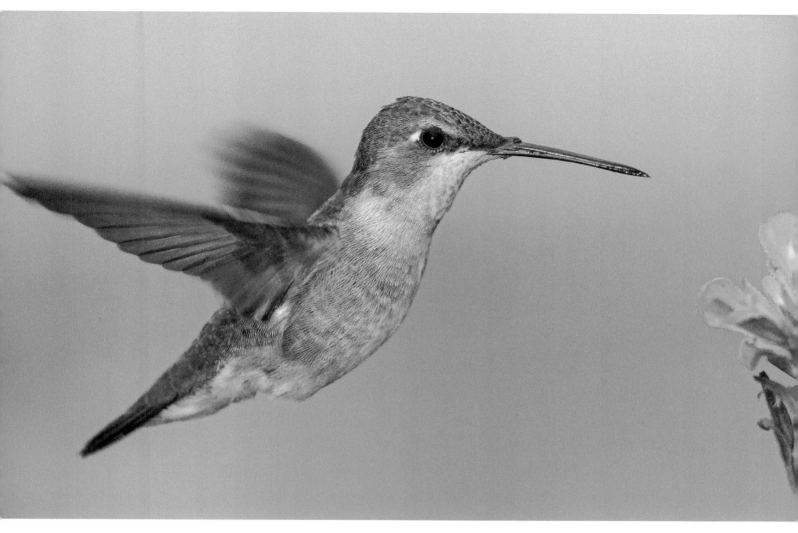

The bright ambient light nicely envelops the female black-chinned hummingbird in detail revealing light. Fill flash was used at −2 FEC to more crisply capture the wings revealing more feather detail. High-speed sync (HSS) was used to make the flash work with a shutter speed of 1/1000. Canon 5D Mark III, 560mm, ISO 1250, f/6.3, 1/1000, Flash WB, manual ambient and flash exposure.

CAN YOU DELIBERATELY BLUR THE WINGS WITH FLASH?

Suppose that you have just happily filled a memory card with a thousand gorgeous hummingbird images, each with crispy sharp wings. You decide that showing some wing motion would give a nice change to the images. Can you use flash light exclusively to reveal wing motion? Most assuredly! Remember that the wings are frozen by the very short duration of the flash bursts when the flashes are set to manual mode and to 1/16 power or less. If one were to look at, for example, the flash duration chart published by Nikon for its SB-910 flash, one would see that at 1/16 power the flash duration is 1/10,000 second. That shutter speed is just fast enough to freeze hummingbird wings, so any longer duration will blur the wings. If, then, one

was to set the flashes to, say, 1/4 or 1/2 power, one gets to enjoy blurred wings. The bird's body is relatively motionless, so even the longer flash burst will freeze it. How blurred will it make the wings? Your call! Just experiment with the flash power. Be prepared. Most of the images will be rejects for one reason or another, but a few will be absolute winners! As you go through the edit process, remember that one factor separating super-shooters from beginners is the super-shooters' complete willingness to wastebasket anything not worthy of showing. That shooter has only winners to show!

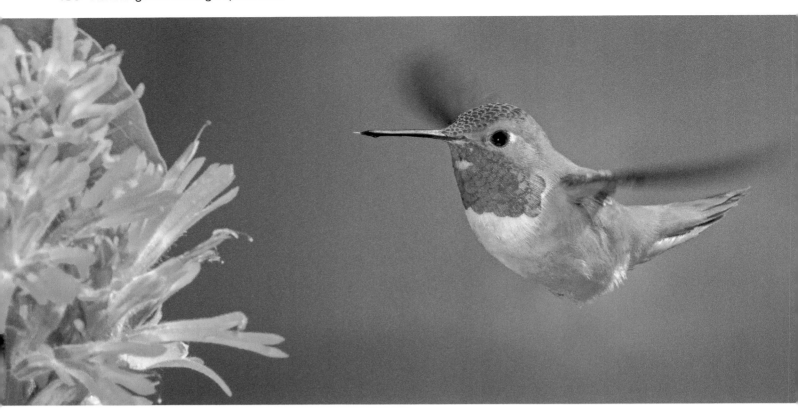

Using flash as the only light source doesn't necessarily stop motion and the wings can be pleasingly blurry. How does one do this? Use the longer flash durations at full, 1/2, and 1/4 power. The male rufous hummingbird wings blur nicely when using 1/4 power on the four Canon 600EX-RT Speedlites. Canon 7D Mark II, 200–400mm at 400mm, ISO 100, f/20, 1/250, Flash WB, manual flash exposure at 1/4 power.

HOW QUICKLY CAN YOU SHOOT?

When using your flashes in the manual mode (as you do in virtually all hummingbird photography), the required recharging time of the flash's energy storage capacitor may or may not prevent multiple flashes without recycling. Recycle time depends on the power setting being used. Considerably less energy is consumed in a flash set to 1/64 power than one set to 1/2 power. When using full, 1/2, or 1/4 power flash settings, it may take a few seconds to allow your flash to fully charge to optimally expose the next image. To shoot consecutive images faster, consequently, go with short flash durations of 1/16 power or even less.

As this book was drawing to a conclusion, I pushed the limits to see how many images per second I could shoot at 1/16 power and still maintain an optimum hummingbird exposure. With Canon 600EX-RT Speedlites, I can shoot about four images per second before the images begin to go dark as the flash is not able to recycle fast enough. By zooming the flash head to 200mm, using ISO 400, f/13, setting the power level to 1/32, and moving the flashes as

close to the subject and background as possible, 12 well-exposed images in 1.2 seconds could be captured! That is outstanding, because many times you must wait for long periods before a hummingbird arrives, so it is enormously helpful to be able to shoot plenty of images rapidly. Still pushing the limits, I then tried 1/64 power. I got 25 optimally exposed images before the camera refused to fire. Did the flashes run out of power? No! What stopped me from shooting? My Canon 7D Mark II camera's internal buffer filled up! Still, that means I can now capture 25 nicely exposed images in 2.5 seconds! Awesome! It is vital knowledge to have.

For your reference, here is how the Nikon SB-910 flash changes its flash duration with the power setting. Most similar flashes will have similar numbers.

Nikon SB-910 power level	Flash duration (seconds)	Flash duration (milliseconds)	Flash duration (microseconds)
1 (full power)	1/880	1.14	1140
1/2	1/1100	0.91	910
1/4	1/2550	0.39	390

Nikon SB-910 power level	Flash duration (seconds)	Flash duration (milliseconds)	Flash duration (microseconds)
1/8	1/5000	0.20	200
1/16	1/10,000	0.10	100
1/32	1/20,000	0.05	50

The hummingbird micro-book reaches the end and we conclude the entire flash book. As to the hummingbird photography, I can't even begin to convey how much fun you will have doing it. A web search reveals many hummingbird havens and hot spots. A plethora of hummer workshops are available. Speaking of workshops, one last pitch for ours! The annual Gerlach hummingbird workshops in British Columbia will turn a beginner into an expert in only one week, and will turn an expert into a sublime artist in the same week! Moreover, practically all of the other flash techniques we have so carefully and enthusiastically espoused here are dutifully tutored and practiced at all of our summer and fall Michigan workshops.

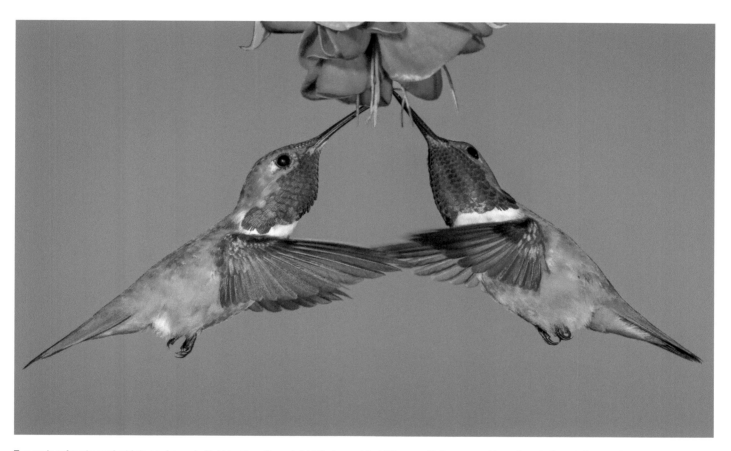

Two male rufous hummingbirds are frozen in flight by three Sunpak 544 flashes set to 1/16 power. Today we would use four dedicated Nikon or Canon flashes to make this image. Nikon D3, Nikon 200-400 at 290mm, ISO 200, f/22, 1/250, Flash WB, Manual ambient and flash exposure.

14

Important flash-related websites

www.kirkphoto.com

Kirk Enterprise Solutions builds many products for flash-bracket users and macro shooters. The late Mike Kirk was a personal friend of mine when he started his business years ago, and his able son, Jeff Kirk, has taken over the business. Jeff is as warm and helpful as any customer could want!

www.tripodhead.com

Clay Wimberley and his helpful staff operate a photography specialty company with many useful products including flash brackets, the world-famous Wimberley gimbal heads and other accessories. This is a necessary site for you to visit.

www.flashzebra.com

FlashZebra produces custom adapters and flash cables that are especially useful for off-camera flash in manual mode. Moreover, FlashZebra is open to furnish custom items for those enterprising photographers who like to have personalized flash gear.

www.vellogear.com

Vellogear designs and sells numerous camera and flash accessories that are highly useful to outdoor photographers, and especially to those who frequently use flash. Be sure to examine their extensive line of shutter releases, dedicated flash cords up to 33 feet long, flash brackets, hot shoe adapters, flash diffusers and remote flash trigger systems.

www.honlphoto.com

Acclaimed professional photographer, David Honl, offers a creative line of flash modifiers that he designed to solve the flash problems he encountered in the field. I use the Honl Photo Traveller8 Softbox that mounts directly on my shoe-mounted flashes. It effectively diffuses the light from the flash unit. I personally use the Honl Photo CTO Warming Filter Kit frequently to modify the color temperature of my Canon

The masked flowerpiercer is foraging in the bushes around Guango Lodge in the Ecuadorian highlands. Since this bird is active, Barbara followed it around with a Betterbeamer on her flash to reach the bird. She set the ambient exposure about one stop underexposed and used +1 FEC to optimally light the bird. Though shooting hand-held at 1/200 second, the image stabilized lens and the short flash duration produced a sharp image. Nikon D300, 400mm, ISO 1250, f/7.1, 1/200, Flash WB, and a Nikon SB-800 Speedlight.

Remembering that unfiltered flash is similar in color to sunshine during the middle of the day, quite often making the light more yellow to simulate golden sunshine early and late in the day is helpful. We filter our flash a majority of the time. The Honl CTO gel set, speed strap, and fold-up wallet for carrying the gels is superb! (www.honlphoto.com)

Speedlites, and I highly recommend them. The filters are stored in a Honl Photo Filter Rollup. A Speed Strap is fastened to the flash head which permits the CTO filters to be easily attached to the flash and removed.

www.pocketwizard.com

PocketWizard's radio-based wireless flash trigger systems are legendary in the flash photography business. Users report that they are versatile and reliable. The PocketWizard line includes flash control gear that covers Nikon's i-TTL mode flashes, Canon's E-TTL flash systems and others as well. If you are looking for a third-party wireless flash control system, consider the quality PocketWizards.

www.paramountcords.com

Paramount sells a wide variety of flash connecting cords that include sync cords, E-TTL cords, Y-cords, special cords for PocketWizard gear, PC Tip Conditioners and other accessories.

www.ocfgear.com

This company offers extra-long flash cords for i-TTL Nikon systems and E-TTL flash metering for Canon Systems.

www.pixsylated.com

If you are a Canon user, and even if not, Syl Arena's website offers loads of information on using the Canon flash system. A visit here is well worth your time. Syl's *Speedliter's Handbook,* now in the Second Edition, is outstanding for the Canon crowd and helpful for photographers using other brands.

www.strobist.blogspot.com

This website is splendid for both beginning flash users and experts too. Flash expert David Hobby offers information on the effective and creative use of small flash systems. Be sure to take a look!

www.learn.usa.canon.com

A wealth of instructional videos and articles about using Canon equipment is found on the site. Click on "How-to Tutorials", and then search for flash. While the information explains Canon gear, much of the underlying theory is perfectly applicable to any flash work.

www.facebook.com/gerlachnaturephotographyworkshops

And now for our last promotion. Our instructional Facebook page showcases images with complete photo details. It stresses photo techniques valuable to photographers of every experience level and info for using any type of gear.

www.gerlachnaturephoto.com

Ok, now for our very last promotion! For 30 years, Barbara and I have conducted a wide variety of well-attended field workshops and tours to advance the beginner and to advance the advanced. Please go to our website to find details of Gerlach Nature Photography, and a plethora of educational opportunities. Classes include the frequently discussed hummingbird workshops in beautiful British Columbia and our summer and fall Michigan field workshops in Munising, where, among other things, we discuss thoroughly and use frequently many of the flash techniques introduced in this book.

Index